ECCENTRIC SPACES

ECCENTRIC SPACES

Robert Harbison

Alfred A. Knopf · New York · 1977

THIS IS A BORZOI BOOK
PUBLISHED BY ALFRED A. KNOPF, INC.

COPYRIGHT © 1977 BY ROBERT HARBISON
ALL RIGHTS RESERVED UNDER INTERNATIONAL AND PAN-AMERI-
CAN COPYRIGHT CONVENTIONS. PUBLISHED IN THE UNITED
STATES BY ALFRED A. KNOPF, INC., NEW YORK, AND SIMULTA-
NEOUSLY IN CANADA BY RANDOM HOUSE OF CANADA LIMITED,
TORONTO. DISTRIBUTED BY RANDOM HOUSE, INC., NEW YORK.

LIBRARY OF CONGRESS CATALOGING IN PUBLICATION DATA
HARBISON, ROBERT. ECCENTRIC SPACES.
INCLUDES BIBLIOGRAPHICAL REFERENCES AND INDEX.
1. SPACE (ART) 2. ARTS. I. TITLE.
NX650.S8H37 1977 700 76-24460
ISBN 0-394-40719-9

MANUFACTURED IN THE UNITED STATES OF AMERICA

FIRST EDITION

For Esther

Contents

The author wishes to thank
John and Artis Bernard, Steve Zwicker,
and the University City, Missouri, Public Library.

Foreword

*T*his is a book about trying
to live in the world which takes
art as its subject because there the in-
tegrity can be assumed, and hence we believe
we can explain its products to ourselves. But this
belief makes all made things problematic. The natural
world does not need explaining in the same way; if it does not
suit us it may be a hardship, but it is not a worry. Human things
have their end in suiting us and we must coax them until they
do, making ourselves at home there by investigation and argu-
ment. Art is troublesome not because it is not delightful, but
because it is not more delightful: we accustom ourselves to the
failure of gardens to make our lives as paradisal as their prospects.

This is the record of a struggle to assimilate more and more
to the realm of delight, which takes up less and less obvious
sources of gratification till in the end we feel we can take the same
joy in almost any made thing. It is about bringing things indoors,
about domesticating reality, and the model for all these objects
is a building—the palpable idea, the traversible speech, the sim-
plest experience of being in more than one place at a time. The
book's movement is roughly from things to ideas, from the real
to the fictional, but it tries to make these states harder to distin-
guish. Its boldest aim is to suggest a history of certain kinds of
fiction, certain transformations worked by the imagination, and
to extend our sense of the part the fictionalizing power plays in
our lives.

It starts as human history did in a garden, man's fullest dream
of integration, where he can persuade himself for a moment that
his life is beautiful and true because natural and therefore not just
his wish fulfilling itself. The book then moves to private build-
ings where wishes can come true because they have only one
person to please, but finds an impossibility in the notion of an
object truly personal, made for just one. It turns from the most
to the least individual large artifacts, to mechanized environ-

ments of various kinds which make a deliberate attempt to de-individualize the world. The last stage on the physical journey from the sheltered self is the city street as the ultimate built place, where various visions of men living together operate visibly and continuously.

The second part of the book beginning with Chapter 5 takes up more intellectual objects which exist on paper. The castles and cities in the two chapters about novels outstrip existing ones, completing our sense of what these objects mean by realizing them in words, populated by the writers' ideas for their use. To put a city in a book, to put the world on one sheet of paper—maps are the most condensed humanized spaces of all. They reverse the gardener's procedure that leads us into outdoor rooms, they make the landscape fit indoors, make us masters of sights we can't see and spaces we can't cover. Our next form of condensation, the museum, takes time as maps take space but gives history percep-tible shape digested into one more or less comfortable habitation.

Like many books, it is working itself free of its material. The goal of learning and of this book as an act is that the critic feel himself a participant, that the describer become the doer. The end is not an actual building but the writing by which the writer becomes as every learner will the exemplar of culture himself. A book is a thought too big and various to be seen all at once, sturdy but unencompassable ideation, and the intimate excuse for a new one after all the other books is this of giving the mind an exis-tence outside itself.

ECCENTRIC SPACES

Chapter 1
Green Dreams: Gardens

*E*very garden is a replica,
a representation, an attempt to
recapture something, but the form it
finds for the act is that of a mental picture,
so in spite of its special properties a garden is
just another of the images of art. All landscape painting
does a kind of gardening, though the idealizing impulse makes a
show of diluting itself as we move toward the present. To find
paintings more cherishable than actual gardens, we have to turn
to ingrown, self-reflective ones like the enameled forestscapes of
Netherlandish Mannerists in smooth yellow-green and mossy
brown, colors so purely conventional they seem varieties of
semiprecious stone, which hollow out a small nest beyond which
tunnel-paths diverge, worming their way through leaves instead
of the soil. Pictures like these make us wonder why we don't
move from summary to more inclusive summary, leaving the
elongated physical form of garden behind for condensed rectan-
gular versions, substituting pictures for landscapes, and perhaps
maps for pictures. But to some extent this happens, and we re-
place the world with our ideas of it, gardens being intermediate
enough to make us think they *are* nature and not simply embel-
lishments or enhancements of it, regions which unlike paintings
let us forget there is anything beyond.

More than the others, botanical gardens make it hard to
forget the idea of them, textbooks of plants where every leaf
could teach something if the visitor were apt, but even here the
literalness of the lesson triumphs over the science, the textbook
a splendid confusion apprehended at once before a word of it is
read. In fact these gardens are the most faithful imitations of
Eden, presenting a conspectus of all the species, all climates and
places harmonized with each other, all history overlapping, the
rain forest on the point of swallowing up papyrus, where tracing
the windings of narrative opened by each chance juxtaposition

gives endless occupation to those who hurry by, working out the first steps of a few of the paths that branch off to the sides.

Gardening seems an easy art, for infinitude is almost as well suggested in a small plot as a large one, if one remembers the whole range of focal lengths, from the remote to the microscopic, and the fact that one can't keep one's elements from rearranging themselves drastically if not quite kaleidoscopically as they grow. What is missing for most gardeners to make them feel like artists is a sufficiently harebrained plan, an inclusive enough subject for imitation.

Uncle Toby is kept waiting in *Tristram Shandy* a long time before he gets the idea of reproducing in his garden the battlefield of Namur. His foolish plan conceals the ground of a great pleasure, and unlike most things characters think or do can make a reader envious, for Toby has thought of the entirely satisfactory act, practicable and yet a dream come true.

The plan answers to needs everyone shares: the need to memorialize the past and hallow it, to rationalize confusion, transmuting ugliness into ease without losing the sense that disturbance preceded harmony, to reduce it to comfortable proportions for play, to summon up other places and other times, to have everything at hand, to stay at home. Though most of these are done by poems or pictures, Toby's model is different from them in being more literal-minded, in being like all gardens a real place. To enjoy it we must walk around it; it cannot be brought to us by someone else, nor can we take it indoors if it starts to rain. Though gardens can be reproduced in other places—Toby thinks he re-creates Belgium in England, Hadrian imitated his favorite physical features from various corners of the empire in a garden he built near Tivoli—the act of reproducing will inevitably be more startling than the supposed reproduced.

Toby's plan is a summary demonstration of the mental processes at work in gardens and especially helps us gauge their hopefulness, rarely conserved in other forms of art. In fact, it does not feel right to call even the best gardens works of art, because they are literal worlds in which artifice strains against senseless growth. A gardener takes what is there and begins to bend it to his will, but it is always getting beyond him. While painters don't make pigments or writers language, those materials do not go on living and dying visibly, those works are not green one day and brown the next, tamed for a time but never permanently subdued. Although the grandest conceptions have been achieved by the gardeners who resisted least the natural tendencies of plants, their gardens are finally as thoroughly human as the most strict.

A nineteenth- or twentieth-century man who did not know it would not guess that formal gardens preceded irregular English gardens historically. The most elaborate theoretical justification for the ones which strike us as more natural will be found in French writers fascinated by wildness, impressed with the nobility of savages, and the most abrupt juxtaposition of the two poles of gardening occurs at Versailles, where the elephantine stasis of the palace shares the ground with the butterfly charm of Marie Antoinette's *hameau*. It is tempting to make her cow barn presage the slaughterhouse, her sylvan glooms hide assassins, and it is a haunted place if only for vividly showing how contraries meet or call each other forth in the mind. Imperial responsibility begat rustic oblivion begat ecstatic butchery, which teaches the pendulum-working of the imagination and gives us the goal of keeping the need for order and need for violence in balance, both acknowledged.

A garden is a field for these forces where one is usually given the upper hand, so there are gardens which could not exist without their walls, gardens which are themselves geometrical figures with sharp edges, and two kinds of garden without edges, one like Versailles or Fontainebleau, still geometrical, without the figure's being closed at the far end, the lines ruled but stretching off to infinity. These gardens start narrow and go on to become suggestively wide, even appear designed for a single main perspective and to originate in a single point. In spite of the freedom at the other end, they are the most rigidly organized of all, intimating a reasoned progression from small to large, from managed to more bushy greenery, hard places to relax in, the ends of the vistas foregone conclusions exhilarating to contemplate but tiresome to achieve except with the eye. They are theoretical gardens most enjoyable from a fixed point, a window, a bench.

The other kind of boundless garden is not a geometrical figure at all. This English kind has no obvious beginning or end and the bounds are confused on all sides, so that for this garden an un-wall had to be invented, which performs the physical functions without having the visual value of a wall. The ha-ha or sunken fence is an English joke on law and order that exercises real constraint with the English deviousness and we can almost imagine a simple person stumbling into these sophisticated gardens without realizing he is in a garden at all, like someone who misses an irony.

It is easiest to begin with the kind which looks best on paper, the one which forms a closed figure. If there is a first notion of a garden this is it—a closed place set apart, protected, privileged,

with different rules and styles of life inside and outside. Eden had gates and therefore suggested life outside but it did not let you view it.

The best gardens of this sort are Italian, but the best pictures of them are French, Fragonards and Hubert Roberts where people become dreams of themselves, lovers and boys with wheelbarrows alike falling under the influence of a softness, which nearly dissolves them and turns every act to play, makes all industry look idle. But this narcotic spirit is different from that which drove the ingenious conceivers of the Boboli, Villa d'Este, and Bomarzo, all Mannerist creations. We find Mannerist fancies at their most riotous when they have escaped out of doors at Tivoli and Bomarzo. All those exclamation marks of water are too much of a good thing to remain serene, whose noise alone suggests an effort at diversion, to deafen thoughts.

Jan Kott sets *Midsummer Night's Dream* in a Renaissance country house for a decadent society of masked revelers whose woods are the darkened gardens beyond the reach of the torches, and sees it as an evocation of erotic distraction in the paths of a garden at night. Thinking of Bronzino's sitters in them, we fill Italian gardens with this excruciated sensibility. They are the creations of contradictory people who hid meanings amid the shrubbery and created caves in which to bury what couldn't stand the light. Their grottoes are populated with half-human monsters, with all the rarities of the animal world, and the encasing lava makes everything seem on the point of turning into something else. In the caves things change their natures and the surrounding gardens give room to the beast in man. Far from a trivial decorative art, gardening of this sort provides calculated excitements and incitements to anarchic impulses. But this is not the whole story, for if the Boboli tempts us with the dream of release, it also teases us by throwing obstacles in our way, maintains a tension between feeling free and wondering where one is.

If we imagine the forms of a formal garden like the Boboli or Villa Medici in masonry instead of vegetation we get an unexpectedly bizarre construction which shows that people let themselves be confined by plants in ways they would endure uneasily indoors. In the Boboli there is proportionately so much corridor for the number of rooms one might think we came outside for the experience of confinement, which can be enjoyed at greater length there. As soon as we step out, the view opens overhead, but it quickly closes again in front, and the pattern of these intermissions of air is less decipherable than it is inside. At times it seems that gardens exist to give a controlled experience of being

lost or trapped and the distance seems slight from the maze at Hampton Court to the horrid gardens of fairy tales with poison plants, poison fountains, traps, and cages. Going further we can imagine a surreal garden on the model of a fun house, but such jokes are no longer embedded in the landscape, unless the follies of American expressways can be included here. Still, Stuckeys and Howard Johnsons burlesque the idea of ordering the landscape by overriding and contradicting it. No Mannerist antinaturalism can match them for their violence of "I am here. How did I get here?" fully unpredicted but sufficient substitute worlds, saved if at all by the Gargantuan wit of their impossible signs and indelible colors.

Many of the jokes described by John Shearman in *Mannerism* have disappeared from Italian gardens, dependent as they were on visitors' being shown around in a calculated order. To judge from Vasari, visiting the Boboli was a more special and specific intellectual experience than any of us are likely to feel it. They tested their refinement against its fine stimulus, school for a Jamesian perceiver. Now, it takes time and learning to dawn on us, at first seems bare and repetitive, but offers to recollection the marshaling of natural forms in geometrical ways with both subtlety and carelessness not found at Versailles. We notice what is missing—large flowers are strained and unnatural features of gardens, ornaments which could never have come there without human agency. A garden that wants to feel sylvan, rural rather than urban, to be an idealized nonhuman place, avoids them. Even one which wants a citified but stoically Roman impression may, as they are the equivalent of tapestry or figured carpet, not bare marble floors.

The monotony of the Boboli—a few kinds of plant are repeated everywhere in it—stems from an architectural conception of gardening. Once the building material has been chosen it will not be varied, so we will find no walls half brick and half stucco. Within the bounds of the formal type, which it is—insisting at every point on its walls, its alleys, its intersections—it shows a deliberate avoidance of effect; it lets the trees and shadows speak. One of the grosser but more telling measures of a garden's spirit is how much space it tries to organize and give a stamp to. The Boboli is conceived in a large way for a garden much smaller than the big French ones, its denseness making it seem larger than it is, big enough so one can go there several times trying to see it all and miss the best part, which is farthest from the natural starting place, the house. Everyone would agree that there is a best part, and though it is an ample and open spot it also feels

secret. This spot has its own name, Isolotto, and the only complex highlight in the whole garden. All the other architectural features can be seen at once from the back of the house and have little force apart from the terrain they are perched on, but this island in the midst of an elliptical pool with four gates and two bridges is inaccessible like a goal in a dream. Elsewhere in the Boboli the colors are simpler even than Uccello's—the green relieved only by tan of paths and gray of statues, as in a grisaille or sketch—but here there are lemons and goldfish.

In this simple myth the circle sunken at the end of a cypress alley draws things and disposes them collectedly round it, getting there and leaving there contributing to the sense of falling toward or ascending away from a center. The circle of lemon trees cut by a cross is echoed in the water and again in the benches hidden in the enclosing hedge. It is the perfect place, and the perfection is mildly active as the flutter of hundreds of fish draws the observer out of himself through water.

The activity peculiar to the Boboli is erroneous wandering, away from the straight track, not far away but usually out of sight of it. It is a loosened, relaxed maze which challenges us to cover every path once, but just once. Every time we try to find paths not taken before, and to be tricked in this attempt can be like reading the same page twice or losing your place by your hand's slipping out. The pathy garden is an intellectual place, at times a puzzle, that invites solution or at least comprehension. In a large irregular garden a map is a necessity if we are to see it all, but in a geometrical garden a map is a crib, because the garden is a map that must be lived to be grasped. Like a maze this kind of garden can be frustrating, though as the sense of a goal is less strident, the disappointments are milder. Who ever stopped to sit down or smell the hedge in a maze? To look at the "answer" puts the garden back on paper and the visitor back indoors, where he becomes one of the people who must read about a place while in it, only looking up from his guidebook for a confirming glance at the fresco, a winning seriousness which tempts everyone serious until he finds that it denies the experience it sets out on. True guidebooks should lead you to things and leave you at the door, lists of places where certain kinds of experiences may be had. If you are reading you cannot see and the other way around. Travelers should only read after dark.

But at the beginning most travelers have been addicted to guidebooks, dreaded missing something important, and had trouble to learn that the eyes are not as greedy as the intellect and cannot be driven to look by telling them it will do them good. The

Boboli is the only place in Florence which cannot be exhausted, which a visitor will never tire of. There is no point putting a painting far away and it is not easy with buildings, but our distance from a tree can be varied endlessly. Unlike works of art trees do not demand a certain level of response, so we can flip by whole rows of them without feeling blunt or blind. Natural things are pure gifts as human ones never are.

Sculptures in the Boboli approach this state of nature as nearly as art can. What sculptor can vaunt himself on works lost in the woods? No one can keep track of all the figures sprinkled there, though Eve Borsook's greatest triumph is to have fixed many of the Boboli population. It is a fine Mannerist fancy, this idea of chalky wildlife, dwarfs, deformities, and ragamuffins all enjoying themselves in rough games, sour music, and crude laughter. They seem to get wilder the farther we go from the house and feel like an equivalent in sophisticated art for the wildness of nature. Even though some of them became famous they are anonymous in spirit, no cautious love lavished on their mass production, no finesse contradicting the grotesquerie of the conceits.

Another kind of mock sculpture, the oversized imperial head, is different in these trees from its urban self. Constantine in the Capitoline court at Rome—spread in little bits, his fingers, his toes—is a laughingstock, a joke preserved, but the fragments in the Boboli lose their gruesomeness and become natural marvels or new species. Gardens smooth the rough edges of thoughts, things seem less grotesque out of doors, even licentiousness fails to arouse.

Some of the statues in the Boboli make us wonder if we could recognize perversity when we saw it, outdoors. The place to find out is also in Italy, at Bomarzo north of Rome. Bomarzo in its present state will not fit many people's notion of a garden. Perhaps the easiest thing to call it is a fantastic landscape left purposely and glaringly incomplete, lacking consistency or inevitability except that all the stone nightmares occurred to the same dreamer, loosely strung variations on an obsession. The project, better known since Edmund Wilson's long piece in the *New York Review of Books,* is a collection of grotesque garden follies, many carved in natural outcroppings and hence located irregularly in a small piece of bumpy woodland near the little hillside town of Bomarzo. They can never have been visited by many people in this wild place, made more wild by Orsini's imaginings, but the rock is nonetheless covered with explanatory, justificatory, admonitory inscriptions. This garden is a powerful monologue and

brings home poignantly that gardens never just *are* like landscapes, but need to be responded to, making our admiration feel human because it amounts to paying someone a compliment.

The odd tilt of Orsini's mind is evident in the first structure he had built, for which he employed a famous architect. Vignola's circular pavilion has an ample and graceful rectangular porch but no door gives on the temple from it, that is found on the other side. Already Orsini invites and then rebuffs, begins civil but is seized by a bearish whim, a tangle of motives which becomes more acute in the other enterable structures on the grounds. One of them is a howling face ten or twelve feet high whose mouth opens to make a little chamber lit by his dark eyes. A tongue floats in the gloom which turns out to be a delicately fashioned table for picnics surrounded by benches of teeth. Grotesque faces are familiar ones in the designs of the period, one of its ornamental clichés, but here by overheated enlargement Orsini permanently acts cannibal aggression. What can be quaffed at this table but the black juices of hatred? And yet he spells it out, says "Tremble, Marvel," as if the terror will wear off.

Orsini's park of monsters is a determined effort to make a mood eternal, to memorialize an intense disgust. Finally what is astonishing is not the physical presence but the guessed intention, the desire to preserve bitter and fugitive sensations. We find some appropriateness in the way he has done it—the amateur carvers are more effective than masters at conveying the rough impatience of the sentiment; the creatures springing or half sprung from the rocks seem crystallizations of the foul air—but we only know how we are to feel without feeling it. In the end his torment is inaccessible, he communicates the fact of it in an imagery relentlessly strange yet inevitably borrowed, and this man who parades his unending distresses remains remote. Some of his failure is in the mixture of his purposes—he cries for help and yet he wants to wound, shows that a didactic unsociable art is impossible, and ministers to our suspicions of Italian self-display at any price.

Yet it is a provoking attempt to use the grotesque vocabulary of Mannerism to express private pain. The elegance and serenity which keep us from hearing the psychological exaggeration in Vasari or Primaticcio are stripped away here. When the grotesque loses a sense of itself as a style it becomes the Awkward or Oafish, a negative thing, creating bold and eccentric errors like this, good to return to, but fitting only one mood, truly suitable to just one person. Every human creation has its private echoes which it is the end of our appreciation to hear, but we can trace

them without revulsion only when we have participated in a discourse. Bomarzo seems at first a symbol-hunter's paradise, but overbears us with a blatancy that leaves no room for gradual appreciation.

The sense of pure contrivance at Bomarzo has a sunnier counterpart at Tivoli, an extended invitation to carry on. It consists of a series of water events and we imagine a delirious joker dashing from one to another. Here ingenuity continually calls itself to our notice, in a string of a hundred fountains that recedes in a straight line forcing an exaggerated perspective on the observer, who sees a vista of spurts projected from stone mouths at three different angles repeating themselves in series like a hundred well-organized children playing. Pieces of mock or abandoned architecture are shot through with water and can be threaded watching out for drips: the waterfall arcade is a hemicircle of rustic arches, down the front of which a sheet of water roars; from inside it is a house of moss with walls of water, so precarious no one will stay long. Elsewhere a mound of toy ruins like a model of Hadrian's villa nearby oozes water from doors and windows and spouts from little domes in the roof.

The most riddling features at Tivoli are the raceways, which have the practical function of carrying water away or on to the next firework. They consist of a series of troughs, each of which diverts the flow slightly then lets it continue downhill. These purposive elements, like some children's toys, remind us of work and come to seem emblems of human futility, but the same dumping on a larger scale has a calming effect. The noisiest feature, the water organ, gives an indelicate performance of huge spouts, creating noise chambers by throwing water against the back walls of little grottoes, and ending in a set of four large flat ponds, each two feet lower than the one before. The sluggish shifting makes geometry quietly hilarious, but for the most part the terrain—a steep slope—causes things to happen in a rush, and this hyperactive but confined place finally provokes thoughts of grand unadorned nature, of California redwoods. Tivoli even more than Bomarzo affronts nature by continual meddling and says that ingenuity is always more interesting than artlessness.

Italians have a penchant for garden effects in small spaces. Instead of parks we find in Italian cities dusty *piazze,* tables set, in Rome, with aquatic centerpieces. One of the grandest, Bernini's Four Rivers, is from a distance a surprising mirage or miraculous survival of a popular festival, which takes the form of an artificial mountain whose crags rise to an obelisk, but the stone mass is so boldly pierced it becomes four legs supporting

the antiquity, geometry disguised by unpredictable contours. "Rocks" which adopt fantastic shapes, sometimes flamelike, sometimes soft like fabric, making sculpture of matter that pretends to be unhewn, are decorated with vegetation and animals in the same travertine, and four river gods and the papal arms in marble. Each river has its animal and plant attribute, but the horse, lion, dolphin, and armadillo disposed so randomly are freed from their sponsors, and a spiraling palm tree collects and shades the whole. No matching regulates the figures—Nile hides his source in the cloth over his head, Ganges strikes the only classical pose holding an oar, Danube with raised arms faces inward, and the Moor Plata, strangled in draperies, teeters backward. Four rivers pour out at the corners and flow underneath to make dark pools in the central caves. Rocks and vegetation were originally colored, and gilded inscriptions adorned the base of the obelisk. It is practically the only taste available outside prints of those phantasmic confections that sprang up for triumphal entries and royal marriages in seventeenth-century capitals, and of which Rubens is the other great perpetrator. In Elizabethan pageantry too, artificial lakes and islands often played their parts in making the celebrations feel like reconciliations of nature and society. Both the Four Rivers and the Trevi are mock landscapes attempting this bold ligature, and the gush of water, unlike the vagaries of Tivoli, is meant for a natural effect.

The largest mock landscape, whose strong effect certainly comes in part simply from its extent, is Jean Dubuffet's white plaster *Jardin d'émaille* plunked down with unmistakable effrontery among some very green woods in remote Holland. It is a garden where there is no need for a garden, the most artificial, the most grotesquely imported object, a fortlike raised construction in white cement which reveals almost nothing from outside. Roughly rectangular with an edge that wavers unsteadily, it hardly signals the entrance through a dark and narrow hole in its side, which leads from a vestibule up stairs cramped into the open trunk of a large white tree like a drunken toadstool. When the visitor pops out onto the bumpy platform, impressively large yet easily traversible, he has entered a fact of burning whiteness, even on a gray day like a hot beach, a grand expanse of glare. Besides the towering tree he finds two unplaceable objects he had just glimpsed from the other side, a six-foot porkchop and a four-foot knucklebone, but not even these are real relaxations from the prevailing graphic emphasis of the territory, where the contours of a set of variations on bathtub shape are outlined in plump black lines, lines which obeying certain laws—no angles,

corners turned like tramcars, but the grid rectangular anyway—
still falter, not minding when they fall over an edge and hence
misrepresent a contour, as if a pattern kept sliding and the tracer
went on drawing in spite of it. This treachery is extremest on the
two sets of steps, elaborately and mistakenly outlined, but exist-
ing more to form ripples or eddies in the graphic surface than for
any use, since no foot will fit them.

The visitor to this huge piece of playground equipment
which stays absolutely noiseless and inert still enjoys a triumph
on top of his large mound seven feet above the ground outside,
and ringed by a three-foot lip, a place without shadows where the
only motion is the dropping onto the pure white of a few mis-
directed leaves from the real trees nearby, which the building that
disobeys more laws than any the visitor has ever seen cannot
prevent from blocking its drains.

Under the fooling is perhaps a mighty dissatisfaction with
reality the way it is, a dissatisfaction so hopeless that instead of
embarking on the usual French re-ordering it relieves itself in
scrawls, refusing to pretend it could ever find a use for its designs.
Yet just in clearing the ground it displays a heartening determina-
tion, and walking over a Dubuffet seems utterly different and
grander than looking at one.

The most illuminating comparison to Dubuffet's vagrancies
and Bernini's crescendos is the normal French extreme of garden
artifice, for which you need only sand and a ruler. Rows of trees
with sand under them instead of grass are the main constituents
of Parisian gardens like the Luxembourg, of Le Nôtre's cathedral
garden at Bourges, of the big Colombière park at Dijon as well
as the ones at Fontainebleau and Versailles. This kind of garden,
like Japanese sand gardens, gets its power from being unmiti-
gated, from a pure geometry undecorated. The trees are trees out
of nature, trees brought indoors, hence a marvel. How simply this
transposition is achieved and what precise gauge of gradations of
light takes place as the eye follows one of these unsubtle rows.
In a French garden trees actually feel laconic, as if on this floor
conversation might be expected. Strollers are more important
here—the people become decorative, separate integers, become
real Figures. Italian gardens are usually set on awkward slopes, so
Tivoli and the Boboli contest the terrain actively, but almost
every French garden starts perfectly flat, taking a stable plane as
given. Such landscapes were an inspiration to surrealist art; one
must have a mind of winter to want nothing that is not there and
the nothing that is.

At the other extreme is an accidental kind of garden, discov-

ered in Italy and afterward noticed in England too—the open-air ruin, now overgrown and suitable for strolling in. Most large gardens since the eighteenth century have been partly inspired by these disorderly places, archetypes of landscape as memorial or mine of history.

A few evocative lines in Virgil predict the present state of the Roman Forum. In the eighth book of the *Aeneid* he finds picturesque excitement in remembering that cattle formerly grazed where the center of Rome now is when there were thickets on the capital. Of course now there are again, and his wild fancy has come true. These lines are one of the best interpreters of what it feels like to wander among the ruins, not just of a building but of a city, which can be a restless, divided experience. The vegetation softens and makes agreeable huge and sterile buildings yet the spectator longs for what is not there, tries to re-erect fallen pillars, to hold a decayed roof in place, to decorate and furnish before it all collapses into the present.

The rubble in the Forum now groups itself in indistinct vegetablelike forms instead of the angles and curves of architecture, a garden of stone. Not dissimilarly early collectors arranged outdoors the classical fragments they had found buried in the ground. Today the Terme Museum set in a cavernous ruin stripped of its finery, half indoor half outdoor, can suggest what the mediation between art and nature in these arrangements felt like. The sculptures dotted in the spoiled halls of the Baths of Diocletian are so much too small and so much too fine for it that they seem to have taken shelter from some storm, gods among the rustics. Especially in ragged surroundings objects from classical times are messengers of a higher reality, give an aching sense of what is missing, and mark the passage of time more vividly because its rough usage still goes on. One could leave loose ends mysteriously dangling this way, significant of broken connections, or one could work the pieces into one's own unity, less grand than the original but more comfortable than shreds. In the courtyard of the Palazzo Medici in Florence an elegant patchwork composition has been made of assorted bits of classical inscription, the result a scholarly cabinet as well as a scheme of decoration. Memorials like this are works of art themselves, where pieces of the past are fused into contemporary wholes and for us the style of the sixteenth or seventeenth century overrides that of the antique. From the beginning museums were more like settings for jewels than simple chests for coins, and enthusiasm rose to emulation in providing accommodation for its prizes.

Like one of the viewing platforms the Chinese use to certify

great landscapes, a noble seal has been affixed to the Forum. Luxuriously surveying this garden museum from the Palatine among the gardens built for just this contemplation by a Farnese cardinal in the sixteenth century, everyone catches himself thinking how grand it must have been when complete and glistening, white and gold instead of green and red-brown, but it must have been as vulgar as any modern suburb or any world's fair. There is a piece of architecture in modern Rome taken from the model of ancient Rome and it provokes shudders: the Victor Emmanuel monument. The wishful reconstructor finds Rome brick but would leave it plaster.

Roman imperial architecture was usually overbearing, but in its present shambles in the Forum and Palatine it is the perfect picturesque caprice or toy. Piranesi was apparently one of the first to see it this way, increasing its density in his views, making the fragments more threatening than they seem to us, darkening the colors, adding shag and bramble to the vegetation, in short making the melancholy theatrically evident rather than mute and elusive. For this connoisseur of useless imposing bumps and jutting blocks, a lover of extrusions who peppers his walls and bridges with them, walls, doors, and windows become simply ornamental and symbolic. His art is the triumph of bits; in his more fantastic engravings bones, chains, slices of columns, herms, Egyptian lions, and garlands of moss hung with medals are tumbled together, every outline fuzzed, chewed, whittled at, with vegetation crawling like insects over all of it. Taking him as a garden architect has more point than as an architect pure and simple, because he revived the classical past as a great humanized landscape literally existing, and because his own buildings like the Maltese church on the Aventine are fragmentary and patchy in feeling, like mock ruins. Details on the church are too big for their spaces, and thus intimate a larger building, seem thrown or heaped in rough abandon.

The Palatine is even more Piranesian than the Forum, because it is more deserted and buried and hence inscrutable, because the structures are large, and because they hint at private lives. The most evocative place in the whole is the huge half-enclosed space in the Domus Augustana, which may have been an arena for races or a closed garden, where from thirty feet above we look down into a pool of high grass onto an ellipse laid out in a rectangle. Here all fineness of detail is absent, everything rough brick except for a few meaningless bits of marble at the bottom. Time has cleaned this place of specificity, leaving it hu-

man but utterly vague, so like prehistoric sites it has no personality, but unlike them, great refinement.

The most delicate Roman visual poetry is the poetry of plants in the house of Livia on the Palatine. Though the plants formed into garlands are overlifesize, they are emphasized at the expense of architectural elements in the fresco and in the room, making the place a bower. We quickly remember that Hadrian's and Augustus's mausoleums were covered with mounds of earth and planted with circles of trees, and it is more than ever appropriate that the seat of these country-longing urban people should now be a wilderness.

The fact that classical places were overgrown helped suggest to eighteenth-century Englishmen a kind of classicized landscaping with memorials buried amid the trees. At Stowe we are to imagine a place once more heavily populated than it is now, and to see the temples scattered so thinly on its paths as bare vestiges of former inhabitants. This is why the plan is so obscure and why it is so much wilder and less tended than any other garden (it has little of the circumscription or delicacy of a garden). The Grecian Valley, one of the last features built, is a rolling farm field closed at the top end with a Greek temple best viewed from amid the corn. Small-scale details never mattered much, even when the woods on either side were dotted with statues since erased. Stowe is always trying to lengthen the steps of the mind and the sweeps of the eye. Long vistas accumulate, views of temples from other temples, across dips, through screens, so that landscape is felt as obstructive or as some intervening plasticity. How often an interesting situation is the object: the Congreve monument on a miniature island is a lure onto the island to enjoy the novelty of the terrain. Perhaps the monuments exist just to give some schedule or definition to a walk among the trees.

But no, the names are important—temples of Ancient Virtue, of Friendship, of British Worthies, of Venus, memorials to poets, soldiers, politicians. They are hard for us, and we are embarrassed at four walls just for Friendship. Gardens like Stowe and Bomarzo which try to provoke specific reflections run this risk, but after walking there awhile we find the names less silly, because it is a thoughtful place. It teems with thoughts, they are in the ground and the air. When he comes to the view through the rustic superstructure of the cascade onto the lake, the viewer feels invisible guidance over ground which has been well mulled.

The model for a ground imbued with meaning is the country churchyard as well as the landscape with classical ruins. It surprises us that both Stowe and Stourhead incorporate little Gothic

churches and homely burial grounds in their grander schemes, actually if not in echo the oldest things on this ground, their preservation a reverence for all the past not just approved sections. Some of the monuments contain remains, even if the ground is not full of departed pets as Pope's garden was. Secular reliquarism prompts us to preserve something of the admired great even if only in fancy, and the point of putting busts of the dead in solitary spots is to make them faintly numinous, to suggest spirits hovering round.

The Gettysburg Address and monumental Washington are more solemn efforts to memorialize a ground, also in the antique Roman way. The Grand Park part of Washington has more matter just to be looked at and thought over than any other urban district. It has more statues and shrines; it is more a deliberate esthetic venture. Sheer weight of concentrated symbolism and huge carved words makes it feel funereal and deserted in spite of crowds, built for people bigger than we are, who would not need shuttle buses down the great green vistas. The whole is a too ample park, Stowe made into a seat of government, which sounds like a charming fancy, especially in a new country which needs to express long memorial continuance, but the lightness of the fancy is altered in Washington by the eighteenth-century plan's being mostly filled out with buildings of the mass-minded 1930s. Like other American landscapes it is dream or vision with overtones of nightmare, and warns of summoning up grandeur only for dead things. To L'Enfant, Washington was an airy dispersal, but has since become a dense collection of sepulchers.

The original grotto, the buried Domus Aurea of Nero, which had once possessed huge gardens autocratically cleared at the center of Rome, was taken in its ruined state by Raphael and his contemporaries to be a secret hideaway. As it is now, it is an imposing semiarchitectural experience, whose rooms are not like rooms at all, but high narrow places found and then embellished with vegetable scribbling. A subterranean effect became part of every large sixteenth-century Florentine garden and then of the eighteenth-century English ones. Even Pope could with rare rocks that he arranged himself produce a chamber of variegated ugliness which communicated with the riverbank by a tunnel under the road.

But the grotto has disappeared from Stowe adding to the effect of this greatest product of the English visual imagination, the effect that is of there being so little substance to the artifice. Like many of the best moments at Stowe, the Congreve island is almost not perceivable any more as an island, in a lake barely

perceivable as a lake, among plants not principally cultivated, with no odd shapes or jarring colors. One can turn around and it will almost not be there, will have slipped into a simple field of bulrushes. At Stowe the time cycle suggested is grander than in any other garden. Its vistas of duration show the trees lakes and temples alike undergoing change and returning into the Creation they came out of.

Stowe was one of the first romantic gardens, but remains the subtlest. Its great eighteenth-century rival Stourhead is a more tranquil, closed place in spite of its agitated outlines and separate diversions. It is a more perfectly formed experience than Stowe, a single huge composition focused on an irregular but roughly round lake. The only path circles the lake, dipping sometimes toward it but never straggling far away, and buildings form a narrow band or chain around it, spaced a few hundred yards apart without any disproportionate gaps, the ten stations of a picturesque passion. A certain kind of path gratifies homing rather than adventuring instincts, and this feels pure of that kind like the paths in Ariosto. The riddle of why that stay-at-home poet is obsessed with the word *path* (*sentiero*) is explained when each path connects with some earlier stage, when each puts us back in a place we were before. The walk at Stourhead gives a much clearer sense of going nowhere than the walks at Stowe because we can see all parts of the journey at all times, no shortcuts are possible, and we must end where we began.

Buildings here form an anthology of styles, Gothic almost balancing Greek and Roman, but with primitive and Chinese (now vanished) enlivening the mix. Self-conscious distillation makes the historicism more witty and precious than Stowe's; here buildings exist freely in space, not nesting or brooding as at Stowe, trying almost not to be seen. The imaginary temple in the background but at the center of Raphael's *Marriage of the Virgin* in Milan is symbolism of the same kind as the temples at Stourhead and can help us probe their secret. The two parts of the painting, human foreground and architectural far-off, are built into each other with a hypnotic and distracting checkered pavement. The temple is glorious but not in use, though one might expect the marriage to take place there. It crowns the event, represents the home, seat of marriage, sacramentally, and usurps the higher meanings of the scene. The breath-taking window in it through which we see sky as through a telescope feels like an organic aperture onto the world of thought. The temple may thus quiver like a living thing but it remains enigmatic, insoluble, without a real expression on its face. The buildings at Stourhead,

similarly elevated, similarly distanced, are also external forms for motions of the soul. From afar garden buildings often hint interesting uses, and since they have practically none they don't telegraph what it is until the last minute. Though so small as to be merely mock-ups of full-size temples, they are saved by uselessness from determined character. Yet as we draw closer to them we get further from their meanings. Across water their miniature fineness sounds harmonies unheard elsewhere; close up they are only buildings, though the two views seem to exist without interfering so that we are always gratified by the methodical inspection of the dream, entering the dank chamber partly dispelling an illusion but so incongruous as a conclusion it stays distinct, body keeping its distance from spirit.

It seems a cruel mystery that eighteenth-century England produced the West's most moving enhancements of landscape and the first large industrial defacements of it. Even stranger is the fact that the very people who created the picturesque garden contributed to the late-eighteenth-century phenomenon of industrial tourism, in which mills and furnaces among the vales of Shropshire became obligatory stops for aristocrat dabblers. How does one explain the taste whose most familiar record is some paintings by Wright of Derby—mills in moonlight, furnaces by night?

Gardens are built on the idea of contrast: one thing superimposed on another thing, art on wildness. If one allows the contrast to be strained to its utmost one can feel clanking machinery among the fields as a picturesque effect. The roles are slightly altered: now the man-made threatens the vegetable, is fiercer and wilder, now the plants assume some of the virtues of civilization, seem decorous and self-contained. But we are still enjoying the jostle of contrary forces and the mind kept awake by tensions. The taste for the industrial picturesque did not last very long, for as the clanking drowned the faint music of the countryside, turning the green to gray, it brought sleeplessness simply Satanic.

Later picturesque garden effects are responses to the esthetic torments of industrialization, so Nash's landscape creations usually exist hard by industrial centers (Blaise Hamlet near Bristol) or in the Great Wen itself (Regent's Park, London). Their unreality is different from that of the gardens, because they are places people live instead of amusement parks. Shutting oneself up in a Gothic cottage is a different thing from musing in a pavilion. The exaggerated irregularity of the cottages cramped around the green at Blaise feels querulous, and so it comes as small surprise that the buildings are rickety, for Nash's response to modern life

is ingenious but weak, and his pride has become a curse: the inventor of the suburb.

When people talk to me about the weather
I always think they mean something else
—*OSCAR WILDE.*

Gardens always mean something else, man absolutely uses one thing to say another. Vegetation in gardens is symbolic, hence one can write about them without using the names of plants, and people sometimes do without plants entirely in sculpture courts and sand gardens. But the trees in gardens are already statues and the grass a counterpane. Here the outside is arranged to suit the inside, in mocking imitation, in imaginary threat, in soothing reminiscence, as it leads the soul through all the old situations, portraying comforts and dangers enlarged or diminished in neutral unhuman green. Trees, bushes, and slopes show us closeness, separation, dependence, arrest, depression, exultation, until rarely even in dreams can a person get such a sense of traversing years in a jump, surmounting obstacles with a few sloping steps, looking back on the past with a turn of the head. In gardens everyone is free to go where he pleases, to follow a number of avenues, to make contradictory choices.

A garden connected to a house can be a second home more real to the inhabitants. One small homemade garden that I disagreed with off and on for two years while living in it and being naturalized by it matters more to me than the others. Its maker did not think of it as a work of art but she did think of it as a whole. It was closed in and overgrown, a tunnel and not a tunnel where one felt overshadowed and impeded but more brushed and caressed by plants. We need these two homes, a green one and a brown one, a grown one and a built one, two worlds in tension.

The freshness and light shed by the eighteenth century is partly that of freer converse with the outdoors; in the mid-nineteenth century a change occurs. It now feels claustrophobic to us because it is an indoor century, the time of overfurnished nests and the roofing of huge spaces. The Crystal Palace and new railroad sheds create artificial environments on an unprecedented scale, and reaction against those new scales and techniques made itself small embattled privacies. Ruskin and William Morris for all their allegiance to plant forms were really not happy till they had brought the leaves inside and got them down on paper. In Morris's rooms there is more play of mind than in the furnishing

he was trying to replace, but his spaces even more than those oppressive homes are retreats, cloistered spots; to understand both sets of Victorians we must follow them indoors.

Chapter 2
Dreaming Rooms: Sanctums

If one takes architecture
as the expression of an indivi-
dual life, one starts at the center rather
than at the face, asking what space is created
rather than what plot is filled. Places thoroughly
lived in become internalized in a series of adjustments
till they represent a person to himself, a process the critic can try
to follow in reverse, deducing the life from the quarters.

Self-expression in sixteenth-century architecture looks for
cramped places as if true privacy is possible only in a small space
and emptiness hostile to the self. In two of the most ramifying
and confusing castles of the Renaissance we find whimsical parti-
cles secreted, purposeful deformities contained in healthy bodies.
Twined round the grand apartments in the Ducal Palace at Man-
tua is a series of smaller rooms where a person of normal height
must stoop and finds beautifully chiselled doorframes awkward
to get through. These rooms butting on ones of normal size were
constructed for the court dwarfs, who appear in court costume in
Mantegna's frescoes and battle dress in Pisanello's, both in the
building. An ideal visitor to the palace would grow and shrink
like Alice underground or at least feel some tightening and relax-
ing pressure on his historical sense as he negotiated from these,
to crooked Gothic halls, to more regular Renaissance suites. The
spirit of accommodation which incorporates the dwarfs makes
the palace not a zoo but a great ark bearing all to the same place,
because dwarfs like babies in dreams are parts of the self that
have stayed behind, and so deliberately to remind oneself of
them calls for a heroism like that of Carroll playing with his
schoolgirls.

In Florence the Gargantuan and the elfin are brought into
more disturbing touch at the point where Francesco's tiny *studiolo*
communicates by a panel with the shapeless Hall of the Five
Hundred. His Hall of One, without windows or visible doors, is
crowded with the most various imagery in mixed materials—

agate, bronze, walnut, and paint—which leave no room for any-
thing else. Fixed in this cage of imagined mirrors more probing
than literal reporting ones, he would come to resemble more and
more the luxuriously mute mineral samples in the collection.

These quarters designed for the self pay more attention to the
inside than the outside, leaving the public presentation to take
care of itself, but then the outside of a house will hardly exist for
its dweller, who knows the inside better, even if he has designed
it all himself, a situation which bears a resemblance to our rela-
tion to our own bodies. Houses first turned themselves inside out
this way in the sixteenth century, putting the best side next to
the skin in a morbid fastening on the self. The great century of
unchecked self-expression in stone and brick, the nineteenth,
also inclined toward extreme forms of enclosure, so Victorian
houses are often secretive and odder inside than out. Closing
themselves in, people find out about themselves or they achieve
a petrified fetal calm, and among later private sanctums we find
the forms of the sixteenth-century carapaces repeated—amusing
ones, showy ones, and ones no one else can understand, little
solipsisms that deny everything outside. But no longer is the
aberration contained, for now the whole structure becomes fan-
tastic, and the hobby consumes the life.

A high proportion of nineteenth-century buildings personal
to the point of foolishness or obscurity are Gothic castles. Gothic
went on feeling like a bold reaction against conventional classi-
cizing styles after it had become widely accepted, one of those
fads which still seem secret when universal. The connection be-
tween Gothic and privacy is made from the gloom and darkness
of a self which wants to convert its feeling of being embattled to
literal fortifications. A tinge of the desire to perpetuate self-seclu-
sion underlies the most denatured and extensive reconstructions
of Gothic, and even in markets or stations a shade of old night
drops on the mind. Thus a late public example of the Gothic taste
may give the universal key to the Gothic fascination better than
pioneering monuments like Walpole's Strawberry Hill. In 1884 a
medieval village and castle were built in a park on the banks of
the Po at Turin. Here the castle hoisted onto a little mound
dominates the village, its outside wall with coyly scattered grilles
and oriel windows curiously moving. The two of the first and
three of the second make the appeal of machine-made identical-
ity, a badge of purity—there are no dungeons here, only pure
literature pursuing the idea of the dungeon to its psychic equiva-
lent, and thus more informative though less numinous than a real
castle. The coarse unvarying red brick has the innocence and

guiltlessness of an imitation, the unhoariness of a favored child grown up, yet this toy castle is a historical reconstruction, under which seriousness of purpose always hides the child clinging to his own past as well as man's. Ruskin identified Gothic with the far-back time in his life before sin, so his reconstructions were in two senses products of the nursery. With blocks he had brought the world into his bedroom, now the old styles took him back to childhood. He acted and he repeated.

Being grown-up children nineteenth-century men were able to find satisfactions in simple things which do not usually have the laundered feeling of the little village at Turin, an ideal nostalgia available to everyone. The castle William Burges the ecclesiastical designer built himself in Melbury Road, Kensington, still stands like part of an altar service. All his fancies—beakers, beds, buildings—have the same knobbly, animated form, covered with bumps, pierced with holes, crowned with heads. Jokes scamper over them in the form of lizards, inscriptions chasing around corners, and scenes bright as comic strips, painted in jolly primary colors or bejeweled, variegated, wrinkled, inlaid, always in the most indelicate way. He summons up a thoroughly enlivened environment which reads him bedtime stories everywhere he turns. The ubiquity of picture on his walls, ceilings, and furniture may be inspired by the clotted narrative of cathedral portals but has a different function even though it seems similarly a substitute for the printed page, because it represents a deliberate regression to a more amusing form than prose. Besides, the medieval model was never so full as his imitation which counts on duplication for some of its power, and though he gives all the figures a conventional form, all he has to say is said to himself.

The fearlessness in the clutter of Burges's well-known bedroom, unlike Francesco's study's, is that of a man who scrawls and splashes paint on his own walls, an amateur not a connoisseur, dreamed up not thought out. If there are absurd notions of himself as brave knight there is also a healthy willingness to make mistakes by carrying things phantasmagorically far. And Ruskin's beautiful raving in which he enters a symbol-laden realm of chivalry, of heroes, lions, and maidens, wakes us to the interest of that ramification of the taste for Gothic.

Burges's lack of refinement when set against Morris makes him seem more childlike and pure, but Jung's castle at Bollingen is the clearest fruit of a man choosing to act the child. There the primitive stone forms are deliberate efforts to call forth and satisfy what is primitive in the soul, the old child of the mind. Again he turns toward Gothic, breaking large areas of rough stone with

small figural and animal forms carved by his own hand. There are no conveniences because fires he lights from wood he cuts are his fires, from which comes a comfort, among the discomforts, of knowing one's house, reached by taking Gothic further back than the Victorians to the bedrock of the self.

Home was freshly realized to be an archaic idea in the nineteenth century when historicism took the inevitable form of a series of primitivisms. Jung's version of this primitivism feels really archaeological and preverbal, Burges's by comparison like untutored chatter, a kind of free association, but much more willing to admit the essentially gamelike nature of romances with history. The assemblage at Turin, Sunday amusement as it undoubtedly is, still shows how far the Victorian search for roots spread.

The century of Freud is named after a woman who wallowed with complete innocence in the home he identified as the source of all conflict and illness. And Victoria is still one of the strongest presences in Britain, as if this nondescript gray Will represented something so necessary she became the idea of England, an idea of self-enclosure, of Home, a cozy insular sense of stability that has not changed much to American eyes in a hundred years. After dark when cities dream of some part of their past, residential London becomes Victorian again. The English live in the pre-Freudian past, and nowhere else is there such a sense of a family behind each door withdrawn into itself, which is not spoiled by people's living alone or there being foreigners in London, because foreigners there are like the foreigners in Sherlock Holmes, curios or spices which tell of English adventure beyond the seas.

Although Victorian literature expresses over and over the sense of home, Holmes's bachelor household gives us one of the most distilled versions. Perhaps his enclosure is so exaggerated because people are missing and ritual fills up every empty space. The first thing Holmes and Watson do in these dream stories founded on the ordinary is to take lodgings, and everything about these arouses reverent enthusiasm: the stairs, the breakfasts Mrs. Hudson provides, the cab outside the door, musty chairs and heavy carpets. Why should the fact that they have just one floor be thrilling, if space of one's own is the ideal? Because they are part and yet not part of something else. They must thread their way up the tunnel of the stairs and once inside must dispose themselves carefully, a good fit like an old piece of clothing. Mrs. Hudson warms and protects without demanding anything in return, so if she falls sick Watson prescribes, and if Holmes does she nurses. Holmes is enclosed by compulsive habits as well as

snug quarters, each time he takes tobacco from his slipper is reminded of himself, reliving the whim of the original arrangement and confirming himself in the privacy of his ways. Odd devices like this are fences around the self even after he reveals them to Watson, who will only appreciate not participate. In countless devices Holmes assures that he will be given a wide berth by intimates, yet encourages strangers to call on him at all hours. Still, he never tries to banish intimacy, only to keep from knowing that without it he would die, but the stories do not conceal that Watson is emotionally more free than Holmes because he does not attempt the heroism of independence.

Holmes is a bit of a fraud as an adventurer, for he is really a passive spectator of the City and of Motive, a scientist of gossip. His business consists of getting into other people's houses all over London, not as a friend but as a fix-it man, who works on conflicts between persons instead of the pipes. In the distressingly simplest terms this is the crux of social life—getting admitted to other people's homes, to which he has found an odd but gratifying solution. If the stories were not so compelling we might notice that they all begin at the end and work backward, like a neurosis anxiously rehearsing. And that if Holmes manages to defuse any of this boring dynamite the survivors are left in a state of depression.

But this is a cynical view of the stories, which assure us with a heavy sauce of adjectives that these are the most expensive, cleverest lives in England and that Holmes's sanctum is one of the intellectual centers of Europe. They embody the powerful illusion that conventional lives are not boring, that stereotypically English people are the most pleasing, that the already well known is remarkable. Home is a place where the nondescript is sanctified by its necessary place in a system, where sublimity and predictability coincide, and moral grandeur results from the combination of alertness with incapacity for boredom in boring surroundings.

Each of Holmes's clients is the perfection of some type, and all their living arrangements so usual they hardly need mentioning. Yet they are mentioned; Holmes always memorizes floor plans and daily schedules of houses he examines. It usually turns out people do not live quite the way you expected or make some bizarre use of an ordinary domestic appliance like a bell rope or fresh coat of paint. The characters are often established as being of higher social class than ours. "Of course my family has lived at the Grange for three hundred years so there is no one in the neighborhood who wouldn't know us." They derive greater satisfaction from such things than anyone reasonably could and take

huge pleasure in the nonpersonal features of their lives: doctors are proud to be doctors, Kentishmen to live there; all roles are acted enthusiastically. Role is superior to character, so Holmes can interpret strangers with perfect accuracy, in a world where everyone is in place and the city is a huge filing cabinet. "I should like just to remember the order of the houses here. It is a hobby of mine to have an exact knowledge of London."

An innocent view of things underlies the sense of home in Sherlock Holmes, and a primitive firmness acts in seizing what is wanted. The predictability, safety, and comfort of assigned places is sought throughout social life. An English mystery, the reverence for old business firms, is now solved, a reverence which satisfies more by being unthinking and perhaps replaces the lost feeling for parents. It can be unthinking because consequences are small, since the firm performs its ministry physically, reliably, but unobtrusively, and reinforces home thoughts without competing with the home.

Foreigners are struck by the large part piety has in the English temperament and surprised at its objects which often seem trivial customs: tea, school sports, clubs. The ruling idea is that of a safe haven in a stormy world, and adventure is seen in schoolboy terms as truancy. Thus Holmes and Watson meet danger by staying up all night in a dark cellar and reminisce over whisky in the morning. Staying up after others have retired is the recurrent way they flush out evil; if they can get through the night, it will be all right once daylight comes and everyone is up and about.

Though these homes are the safest places in the world we always stumble in at a moment of extreme danger, as if the world of habit is under constant threat. Doyle's idea of evil is basically an idea of the invasion of a home by a foreign force. A stranger has inserted himself in the family or one of its members has picked up an infection outside, and now people unused to defending themselves experience a state of siege, at which point Holmes comes to teach them methods of warfare or to stand in for them and bear the attack himself. From this vantage point the old days in the unthreatened home are beautiful and we guess how glorious their meals and naps must have been when they enjoyed them in peace.

There is a remarkable English institution more homey than any home can sensibly be and more old-fashioned, an institution public in a way peculiar to itself. Americans, who forget that *pub* comes from *public,* take it for a special sound signifying coziness and contentment, and it becomes an idea so potent no single

embodiment can live up to it. But every nation's envy of the English comes out in talking of pubs, where they have made themselves comfortable by preferring a muddle or jumble to any sort of effect. Pubs are eminently Victorian, where the past lives more freshly than in scholarly reconstructions because they deliberately give body to a dream of the past. Though every European country had village inns, elsewhere they have become gleaming cafés, while in England they are more villagy than ever, more like burrows.

These public homes represent escapes from home into the arms of an even rosier home, are more fervent expressions of the need for enclosure than cranks' castles because for most people they are homelike supplements to the home, which because outside represent an unattainable idea of mellow shadow and irradiating warmth. Every pub feels slightly different from the others but a good one feels familiar at once, can be large but is made to feel small by breaking up the space illogically. Most important are furnishings like heavy curtains which muffle the doors, symbolic safeguards against an unspecified threat, quantities of padding on walls and seats, protection from abrupt encounter which would feel sybaritic if all the materials were not so inelegant and dingy. Loud colors are prohibited, fresh paint must not look it, because cheerlessness is conveyed not by dirt or squalor but by emptiness or excessive alertness. They are places where a reassuring amount, where an impossible amount has already happened, but the drabness suggests that this lengthy past has been a past without incident.

This English dream of the good life is so modest and unshowy that it is mostly possible. The timelessness of their clothes, furniture, and equipment says that they have decided what they want more firmly than any other people. Even underground, the realm of endless motion, tube trains convey a little of this same atmosphere, by being a mild bulgy shape and dark red outside, with warm varnished wood and red and green plush inside. In New York a nightmare, in London a burrow, dark, warm, and soft. American disguises rarely work, but the English produce their favorite textures in unlikely places and make even these temporary quarters feel like private dens.

From Orwell's descriptions of working-class homes in *The Road to Wigan Pier* one gathers things have not changed much there in forty years. As in pubs, the softness of surfaces is remarkable, and a great deal of attention paid to carpets. These are invariably English, Axminsters in bright colors but of a fuzzy figured pattern where yellow shades jerkily to brown. The overall

effect is of a dark ground with small fires kindled all over it, but dying down, now smoldering. English fireside chairs are retreats of cloying protectiveness, softly sprung, in colors of green and gray that suggest tobacco ash, that speak mainly of use. This emphasis is a focus on the self varying from Francesco's by re-membering how much it has already done there, and filling the space with a narrative in code which less obviously needs crack-ing than his pictorial one. The old chair deliberately limits choices by making it look so satisfactory to go on in the same way. The sense of a life already plotted could be derived from the more explicit ornaments, but inheres as well in the shapes, which give pieces of furniture the appearance of reliable anchors.

Holland and Belgium are nations of homes to the extent that there is little else to look at. The interesting architecture is domes-tic, the energy seems mostly domestic, evident in the amount of cleaning one sees for which the front door is opened and the soapy water displayed in the street. The houses in a town like Bruges can be seen right through, a tinted glass window in front matching one in back. At the window are placed shiny copper and a few spike-leaved flowerless bulb plants with tile floors the hard, smooth focus of everything. The effect of this is strong but a bit admonitory like the bare inside of a Dutch church: dirt will show up here. The English home is separate from the world by being closed in, the Flemish by being cleared out. The English rejoices in signs of use, the Flemish in signs of care, of work.

With definitions behind us of the initial act of enclosure which sets the limits, of the impulse to cover the wall boundaries with potent signs, of the desire to fill the imprisoned space with imagined experience, a kind of vivified vision of the past, we can re-create nineteenth-century lives physically by entering their homes, much frailer evidence of their thought than words on paper. The unfailing examples, of which Burges's is among the least obscure, are Englishmen's houses as castles, which began with Walpole's Strawberry Hill and continued throughout the century. Initially these feel like self-advertisement not self-reve-lation, but little in them is automatic or unimagined, and they are entirely dream fabrics.

Though garden follies are an eighteenth-century form, fool-ish dwellings are properly a nineteenth-century one, when aber-rant fancies are no longer kept in their place at a distance, but are preferred inescapable. Apparently the most bizarre early-nineteenth-century dream castle, the Brighton Pavilion, proved uninhabitable shortly after reaching perfection, in spite of which it had great influence as an incitement, by showing how far one

could go, what degree of extravagance was realizable. Walpole too had a seminal effect. Strawberry Hill was something all England was interested in, and his publication of the elaborate *Description of the Villa of Horace Walpole . . . at Strawberry Hill* (1784) revealed to many people that his fancies were just what were in their heads too, a contagion which partly lay in the self-willed quality of the project. Though he clothed his project in a show of serious historical reconstruction, he mostly expresses joy at his own cleverness.

In its present denuded state Walpole's castle only suggests its original plenitude and clutter as an image of its creator's mind. Every piece of each of Walpole's collections—medals, stained-glass fragments, miniatures, manuscripts, tombstones, fine bindings, architectural casts—seems to have been displayed, contributing to an effect of seminatural mosaic, like the encrustation of a sea shell. Exquisite surfaces were covered with exquisite parasites, and everything interfered with everything but made abundance, not confusion. The eighteenth-century English mania for collecting is an early hint of the self-indulgence we are tracing, an occupation of idleness which cannot be shared, essentially childish, which attempts to objectify an ill-understood self. But it does not usually work, so the act needs to be reiterated over and over, a process which has no shape, only successive moments.

Each room at Strawberry Hill is treated separately, as a world or a thought in itself. Into each is packed as much suggestion as possible until it becomes a self-sufficient den, but the whole still works as a succession of marvels. We go from highlight to highlight; no spaces are neglected, nowhere is there rest from the high intensity, only varieties of it. In Robert Adam's decorative schemes the smaller and unimportant rooms lead up to a few grand ones, in which the finest effects are collected, for which they are saved, but Walpole's house has no unimportant spaces, no subordinations, and we find nooks, alcoves, and vestibules lingered over and imagined as lavishly as the main public spaces. Palladio's dictum that "rooms for baser uses should be hidden away as the baser organs of the body are discreetly placed" (*Quattro Libri,* II, ii) illuminates Strawberry Hill where one is often to think he is in a privy part of the building even if he is not. There are almost no parts that are not private or secret, intestinal passages and enclosing chambers which avoid squareness, pressing us so one alignment feels more natural than others, diminished by alcoves and screens that give the effect of fluid rather than air space, so the eye flows, it does not leap, among deep blood reds and night blues. If Palladio's proportions are

derived from the regularities of the outside of the human body, perhaps Walpole's calculated hodgepodge is a guess at the inside, which is not in fact symmetrical, as if the body meant to suggest the difference between subjective and objective knowledge. The part we can see is logical, the part we cannot is tangled. He claimed that the inspiration of *Castle of Otranto* was a nightmare which he simply recorded, and perhaps the inspiration of this more solid castle was as insubstantial, a vivid instance of extending oneself to fill a landscape.

Walpole builds himself a body; an architect of the next generation, John Soane, made himself a mind. Although Soane's main historical allegiance was classical not Gothic, some of what has been said about Walpole's dream house fits Soane's in Lincoln's Inn Fields. Again every room is treated separately, space is divided and subdivided, odd angles left over around stairwells are emphasized not ignored, and walls are encrusted with hundreds of foreign bodies. In spite of the Monk's Parlour and the Shakespeare Recess, Soane's house is one of the great monuments to English interest in Italy and the classical past. Put next to Walpole he shows that there is something strong and permanent in the eccentric English spatial taste, that it is not simply a fashion which wears one set of clothes. Soane makes of his regular materials a whole more enigmatic than Walpole's annotated literary one, perhaps because we do not have the fictional fantasy that goes with this house, the *Mysteries of Villa Soane.* He is the kind of eccentric no one can ever treat familiarly, whose mind of mirrors baffles you as thoroughly the tenth time you enter it as the first, nor can this author be widely known, his work an architectural *Finnegans Wake.*

Every visitor to Soane's congested den will notice reminiscences of many architectural manners—in the drawing room pendants dripping from the ceiling as in excesses of Gothic fan vaulting, in the dining room discreet panels of mirror as in Robert Adam. But the memory is always interrupted—the effect of vaulting made hypothetical and imaginary by false arches, the mirrors made furtive by huge eyes of convex mirror above every one. All the details and effects are enriched with blind forms, solid blocks or lozenges of sculptural uselessness, simply expressive and more expressive because the surfaces if not the outlines are stoically uncommunicative. The house is full of verbiage, but the words are mostly other people's, Soane's enclosing comment noncommittal by contrast.

The main display quarters for architectural casts is at the back of the house, study rooms for the students Soane patronized

as well as musing rooms for the master. Though one of the most interesting parts of the building, they offer no place to sit down and barely room to squeeze by. A three-story well lit by a sky-light has been created by knocking out the top floor and piercing the next one, leaving a gangplank at the edge from which the eyes can come to rest on the littered basement floor beneath. Thus with some difficulty an immense amount of debris is seen at once in a small space. But the pieces are in many different planes, most of them surprisingly far out of reach, so that the mind cannot keep track of all of them and cannot decide to seize on one. If crowding attempts to present the whole contents of your mind or range of your interests to you at once, to produce an effect of self-suffocation, here it successfully renders you gaper.

The whole back half of the house is made up of these dreaming or gaping rooms. The underground ones designed for the contemplation of death, or perhaps simply for more torpid mental states, contain a huge Egyptian sarcophagus and a viewing chamber onto the dim outdoor court that holds Friar John's empty grave. The upper ones include the strange picture room where a large collection of pictures and drawings is arranged on a series of huge wooden pages that fold into the walls, the last set of them on one side opening onto emptiness so we plummet in imagination to the basement. In this very psychological house the picture room plays the more orderly part of the brain, the conscious memory which keeps its thoughts in clear rows and in proper sequence, sociable moments of Soane's mind which are still, like Poe stories, liable to leave off discoursing and begin gibbering. Only an architect would have had the nerve to translate a House of the Faculties from a febrile mental tale into stone, and to do it not among conspiring pines but on a bland London square, where the outside barely hints the peculiarity of the mind within, projecting itself larger to make diverting if still insufficient company for itself.

The oddities of the earlier periods became to a surprising degree the normalities of the Victorian. Finally clutter is no longer eccentric, and spare and decorous arrangements come to seem peculiar, feel by the end of the century artistic. The change is partly explained by a shift from consulting others to suiting oneself, emptier rooms feeling more public and cluttered feeling private, ones not everyone should see. When the home becomes a defense against the hostile world, a refuge, it becomes denser, fenced in, more secret. The ideal of homeyness which cultures and individuals veer toward and away from is a place small, even cramped, and dark, where one is caught in the toils of the familial

past. When as in the eighteenth century people decide their dwellings should feel airy they are resisting the idea of home mired in the private past and preferring wider allegiances.

A significant Victorian development echoing medieval institutions is the company town. Philanthropic Victorians like the Duke of Devonshire, Angela Burdett-Coutts, and Ruskin thought of dream villages instead of dream houses. For these mostly single people the family was not possible, but their social dream copied its main features—the community would be enclosed, at one in will, hierarchical, and devoted to the past. Consequently it should be small and physically primitive or mock primitive.

The Victorian village like Chatsworth village or Holly Village, Highgate, picks styles for the inhabitants, and some of the most pungently archaic Victorian architecture results, as if the lower classes need to be told more emphatically than oneself to think backward. Chatsworth village is one of the best investments in social stability ever made. Houses of the same dark local stone as Chatsworth itself make an enclosing oval around the church perched on a little tuft. Blaise Hamlet focuses a similar arrangement on a stretch of grass, but at Chatsworth the emphasis has shifted from landscaping to the ordination of a whole society in one architectural stroke. Here the outdoors feels like a room furnished by the owner with houses of differing shapes, where variety is assigned not chosen, and distinct styles match the functions performed by the docile dwellers, whose houses are illusorily large and solid, with walled gardens, their each housing several families being disguised by irregularly placed doors. Disruptive or violent thoughts are unthinkable in this sheepish quiet where life today is rooted and provincial as in *The Mill on the Floss*.

Yet the Victorians were remarkable and adaptable travelers. Englishmen made themselves at home in every corner of the world, often adopting Egyptian dress or Berber customs till they were more native than the natives. Though this sort were mostly lone individuals, the British colony in India created an eclectic life which accepted many peculiarities of Indian climate and culture while preserving in renewed symbolic glory habits like cricket and clubs. We are perplexed to find among the horrors of imperial greed this odd heroism of adapting to strange places, of making new modes of life from miscellaneous materials. Science fiction about voyagers to other planets can be no more surprising than the journals of Victorian travelers, with their heightened perception of both the foreign and the familiar. The English secret was

not an ability to cast off home, but rather to carry it along tor-
toiselike, so Englishmen in Conrad's imperial fictions often feel
themselves to be England, and must represent the whole culture
to an ignorant world. Hence they are more ritual-bound than
home types, never acting out of exaggerated character. In Sher-
lock Holmes, where they form half the population, returned colo-
nials show another face. Being out of society has made them more
ruthless, and tropical cultures have supplied them with under-
handed methods for acting naked will. In both versions colonials
become stronger if not better than those who stay home.

There is another kind of Victorian traveler, the man at loose
ends, represented by Edward Lear and Conan Doyle himself.
Doyle's life up to the time he wrote the first Holmes story was
a series of false starts and abandoned ventures, trips to the Arctic
and to Africa, misapprehensions of his interests and talents.
When he found something he could do well, he felt it was
beneath him and tried to disown it by killing off his character.
Holmes had become embarrassing as a daydream does the more
distracting it manages to be. Though Doyle's mind was indeci-
sive, his opinions were unflinching, all his allegiances—country,
home, monarchy, conquest, and national character—solid and
supportive, in adherence to which he ended his life in a flurry and
confusion of disparate activities. Doyle was often deluded about
himself and seems sillier the more we learn about him, but this
least grown up of lives is interesting as stupidity is not because
sheltering, not native incapacity, made it what it was.

Lear's life appears more continuous than Doyle's, but was
spent mostly abroad simply because the English climate disagreed
with him and he could find nothing to do at home. So he became
the sketcher and painter of exotic views, taking himself unhap-
pily over big stretches of southern Europe and the Middle East.
Much of his interest lies in his misplacement, a man who would
be the truest homebody but for some flaw, who now converts
preposterous places to clever mechanical tracery. To someone
familiar with his books of nonsense the landscapes are disap-
pointingly uneccentric. For an artist to confine himself to forms
other than human is usually significant of something, and Lear
provokes the suspicion that he is in these places because there are
few Englishmen to meet or paint. His earlier zoological and orni-
thological work is revealing because he invests every subject with
personality, but the later, more refined landscapes leave out, as
do all accounts of his life, the essential facts. The most individual
things about them are the droll notations in a springy script,
which are painted out by the colors they describe; Lear erases the

glimpse of himself he gives. And the compositions are of such slender substance, the solidities of the picture often vacating to the back center, evading near-sighted eyes, echoing the flight from the self. These landscapes of melancholy emptiness, faraway places seen from far away, are only a distinctive case of a Victorian genre—romantic topographical sketches of Near Eastern scenes.

Artists like David Roberts (who suited Ruskin) and John Frederick Lewis (who became Egyptian) will have lost their edge for us unless we see them in London in the luxurious privacy of the Wallace Collection or in Lord Leighton's house in Holland Park Road. Leighton House, aggrandized in stages from 1866 to 1889, contains the best surviving example of high Victorian exoticism (except perhaps Whistler's Peacock Room, which has migrated from Chelsea to the Freer Gallery in Washington). Here in the Moorish Court we are transported into another world, and yet we see London outside the lattices. The walls are covered with tiles half antique and half de Morgan replacements, the trickle comes from a small fountain in the middle, seats are angular wooden couches that seem to demand a new sort of sitting and form one piece with wooden puzzles that do for windows. An alcove or spying platform juts from the floor above over the entrance arch, and the ceiling is a reconstruction of pendulous interlocking pyramids in wood. Though in Baghdad this is an everyday affair, in London it is powerfully disruptive, seems to ask participation and to invite the self into new paths. When a man sits, stands, or looks out differently, he is different.

The rest of Leighton's house, however, is pure Victorian on a grand scale, unusual only in its profusion of exotic woods and conversion of many of the rooms to studios. Though Leighton was an artist his eclectic house expresses only the personality of the age, which is queer enough. If the Arabian part tempted one to pipe dreams and loose robes, they would be confined to that small precinct.

It is hard to guess what effect paintings of the Near East may have had. They were emphatically done for London, and they produce there even now a strange disquiet, taunting the homebound Victorian to dream of other clothes and making their point only for those who feel confined by the ones they wear. They exemplify a special nineteenth-century indecision between the literal and the imaginary, functioning like an invented imagery, but located on a particular page of the atlas. The great Victorian thirst for images becomes distorted passing tests of verisimilitude

till in the end it looks excessively circumstantial, the desire to dream ending in confusing piles of equipment.

But late Victorian art frequently takes the form of a more self-absorbed dream than this. An astonishing example of the studio as a dream factory is the Parisian house of Gustave Moreau in the Rue de la Rochefoucauld, now a museum. Here there are a few insignificant pictures of Moreau and his mother, who were closed up in this house until their deaths, and no other record of living people to disturb the purity of Moreau's fantasy, displayed in riotous and obsessive figure designs, the same compositions occurring over and over, in different sizes, slightly altered or reworked. A sociable artist could never be displayed so nearly intact, in overwhelming quantities of paintings, watercolors, and drawings that all feel almost unviolated by light, the extreme privacy of whose subjects makes it like walking around in someone's head and being shown the secrets. Moreau differs from the earlier examples in having wrapped himself entirely in his own productions, creating the physical world over again as he peoples his walls.

His subjects, which sound but do not look conventional— Salome, Oedipus and the Sphinx, Penelope's suitors, Hercules and the Hydra, Chimeras, the Virgin as Flower of Death, the Poet and his Muse, Sappho, Cleopatra—are all remote and nascently luxurious. Gauguin called Moreau's people "pieces of jewelry covered with jewels," and his impenetrable self-reference invariably presents the ideas of dressing in costume, undressing, thrashing into strained helpless postures, being enclosed by foliage. These are the motions of narcissism, where one is locked in a pose, not fertile but arrested, obliged always to act the same set ceremony. His habit of not finishing paintings seems a confession of this final rigidity, so a painting may start by feeling new but as it is gradually filled in, or crowded out, it begins to lead to the same dead end. Moreau had great facility at dreaming up squirrely detail, filling in bounded areas with tangles and overlays of jewelry impossible to untie, but he seems to use up all the air in his paintings and leave himself gasping for open space before the finish has been applied to the whole canvas. Like des Esseintes's turtle, his victims all perish of their beauty, his paintings of their exquisiteness.

His magic cave outstrips the pieces of its paving however, because if a single Moreau is suffocating, a hundred are not. But it may be questioned whether walls lined with paintings ever feel windowed or about to open out, too heavily charged for that like views through keyholes, vistas onto privacy. Ruskin's bedroom

at Brantwood was papered by the dense patchwork of his Turners with no space between the frames. The effect of this is not at all that of frescoed walls, which remain walls still. Ruskin's have become the ultimate imaginary surfaces, fantastically flimsy, the membrane of a bubble, yet still resistant and idiosyncratic. It was these walls which opened on the world of what he called The Dream, a self-constructed existence where, as a lamb, a knight, a gilded horse, the Lion of St. Mark, a little boy, he consorts with doges, Ophelia, saintly flower maidens, Ruth, the angel Raphael, the Rose.

His work constantly expresses an overwhelming desire for a response from the outside which feels inanimate to him, a need for fictional life that ends in his clothing himself in stories. Ruskin's madness is a painful miracle of the symbolization of the self, showing how deeply the symbolic habit of mind evident in the titles of his books could go, but he had always seized pictures and stories in a more immediate way than anyone else and believed them more fervently. There were ominous signs if anyone could read them in his earlier wishing for the return of medieval costume, and in his papering rooms at Brantwood with a design enlarged from brocade in a painting in the National Gallery. When he enters a Venetian painting himself, it is one of the great rebellions of the soul against confinement in spaces chosen for it by the parent, an outcry against red brick, Protestantism, and sensual denial, but a moment of triumph achieved in the tomb of utter self-absorption, space with no height and no breadth.

Chapter 3
Nightmares of Iron and Glass: Machines

*T*he world of red brick and
machinery seems a deliberately un-
imagined one; because technology tries
to stay neutral, engineers never paint faces
on machines, nor bridge-builders copy animal
tendons in their cables. If it sought visual effect at all, the
Victorian explosion of railroad and factory building sought a
depersonalized one in forms bare and unsuggestive. And there-
fore the reaction against industrialism was not primarily visual
but emotional, for what people mainly resented about industrial
science was its disentanglement from the maker, its refusal to
speak of human weakness. Beneath everything else a dependence
on art is a craving for sympathy, a need to find love in all creation,
and people who worry about the esthetics of industrialism are
hoping to find there evidence of individuality or of desire and
suffering. Bolder minds have been inspired by the brutishness
and facelessness of the industrial revolution, and what the engi-
neers achieve for modern architecture, Lawrence and Joyce
achieve for the imagination—a dehumanization that brings with
it accesses of power and energy.

In the idea of the faceless Imperson, technology conceals a
powerful dream, the dream of not being *like* anything, of being
nothing created. Natural forms all suggest comparison but tech-
nical ones usually do not, so a device like a typewriter has a very
decided identity but an unplaceable one. Like higher organisms,
machines cover complexity with simplicity, and we forget what
is inside a hand pump or how typewriter linkage works, even
forget that anything is there. They no longer have insides; their
work is invisible and they are simply ideas, functions, powers.

The word *invention* has ceased to apply to the power of the
poet, so that poems are not inventions in the new sense, devices

which fill a specific vacancy or need. From being patentable, unique as poems are not, they go on to be unindividuated species, and evolve like nature, creating a counterworld that renders the natural unnecessary. Though machines only appear to grow in air, nature is no more than fuel, the soil of the garden.

The railroad stations of London are buildings which, like machines, exist to be used, and unlike works of art can cease to be useful, so it happens that the first of the big stations built has been torn down. Euston Station is an emblem of the contradictions involved in treating as an imperishable monument what is only intended as a facility, a crass view of most modern building which avoids the awkward conundrum of what can possibly be left over when you take the trains from a station, the commerce from a market, or the traffic from a bridge. What saddens us is that forms of life change so quickly now, that things no longer happen in buildings formerly alive, huge haunted halls as intolerable as the wounds left by their demolition, like people surviving without their faculties.

The six large Victorian stations in London were built from 1852 to 1902 but the alterations and additions frequently made to them in that period homogenized the group considerably. It is difficult to describe railroad stations as architecture because they are experienced less deliberately than other buildings. One of Ruskin's clearest failings is his treatment of them as so much iron and glass, for no one ever sees a railroad station empty in the architect's-model state he is talking about, and even the idle visitor is soon agitated by the hurry around him, in the middle of arrivers and leavers catches the construction of the building only out of the corner of his eye.

Two famous nineteenth-century paintings of stations, Frith's Paddington (1862) and Monet's series of St.-Lazare (1877), show the difficulties the subject has caused painters. Frith's attends to passengers, Monet's to outlines, to the architecture of the experience; Frith crowds the canvas with separate bits: sweepers cleaning, children lost, fond farewells, high life, low life, age, infancy, the whole journey of life conceived as a pageant, an elevating spectacle; but the most intriguing parts of Monet's scene are above eye level, in the magical smoke suspended in its arbitrariness forever, part of an atmosphere that gets more opaline and palpable as we approach the soft angle of the roof, a refined experience of densities. Frith tries to humanize the scene by pretending that social life can continue there as in a drawing room, Monet to cull off the building as an image of the capacious tranquil mind. Both of them are partial, Frith's an indoor scene and

Monet's an etherealizing of gross reality, two improving pictures. They leave out the motion which stations even more than trains are all about, which the "architecture" of Victorian stations recognized by being minimal, by keeping out of the way as much, and touching ground as seldom, as possible. More radical later attempts like Boccioni's to convey the nervousness and speed of stations are almost picture writing, depending on numbers, letters, arrows, comets to suggest a disconnected public experience, making their point by the way they fail. In *States of Mind: The Farewells,* he has ransacked the world to represent modern life and found careening figure 4's and flying E's, incomplete parts that cannot be resolved to a meaning. The title frankly takes the railroad platform as an image of the psyche, a place crowded with flying debris. Social experience is collision of atoms and the mind repeats it.

Railroad stations leave one of the strongest impressions of city life, which lingers after more strictly architectural ones have faded. These are some of the most ambitious and least demonstrative things ever built, which properly have no outside, their shape a primitive and amorphous one, a deliberate huge simplification to a single cell. They could be added to or their furniture shifted without disturbing the encasing structure, a loose molecular wall providing scant definition. Their image of freedom is that of the undifferentiated cell as a flexible machine, presented after one has got past the front part of the station, the stone, decorated part which is really just a big door. Strictly speaking, nothing is needed but a wall across the end of the shed with an entrance in it, but understandably railroads could not put these huge things in the middle of cities without making them look like buildings. The Euston arch and the double barrel of King's Cross are two bold versions of the station as an Entrance to lots of other places. By contrast, the fronts of Victoria and Waterloo are charming but irrelevant disguises, and St. Pancras's brick castle front a gilding trying to swallow its pill. The hotel-castle is so large only because it must wash down the huge train shed which docilely points itself into one ogee arch, but an arch that multiplies the scale of the castle by a hundred. On the most expressive nineteenth-century building in London it is not simply decoration for which no use can be found, but humanity. The division at St. Pancras gives the work to the inhuman future and the idleness to the accumulated florid past, a separation fulfilled now that the castle is unused.

When one of these glass and iron sheds was given the overevocative name of Crystal Palace and conceived as a pleasure

dome, its contents or its mode of construction interested people more than its form. It was simply a pair of spectacles used for viewing the products of industry, and adjusted itself like a caterpillar, putting on segments to accommodate more. As airports and expressways now, these constructions were untraditional enough not to look like architecture at all. They did not express permanence by being thicker at the bottom or by advertisements of solidity like rustication, and a glass and metal frame did not look like a wall. They were skeletons or x-rays of buildings that suggested uncomfortably the act of putting them up, which, reminding you of that process, might also be taken down; the Crystal Palace is probably the largest building ever disassembled and re-erected elsewhere. This palace, whose name tried quixotically to make it traditional, was like the railroad stations inhospitably large, but in spite of its constructional similarities to them, was figment and fiction as they never were, an attempt to transmute dross into an insubstantial bubble, and to force human elegance onto technology. Its details are resoundingly prosaic and the photographs of its construction like going behind the scenes of a theater, but it meant to transcend the materials and become a surrounding shimmer. The sheds were invisible in another way, as work is: built to do, not to be; existed before they seemed achievements; and first made architects trivial and accessory, critics not creators.

Even purer architectural diagrams of motion, bridges likewise got built without architects and used the same unlovely iron. More clearly than the sheds they are devices, machines of a kind, which do not take decoration easily. Derby's Coalbrookdale bridge (1779) and Brunel's Clifton suspension bridge (1862) represent two uses of metal in construction, a cheaper way of spanning a space where a stone bridge was possible, and a way of putting a bridge where none could have been before. The Coalbrook bridge is airy and elegant, something even wooden footbridges had never been, toppling notions of what strength looked like. An advanced stage in the process, Clifton suspension bridge leaves the ground entirely, one of the earliest examples of a bridge as flight to survive, like the stations expressing a clearer symbolism of transport than any of the vehicles themselves. Today its miniature scale and glowering Egyptian towers make it theatrical, but in the years when these bridges were still failing, crossing it was an adventure. Almost more than airplanes, suspension bridges cut man's ties, take away his body, and entrust him to a void.

In the new thin strength and in taking man off the earth,

metal violated his relation to matter. In countless ways it makes existence more imaginary, more invented. Hence our deep hostility to it, which appears first in the colors of Bosch's pictures, where it blows hot and cold, rigid and tumescent, gray or pink. The surfaces of machines are so bland because they are always threatening this transformation. Smoothness of forged metal belies the trouble of its birth, fires are succeeded by an oblivious calm. Materials that have forgotten their past are properly the stuff of science: metal, rubber, plastic.

When man envies the freedom of machines he dreams of changing himself to metal, a de-creative transformation to unindividuated robot. There are no torments there, and no death, because with the death of feeling it has already come. Renaissance armor turns the body to metal, cutting flesh to arbitrary patterns, dictating the poses the inhabitants can adopt in the curled fingers of metal hands and fixed right arms which make men battering machines, frozen at moments of destructive activity. To us these transformations seem absurdly literal, but only because we have been able to go beyond them in engulfing vehicles and huge metal envelopes. Operators of bulldozers and travelers from Euston have no use for suits of metal clothes.

The tiny reverses of medals often show armed men from behind, when they become pure featureless sculpture, but the greatest Renaissance enthusiast of metal expanses is Uccello, whose name was one way of saying he did not care much to be with people or paint them. Vasari thought Uccello had wasted his talent on mathematical studies, which led him to a dehumanized presentation of armed bodies locked in fierce struggle. At first there seems an immense amount of activity in these scenes, but as we decipher the overlapping surface, much of it brownish metal, we find repeated instances of a rusty dream of invulnerability. Men and horses are here fictitious constructs, one set turned from metal, the other from wood, machinery for elaborately engineered play. Uccello no longer seems engaged by real questions of power, or it has shifted from physical to mental power, impressing us with an understanding of thrust, not with the size of the thrust itself. All the apparent clatter, like a gesture made by armor, is a kind of stasis after all, or a game in a circle which, if impressively vicious, isn't impressively large.

Fifteenth-century artists can feel scientific and utterly lack sweetness, without being as fully mechanized as Uccello. Piero della Francesca, a less extreme example, shows how Renaissance science gained freedom by systematically dehumanizing the world, resulting in visions with the clear intricacy of machinery

but none of Uccello's direct reference to technology. Piero was the author of mathematical treatises and often delights in spatial puzzles. His two most problematic pictures are a Madonna and saints in Milan and the Flagellation in Urbino, in the second of which a staring disproportion between foreground and background creates deep narrative mystery. Placing great strain on the system of perspective, he produces emotional dissociation without exaggeration of gesture or expression. The Milan picture has only recently been recognized as something other than it seems. A virgin and child with six saints and four angels appear to be standing in a shell-shaped apse with an egg suspended by a string over their heads. But observation shows that they are standing in the nave, far in front of the shell and the egg, so that the building is considerably larger than the chapel it seems, and the egg an ostrich's, not a hen's. The land form (eggshell) and sea form (scallop shell) of aboriginal enclosure are shown on disproportionate scales to begin with, presumably to provoke speculation on the coincidence of different birth mysteries, the picture a geometrical fantasy on the Incarnation, which normal logic cannot comprehend. The figures in the painting are only means of measuring its peculiar space, existences thoroughly submerged in mathematics.

Other of Piero's paintings, like the London Baptism, arrange figures mathematically as notes on a sheet of music or as elements of an equation generated from each other, the four small clothed figures on the right being related to the man undressing in right center and to Christ and John as 1:2:4 (the ratio of heights in the Flagellation is 1:2, background to foreground). Figures in Piero fall into distinct groups, are more at rest and self-contained than those of other painters, and reveal more of the abstract completeness of numbers. His chaste, clear colors, colors of stone, are in harmonic relation to each other and his conceptions stern and denuded. He prefers landscapes in which the land has no clothing, he is a poet of winter who transcends personality utterly and can be felt surest in his searching interest in rocks and trees, not an interest in textures, but in the secrets of their geometry. The life in his paintings is not obvious; there is little narrative, nothing amusing or peculiar, nothing pretty or touching. When these paintings call up something in the looker, it is usually a feeling about substance: a necklace will remind us that jewels are solidified liquid, a fold of robe of an ideal relation between downward and sidewise forces. These are paintings absolutely at peace with the permanencies and inevitabilities of things, and the inhuman painter of them shows how elevated an unpersonal vision

can be. Even though only three secular projects by him have survived, he represents a deeper, purer classicism than more obviously nostalgic artists like Mantegna.

But there are many sorts of classicism: a literary and theatrical kind that includes Mantegna, the reliefs at Rimini, Piranesi, Jacques Louis David, a strain rugged, masculine, and difficult; at another extreme the elegant feminine classicism of Raphael, Canova, and Ingres, deliberately reserved or entranced; and a third openly pagan and sensual, running from Giorgione and Titian through Rubens to eighteenth-century Frenchmen like Clodion. All three of these spirited varieties, with their overtones of sexual hardship or indulgence, can be set against the less resonant, sensible tradition—Giotto, Uccello, Piero, Palladio, Poussin, English classicism, Ledoux.

These are artists not as humanists or men of the world but as specialists or technicians. Their Roman connection is not romance-shrouded, because they admire Roman technology, Roman power in the mental world, and produce work without antique patina which feels new, not reminiscent. They are closer to the spirit of Roman achievement, which rejoiced in the ability to do things, which admired physical size and success. To romantics Palladio's straightforwardness seems vulgar, and Poussin's dull. Their goal is power, not refinement or titillation, an art of clear assertion which takes away defenses.

The source of most dreams of power is Rome, and the secret of the long interest in them and the reverence for them in British schools is the dream of turning a stern ethics into material success. Victorian and Roman ceremonial architecture are both self-congratulatory, blustery, and sentimental, echoing societies traditional yet ruthless, which place high value on complex organization as a pacific force. The impressive visual achievements of each were engineering not architecture, each by styleless boldness in the things that really mattered produced a dramatic change in the scale of life.

The grandest Roman constructions are not the temples and gardens of romantic classicism but waterworks, roads, and city plans. At Pompeii we find thinking on the huge scales usual for us but rarely realized again until the nineteenth century. None of the intervening centuries could know from participation as we do what drove Roman civilization, and so they felt the envy incomprehensible to us. The size of Pompeii is unexpected, but even more is the rationality of the plan, a city conceived as a honeycomb, made up of identical units that can be added indefinitely. This kind of uniformity is possible only with heavy regulation,

and so it does not surprise us that traffic in these cities was more stringently controlled than in ours. Pompeii is so homogeneous that only by signs can we find our way about, in an order that is mental not visual.

The most interesting building at Pompeii is one that was rarely entered, the Castellum Aquae, which distributed the city's water supply. Now it is dry and the gigantic stone catch basins that filtered and divided the flow into three smaller streams look like accessories of Aztec rites or Romantic drama. Like those of Roman arenas, these forms are more provoking than the studied ones of temples. Though practical and ornamental Roman forms are both severely geometrical and proud of sheer size, a big temple is pure self-assertion and self-applause, and an arena partly self-forgetful in accommodating crowds.

An arresting feature of late Roman society is the importance placed on superfluities of water and its inclusion in the main communal rites. Public baths became centers of leisure and even intellectual life. The whole system is a comfortable translation of Greek athleticism to the indoors and an identification of cleanliness and civilization. Water in these quantities is an impersonal medium, which simplifies, empties, purges; cleanliness an equalizer of persons, which permits efficient crowding. Those pompous buildings are fascinating as social history, great pasteurizing and homogenizing machines, but innovative Roman building is usually even less personal than this, never intended as habitable, aqueducts like machines, that last on and on without human interference, without being influenced by their users as buildings are. Like the railway arches which crisscross north London, aqueducts are domineering facts of life but do not ask one to form a relation to them and feel to pedestrians like fortuitous sculpture. Though unkempt and dirty the arches strike a note of the infinite, repeat themselves until out of view, cross the street pattern irregularly and so remind us of themselves unexpectedly. Their intersections with the life below can be so odd we never take them for granted as we always manage to take buildings that line up with the others. Railway arches are to the nineteenth-century city what spires and towers are to the medieval, a break in scale, a violent suggestion of other dimensions, of foreign powers, of rule from above.

Roman geometry begins in the single points of obelisks or milestones and extends itself in roads and aqueducts. Though they stole obelisks they reinterpreted them, making them foci, primitive organizers, markers of beginnings and endings. The roads which ran from Rome in various directions till they hit the

coast were not prevented from carrying real traffic by the fact that they were ideal rays, radiations of Roman power. "All roads lead to Rome" coerces more than we think, means that the center has absolutely been ordained by human will, that all journeys have been plotted at the start, that the quality of clockwork has been imparted to human affairs. Roman roads were laid perfectly straight in an outlying place like Britain not because it was easy to do it that way but to show that even this wild did not defeat the Roman mind, which could treat it as if it were a plane. These roads stated clearly that the power came from man, who did not mean to respect the land. An Amazonian capital or an Alaskan pipeline is partly this elementary geometry of human power, which would have its point as long as the airplanes flew over even if the oil never flowed. Roads now make indelible lines on the map the earth has become, and seeing the whole earth just means having a larger drawing board.

Centralization is the geometrizing of human affairs, for a center always posits a rigid figure. The most impressive single Roman remains in Europe and Africa, the arenas, are solutions to mathematical problems, which make thousands of individuals into a single focused cell by jamming them together in a union visual not tactile, facing them to the center not each other. Focusing all these rays produced its conflagrations, but assured control of them. It is not quite true to say that no one sees anything but the center, or there would be no difference between the Greek semicircular theater and the Roman arena. The crowd in an arena feeds more on itself, sees itself reflected opposite, picks up cues from itself not the stage, but both these forms blur social distinctions to a degree unknown outside the West, reduce all high and low to filling identical spaces, the Greek form somewhat more stable, without the spinning relativism of the arena.

When the architect whose name is more entirely associated with the examples of Rome than any other built his only deliberate copy of a Roman building, the Teatro Olimpico at Vicenza, it was an arena. But Palladio's building is roofed, and its blue ceiling has clouds painted on it, which make it feel even more a scholarly reconstruction. It offers a cooler experience than its outdoor parents to men of taste not the herd. In this perspective box a science is demonstrated; instead of a haunt of idleness Palladio has made a machine for teaching the laws of the visual world. His most learned building confirms the version of him as a very public architect, more often studied from his books or followers than from life, more a classic than any of his Roman models and therefore even less new than they. Though the copied

theater is a serious kind of make-believe, it is also just a club-house for men whose ordinary lives were passed in sixteenth-century Italy. Palladio's efforts to convert Vicenza into a diminutive Rome have gone further than any city planner's ever had, but the illusion took wishing to feel entire. A suggestion of stage set was never absent from the old public hall he clothed in an arcade of giant orders and called Basilica, which still poked up its barn roof. But he meant to make the city over—it signifies that he found himself in a place as small as Vicenza and that such a concentration of his work is found there. Still, in his interpretation neither the model nor the dreams were imperial.

Palladio was an architect who got built, practical not piously archaic, who did not spend his time designing grand temples when private houses were wanted. In the popular codification of his architectural discoveries he gives twice as much space to country houses as to the other two categories, an arrangement which is no more Vitruvian than his logical error that single private houses preceded towns in the state of nature. Both the arrangement and the theory simply fit his practice. Unlike Scamozzi's and Colin Campbell's huge Palladian volumes, his own books were always modest and manageable, without value as display.

Mantegna's was hermetic but Palladio's learning was pedestrian. He walked it out among the ruins of Rome, many of which he was first to measure. He would not describe a place without going there, and his most fantastic drawings, reconstructions of great baths and mausoleums, start from what he found on the ground and go on to express the social dreams that propel all his work and come out in warm enthusiasm for ordeal and fortitude when he treats Greek palestrae. Stoical simplicity informs the projects which have seemed impossibly ideal, like Villa Capra outside Vicenza. It is always called by a name that expresses its impracticality as a house, but the Rotunda is only ingeniously presented as a perfect geometrical temple, an outsider's view of it, its lecture heard best from farthest away.

Scamozzi says it was made perfectly square and regular so that inhabitants could enjoy the views. It sits on a knoll, a small convexity at the center of a wide bowl, with little ground of its own, but of course its grounds are the whole visible landscape, which it focuses as few buildings do in a relation entirely for looking, not walking. Instead of precarious, the compact building in the large setting feels discreetly magnificent, an effect achieved by simple devices. We approach by a steep little artificial perspective formed from a garden wall on one side and the masked work

buildings on the other. The vista up the path is exactly closed by the house, and the top of the wall which fades into the bank at a vanishing point halfway is regulated by urns, a tight geometry easier to draw than describe. The system is closed looking from the house by a little chapel across a public road which it erases by continuing the composition. The barn is turned away from the avenue but not concealed; the road is glided over but not impeded. A hard-headedness even in disguises refuses to isolate itself from useful work, so from the side the farm buildings proudly range themselves against the house, lower but more extensive, a proportion of work to leisure.

Although it is a private dwelling, the Rotunda gives such clear signals it becomes a beacon, a marker, an intersection revealing its purpose in a rhetoric so calm it seems to express itself completely, convert thoroughly to concept. In this particular case of mechanical reproduction, being the same on four sides feels scientific, carrying a façade over exactly to another prospect shows a generalizing tenacity of mind, employs intellection as a kind of power. This return to the unitary state of the single uncrackable atom grants an impregnability which acts as a substitute for fortification, as if the building has no unguarded moments, leaves no weak side, trails no loose end.

Palladio's house feels more "built" than other men's, more a geometry lesson, but kindly softened for use, and he did some of the most concentrated thinking that has been done about the spaces people live in. His reliance on numerical proportions and right angles sounds prosaic, but the cubes of air his walls enclose are never accidental, and experienced, his rooms are surprisingly open. Alignment of doors lets rooms see through each other, permits glimpses of the outdoors through windows beyond. Thus opening interior doors opens the house significantly and gives it breath. Like Roman, Palladian geometry is a system of communication, of tying things permanently together in straight lines. The rooms defeat extremes of individuality and are betrayed by clutter, impose an ideal of frankness, which acknowledges no ups and downs, only lives extending in a single plane. Though they make keeping track easy, constantly remembering ligatures and sweeping beyond the moment, these machines for living square off the lives along with the space.

Architects in the learned, strenuous strain, including Michelangelo, Borromini, Hawksmoor, Ledoux, and Lutyens, rarely seek the deliberate balance Palladio did. But more than those calling themselves Palladian, they resemble him in radical questioning of forms. They might be called the tradition of mad

rationality, inventive like his, while the Palladians exemplify only rationality dead. Cerebral as he is, the others strive for an impersonal oddity, and inspired by asocial or impossible dreams, practice didactic alienations of the viewer. They uphold the conception of architecture as geometrical, rational, and masculine, expressing in an uncompromising way man's right to change and dominate nature. After Palladio these assertions were never made again with confidence. A struggle may be almost surfacing in Palladio's putting brick to the uses of stone, in rustication and giant orders of Vicenzan palaces, but Borromini suffers positive anguish over the recalcitrancy of his materials. Maddening him is the unscrupulous, flexible rival Bernini, who can make any material do anything, for whom walls dissolve and domes fly off in swarms of Cupids. Guarini and Borromini of the starker Baroque are fighting losing battles with the angles of their own minds and the heaviness of matter.

The use of geometry and reason to defeat man has seldom gone further than it does in the mostly unexecuted projects of Étienne-Louis Boullée and Claude-Nicolas Ledoux, who might be monsters from the mind of Blake. They interpret the past as huge and crushing, its lines undeviating, its forms unalterable, as if Palladio had been pushed by some opposing force to exaggerate every assertion of symmetry and solidity, to make his ideas eternal by building them too thick and featureless to accept alteration or decay.

All Boullée's designs are for public monuments, memorializing dead scientists or departed warriors, apostles of reason or sacrifice, huge cemeteries which imagine dead populations concretely, prisons, legislative halls, national libraries. But these commemorations of Mind, these rumblings of the voice of Man, are marked by impossibility and extreme personality, and deliberately dreamed on unthinkable scales. The drawings in which they begin and end are speckled with minute figures which alone indicate the buildings to be hundreds of yards high. The Cenotaph for Newton is an enormous perfect sphere of stonework, set in a huge rectangular base, a planet with a small opening underneath, which leads to the hollow interior where we stand at the bottom by Newton's tiny casket gazing at a universe of stars made by daylight piercing tiny holes in the shell. At night a lamp suspended in the middle of the space completes the reversal of the normal cycle.

All Boullée's designs are based on elementary figures, spheres, rectangles, cones, but few contravene nature as elaborately as this. An artificial vastness is easier to appreciate, eternity

in an hour more telling, so any circle can be made to stand for any other, the small for the big, the big for the small, inside for outside. In Boullée's symbolic world a sarcophagus grows to temple size and holds a warrior of what dimensions? The body becomes the building. The mind which conceives transversals on these immodest scales is really the subject of Boullée's work. His endless cemeteries are about the terrifying power of the thought of death, and when he makes the inside of a conical monument spherical he is saying there is no living with reason, whose uncomfortable fertility constructs ultimate chambers not rooms. Palladio painting clouds on his theater roof applauds the reality he denies, but with Boullée we have entered a grain of sand and the eyes cannot adjust again to normal sizes.

Ledoux's strangest design, for an inspector's house at the source of the Loue, practices an enlargement that feels more like a joke than those of Boullée. The house is a huge section of pipe, through which water rushes, and which manages to fit its curved rooms into the walls. As in the Newton monument, a rectangular base makes grudging concession to gravity. The official is bent to his job and dominated by it, but it is only a noisy hole at the center of his world. Like many of Ledoux's ideas, this one is placed in the wilderness, nowhere special, and like many French projects of the period it is an enlarged partial form. Boullée fancied a kind of architecture he called sunken, which consisted of buildings in the form of gigantic pediments just breaking the surface of the ground, where whatever the dimensions, people would feel crushed. The most famous example of a partial form was the column house at the Désert de Retz, a house in the shape of a large fluted column broken off jaggedly when its height is half again its diameter, where windows must be fitted in impatiently, and the bedroom story has none. After a lifetime of growing up we are set back far beneath childhood by the sensation of extreme smallness in architecture which looks like something else, like objects man would not fit into, which says man is not fit for the world, and so cannot get comfortable in it.

Boullée dreamed of horrifyingly large capital cities, while Ledoux built an ideal town and found an insidious way of remaking Paris. His village of Chaux, isolated in the Franche-Comté near the Swiss border, is a purely industrial installation, an ellipse of severe buildings centered on a saltworks. To make a whole town is to ordain a whole life, composed of buildings which give people directions, or which exist to inspire ideas, like the Houses of Union and Memory. He also includes negative instructors, like a brothel which paints vice so starkly it awakens sleeping virtue,

and gives great power to courts which oversee the virtues: a Palace of Concord will settle family quarrels or head them off.

His other large project, a series of seventeen tollhouses and sixty-six smaller posts on the rim of Paris, similarly approaches style through barriers of stringent necessity. These buildings were little seats of judgment, where people were counted, admitted, and rejected, which exercised control of what Paris was without entering it. Ledoux works best with unpromising materials, imagines many variations on walls and gates, positively inspired at the thought of constraints on freedom to create a geometry of prohibition. The Revolution interrupted work on many of his buildings, including the tollhouses, so that these best warnings of its inflexibility were taken up again later in another style.

Neoclassic art is usually the very reverse of picturesque. When Blake makes what he calls Visionary Portraits of such people as Newton, the Builder of the Pyramids, and his own Spiritual Instructor, human faces become architectural, crystalline yet bilaterally symmetrical, inorganic forms organized organically. Being visionary means taking this freedom of formality and giving more rules to reality. Ledoux's architecture is almost an art of rule liberated from reason, where fiats are obeyed whatever their consequences, and his English contemporaries like Flaxman share the stripped-down, mechanical efficiency. Even the nude can be a vehicle of unreverberative bareness; in Flaxman's illustrations to Homer flesh surfaces are empty blanks, armor and weaponry the seat of tiresome angular density. He wants the human form to say as little as possible, to be remote but unmagical too. Romans but not Greeks could use bodies this way as machines for movement. Similarly the revival of the nude in Blake signifies an interest in faceless power, and all his bodies are the same, all engaged in nonhuman struggle. Pursuing such purposes Flaxman returned to the primitive world of the *Iliad,* and Blake made his own, one of mechanistic inevitability.

The thorough modern attempt to imitate the qualities of machines was made by Italian Futurism, a phenomenon which unlike neoclassicism is strongly antifigural, but of course Blake and the others were already generalizing the body away from flesh and fallibility toward machinery. Both movements are characterized by their own variety of power mania, the other side of a fear of weakness. Though the Futurists are anticlassical by profession, and aim at releasing a barely civilized force, perhaps machinery is inevitably classical, in the sense that is of being severe, symmetric, rational; and these Italians confuse us by their Romantic advocacy of anti-Romantic tendencies.

The warring elements in Futurism appear in the conflict in their works between swirling and cutting movements, between unsynthesized angularity and circularity. And also in their paradoxical preferences for disintegration, for constructs which will not last, for a centrifugal geometry, shattered and disjunctive, which finds glamour in atomization. Though fiercely anti-intellectual and hostile to culture, it was an esoteric not a popular movement. It presents itself as a peculiarly nonindividual phenomenon, a literal movement, artists become vehicles for a Force. Their works and manifestoes are full of demonstrative violence, they profess admiration of war, and ask to be scrapped in ten years when they reach the age of forty. Like Boullée they dreamed of making things over, so Marinetti went to Venice to propose that the canals be filled in and trolley lines run along them. There is an upside-down imaginative force here in deciding to make Venice just another city by expending tremendous effort. The weakness of all Futurist dreams is that alarm is perishable; when it has passed they are obsolete.

Descending from profession to practice we find something else. To free their subject matter of all aura they are reduced to letters and numbers as ultimate abstractions. But they must be depicted somehow, not floridly handwritten but as if printed or stamped. There is a mysticism of anonymity in this, however, a faith in escape from individuality. If we change the clinical title of Boccioni's *Unique Forms of Continuity in Space* to an informative one like *Armored Nude,* we see it incorporates the elegant simplifications of armor, the tendon study of an anatomical model, and the subtlety of a large nude. An archaic pose subdues the baroque fluidities and brings it near to a cult object, so we are not far from Uccello after all. Sant'Elia, the Futurist architect, performs a similar service for power stations, with monumental staircases and huge blank forms converts them to suitable shrines, but there is no truly Futurist architecture, except roofless generators perhaps, making no concession to a weakness for shelter. Like Pop art, Futurism was not serious enough to produce architects, and Robert Venturi, the contemporary who learns from Las Vegas, is what a Futurist architect should have been. His supergraphics make buildings symbolic again but in a blunt unfeeling way. He has deliberately argued himself through to a code of ugly usability and the impressive thought shows less plainly in his buildings than in his bold manifestoes.

The unpicturesque modern tradition has learned a new symbolism, changed its allegiance from the virgin to the dynamo. In the two decades that follow Futurism many vulgar artifacts are

busy bringing machines to life. Cubism, Constructivism, and Futurism are hard, but Art Deco is supremely easy. Its subject matter is often technological, and its rounded forms hum like vague generators, or reproduce exactly cars, ships, planes. But Art Deco turns machines into comfortable jokes, presents them pot-bellied and lazy-looking. Airplanes with clocks or radios in them, racing-car teapots and parachute lampshades make all speed and noise toy-size. When it is more serious, the style turns bland and the imagery recessive, causing even sunbursts of energy to feel cool and reptilian carried out in stainless steel and onyx, a myth of machine-men not heroic machines, which echoes technological innovation fawningly.

Attempts to live with modern ugliness that succeed it, like Pop, are again polemical like Futurism, but jokes like Art Deco spring from such painful ambivalences of feeling that the art itself cannot be lived with. We retreat instead into dreams of obsolete machines and see ourselves among windmills, clipper ships, even trolley cars. There is no nostalgia like the nostalgia for simpler machines, which are now imbued with the warm glow of a smaller past.

Chapter 4
Cities Dark Places:
City Planning and Built Worlds

*T*he Bernini of the present
is a man like Eddie di Bartolo,
the shopping mall tycoon, who lives in
Youngstown, Ohio, but whose favorite pro-
jects are in "crazy Florida," crazy because it grows
faster than anyone can understand. He has made discoveries
which transcend architecture and he changes the way people live
by putting up a certain kind of building. His jet plane makes
actual his mental speed and his jumps from place to place prove
that "Downtown is dead." He sees expressways actively as lines
of force on the landscape and builds his giant toy villages at their
intersections, points which to pastbound people look like no-
where, but Baroque plans, too, sometimes feel as if an aerial
perspective would give them point.

Downtown is dead because cars are not useful in it. After
forcing themselves halfway in, they have given up and set up a
new life in rings around it. The new scale is so large and loose that
it never makes the massed, sustaining effect of the old city, and
makes one wonder if the larger Baroque squares produced agora-
phobic reactions too. The transition between the old cities and
the new dispersal, strip development, was crude but friendly.
Limited-access roads cannot be populated continuously, but
American suburban arteries of the fifties, with their styleless
scattering of filling stations, hamburger stands, and remnant
stores, made a diverting contrapuntal effect. More than the new
form it was a changing place, constantly added to and subtracted
from, the juxtaposing of decay and success giving it the feel of
spluttering life.

Cities have always violated the bounds of individual concep-
tions in the effects they make. Privacy and integrity of thought
are impossible in the streets at the center of Italian towns, but the

residential squares of London, though they look something like piazzas, deliberately strive for the illusion of privacy in a public space. The houses have a purposeful relation to the green but only a circumstantial one to each other, so neighbors are here an unfortunate accident, and their houses inoffensively nondescript.

Streets in Naples overwhelm discrimination entirely, especially at dusk when they erupt in activity which gives a stranger the sense of not being able to notice what is there. People are doing things but he cannot tell what, the street is full of food, on the ground, on tables, or visible through large openings—not windows—in the sides of shops: food he knows must be for sale, but he cannot distinguish buyers and sellers. The ground is thick with children and women sitting on folding chairs, things go on above his head which he has no eyes for, all the energy signifying a crisis which will pass, but it does not. Looking for a street name he finds it unreadable, partly papered over, partly scratched off, with old names underneath showing through. There are no house numbers, a final impossibility—it is the least informative place he has ever been. The observer sees no signs or posters, almost no words—has entered a preliterate world, community so natural and complete no one need be notified of anything, where his path leads from one informant to the next, each of whom can fill in only part of the way. It is the foreigner who lacks words—for the cactus fruits which assume absurd importance, as if naming and tasting them will unlock the whole South; for dark or peculiar oblongs which might be meat, fish, or candy; for ices in intense reds, greens, blacks of Pompeiian painting. Streets are the living spaces in Naples, more improvisatory but more thickly intimate than rooms, the heart of the city one big building. Usually we are engulfed like this by anonymous conglomerations where no maker's personality stands out, effects which some cities instinctively avoid as others seek them. Though Southern Baroque and Northern Rococo pursued them deliberately, the best realizations are styleless places and not Rome or Salzburg.

Like streets which overwhelm all categories, Ruskin writing about art oversteps the bounds of history or criticism and produces fiction. In the second volume of *The Stones of Venice* he approaches St. Mark's by way of an evocation of an English cathedral close and a narrative of his progress through the streets to the Piazza San Marco. Though he is repelled by dirt, idleness, and depravity, he is not unobservant, but renders smells, gestures, effects of light precisely, expressing in the end a state of mind divided between love of the cathedral's beauty and horror at the life attendant on it: "The beauty which it possesses is

unfelt; the language it uses is forgotten. In the midst of a city and full of crowds it stands more desolate than the ruins through which the sheep-walk passes unbroken in our English valleys." Better than other large buildings, St. Mark's gives one the feeling of being at home, but Ruskin expresses ruin and loss, potently conveys that something or someone is not at home. It is the speaker who stands desolate, who feels cut off from the happy crowds, but worse still, from the building, bereft and alien in front of its dumbness. He and St. Mark's are lost together, neither understood, neither loved, every communication a failure. He draws his power from including more than he realizes or anyone expects in his appreciation of objects. His absorption in the curves and slides, the flesh of ornamental stone is exorbitant, misplaced, and has the terrible intensity of all necessary acts.

This city he later disowned was the exactly right place for him, patched together like an imaginary castle in a Hugo drawing, all artifice, all meaning, in the most confined quarters, every inch having something to say but difficult to separate from all the others. His task in Venice was the one he loved of disentangling. Picking the spot on earth most overgrown with art, he would find the order that must lie buried beneath. He gave up, of course, before numbering every stone, and by the third volume talks about anything but buildings. Venice throws a challenge to the discriminator, turns away from the seeker for information, scorns the separator of one thing from another. No Venetian architect stands out like the ones of Florence or Rome; the buildings are not Lombardo's or Longhena's, they are Venetian.

St. Mark's is the product of many periods and consists of so many parts that it seems to require catalogue treatment, seems not to be a single subject at all but a rich collection, yet the piecemeal bits are included in so much the same spirit that it makes a great unity in variety. In *Stones of Venice* and *St. Mark's Rest* Ruskin enters it sideways not head on, starting in the baptistery and edging into the sanctuary, a procedure which suits the nature of the building. One can come in a back way, which begins at a moldy portal behind the church on the little canal the Bridge of Sighs crosses, a portal that has the feeling of leading nowhere and suggests in no way the church, which leads through a sordid little yard, suddenly through a dark vestibule into the warm dark church, where one is dazzled by the dark which vibrates with all its shapes and substances. The experience of St. Mark's is a succession of self-administered shocks, which flow together so insensibly that it is also one of swimming, in which our feet have left the ground and the world has so completely covered us that

we move without losing any contact, without paying any attention or performing any act. After letting his eye wander helplessly from brown to gold to green-black to rose, all surfaces yielding softly to the touch, the visitor will try to focus, though it is impossible to think of looking at St. Mark's in an orderly way or of taking everything in. It is not done with the eyes but with the skin, the effect that of synesthesia at both ends, impossible to tell what the sensation is or how we get it. Easy things to fasten on in this night sea are the marble panels of which the walls are made, marble pictures, marble mirrors, queer but so anonymous they fade into each other. Their distinct veinings suggest loose writing or speech, but they are often laid next to an identical slice of marble reversed, a too perfect echo. The variety of colors defeats perception, all within a small range and hard to decide when a sensation is produced by the shine left by the touch of many hands, or the dull surfaces of a water stain, and when by a color. We have already tasted the leather, candy, fruit of this substance when it occurs to us it is only stone. But all comparisons fail because these are not things, but sensations themselves arrested, and held at bay on the walls.

In the house of pure substance, substances become powers of themselves. The acquisitive instinct ordering display so complete, spreading itself so thin, forgets possession in prodigality. If these Venetian effects are not high art, they are at least supreme illusion. At the Church of the Gesuiti almost every inch of the interior is covered with an imitation of flowered brocade in white and blue-green marble, a surface gilding which forms into knots on the ducal box, hung with tassels, draperies, and canopy of stone, and slows and thickens on the altar stairs, where sluggish folds in simulated cloth now deepen to gold and blue-black. As in St. Mark's, this is transfixed accident preserving in a slight motion like breathing a sense that something different lies beneath the surface.

By accident and by design the space at St. Mark's is one and many. The aisles, which used to be separate, have had their roofs taken off, because as windows were blocked up to accommodate more mosaics they became dangerously dark, leaving behind little walkways which weave themselves into the fabric halfway up the wall and make a net of vines. The aisles are now buildings within the building; from outside they look substantial, but stepping in we are included back in the larger space just when we meant to leave it, sheltered by a roof but not the one expected. This is a mock house, a pretense of sufficiency where there is already ample protection. The chapel altars are also houses within

the house, corner posts and gabled roofs making worlds doubly safe. But the most fantastic building in St. Mark's is the larger of the two pulpits. It is supported by a forest of columns or a dense collection of wooden pilings, which the water has revealed but which have not had time to dry, of different sizes and hues. These are surmounted by a balcony continuously bulging and billowing as it makes its circuit, covered by a fanciful pavilion of simple foreign lines, slender columns with four-lobed globous roof, solid like a loaf of bread or clove of garlic. This pulpit is matched by one without a roof across the chancel, to which it is connected by a peculiar screen of posts, each capped by dark half-size figures. This arrangement just beyond the crossing gives a more palpable focus than the great altar visible beyond. The screen stops movement but it hardly impedes the eye, it divides the floor but not the air, the solid medium of St. Mark's. The eyes now inevitably turn to the gold stories high up in that air, which like all mosaics challenge the idea of architecture by covering the working surfaces of the building with diverting scenes, most of which take place on the ground, for except in the central domes the events depicted are not heavenly. All the exercise for the intellect at St. Mark's is far above eye level, and most of the inscriptions are written on the roof. That requiring study is out of reach, that inviting absorption, near at hand. Pictures on ceilings inevitably tell us of our limits, even if no angels fly through them, allegories of the craning and striving of the mind after knowledge.

The hermetic engulfing effect of St. Mark's is the habitual one of Venetian art. Tintoretto's large room at Scuola San Rocco, so very dark and warm with the energy of his imagination, may be thought of as an attempt to create single-handedly the experience of the interior of St. Mark's. Again it is an utterly interior experience, where the blinded soul touches its way to flickers and gleams of truth, a world primitive and direct where in place of walls we find screens trembling with unsteadily fixed images. The breadth of his execution and boldness of his design make an unmediated communication, not in paint but in an electricity which transmits his deepest impulses and bathes the viewer in a darkness everywhere intelligent, everywhere informed with spirit.

In Venice, because all space has been civilized, there is an easier transition from indoors to outdoors than elsewhere. The outdoors is less rich but even more domesticated than the indoors and the essence of Venice lies in this special transformation. Being in Venice is like being in a painting not because of the

mellowing water or trembling light but because of crowding. Serlio's designs for the stages of comedy and tragedy could almost be literal views of Venice, a city which is ideal in a prosaic sense of the word, which like midtown Manhattan makes an impression of a show continuously kept up, with a density of architectural incident found in theater, not life.

A Venetian campo is liable to be the largest enclosure of masonry we have ever been in, loose but different from other squares in being pure composition. Some of the edges may feel not quite planned, but the floor is level, or intended as level, and because every surface in Venice is built, every one has the capacity to fall into disrepair, hence the city's mournfulness, most powerful in moments like this when we are away from the corroding water. The shabby stone fields of Venice have been deprived of something; to get this heightening and clarifying as on stage we have given up half of life, the earth and trees.

The campos are best when they run on too far, when they really are fields not squares, not focused or wholly usable. Though there is less space to waste, unlike other town squares they are genuinely left-over bits of space, so occupied more unevenly and erratically. The pure calculation of paving is undone by accident of wells or buildings thrown up in the middle; even statues in Venice look movable. Verrocchio's horseman on his high pedestal cannot be put in the center of the space beside Zanipolo because there is no center. The square makes a rough L on the front and south side of the church; centered in one leg he would be off center in the other. He is placed just off the short diagonal from the corner of the church to the open corner of the square, but near the church, an arrangement complicated by the fact that the edge facing the side of the church is formed by a line of buildings, and that in front by a canal and bridges.

Statues are more expected in Venice, the natural inhabitants of the all-masonry city, always close enough to the buildings to be measuring rods, an aid in estimating sizes, and they are also intermediate stages, like figurines in painted still lifes, in a tight series of nature and art. Like most buildings in Venice, on stages, or in paintings, the Church of Zanipolo has sides that are never seen. Often when different parts of a building can be reached they do not communicate, and understandably the impossibility of walking around them influences their shape and exterior decoration. The back of the Doge's Palace is visible but not accessible, and land and sea entrances of Ca' Rezzonico are cut off from each other. Like the Doge's Palace this grand house has effectively a front wall and a side wall and so concentrates its architectural

energy even more than the Doge's Palace which makes them both fronts.

Sitting in the Campo SS. Giovanni e Paolo watching the sun go down on the huge unexpressive church and the eccentric inlaid *scuola* now a hospital, we suppose even the weather in Venice deliberate. The light is so continuously making an effect, marking a detail or throwing a nearby object in shadow, that it must be done on purpose, an enhancement of theatrical illusion, lighting, not just light. Nowhere else does simply looking seem the right occupation hour after hour. Vehicles will as soon appear here as they would in Venetian living rooms, the resulting quiet more touching in gray weather and like any sea town, Venice too, but having declared itself for beauty, suffering more than they do. Off season it feels untenanted as no other city, and the few left behind move aimlessly, each one set off, an unhappy example. It makes everyone foolish, everyone sad, sweetens everything, seems an emblem of the mind, or of art, of made things in a losing battle with the world. It has all been known, has all been thought, but now it forgets things, confuses and misplaces them. There are most cities that change and a few that stay the same, like coral skeletons of former selves, whose passages take us where we have been before, lose us, defeat us, ramble boringly, are never quite new. It is easy to lose the way in Venice but impossible to get lost, absently threading corridors too small of one large house, inconvenient but comfortable. Because it is more intricate, it is more private than other cities, makes everyone feel he knows her best. To be alone in Venice is to be alone with every conceivable memory, reminded of everything, answered by nothing. It is weak, it is fallible, its joys are all shams; marble or paint green with mold, it dies visibly.

From unmanageable intensities in its air the visitor retreats indoors for the cruder predictabilities of art, but often meets there the combination of awkwardness and show which has touched him in the streets. The interior of Zanipolo with its rose and cream surfaces, its large supplies of light that fade before reaching the floor, is crossed by wooden struts between all the pillars, and between each pillar and the wall, which if they were not bleached by age and painted with arabesques would look like temporary scaffolding. Every building in Venice is quite believably collapsing, so that heavy and magnificent stone tombs like those lining the walls of Zanipolo produce a mental strain.

But Venetians are remembered as painters not sculptors; it is an easier medium to produce illusions in, something Venetian painters have always frankly done, a process that reaches an

apotheosis at the end of Venetian painting in the eighteenth century. Venetian art achieves an effect so out of proportion to its means that we always feel victim of a trick; it is not serious to like it. By the time it reaches Piazzetta and Tiepolo, subject matter has almost entirely disappeared from Venetian painting and it has become a rendering of atmospheric effect. If we see Tiepolo's ceilings as materialized skyscapes, we will be less troubled by the strange creatures there, half man, half bird. If Venice is the place where we learn that the deepest physical impressions are made by weather, our memories locked and fixed by that element, here we can also see that Piazzetta's single-minded concentration is no more trivial than Turner's, the English Venetian. It is as representers of Venice that Venetian painters have their meaning, and Piazzetta and Tiepolo distill us such pure essences of the city that they are not easily recognizable as landscape painters.

In their efforts to break down or dissolve walls both of them paint not in lines but in colors and come more and more to prefer pastel shades, getting an effect of speed, ease, and transparency like watercolor. Piazzetta uses two main sets of colors—red-brown, green, and white for secular, and blue, brown, and white for religious pictures. He is about colors, their coruscation, evaporation, dissolution, transubstantiation. What makes his best religious pictures purer pleasure than works of greater painters is the perfect liquidity of paint barely regulated by a narrative all flutter of wings and robes, all flush of cloud and pulse of storm. He turns the gloom of his monkish subjects to unreflective glow by letting surfaces look like anything but themselves, letting everything turn rich and thick and full with no suggestion of weight. It stops at the surface; there are no souls beneath the paint, and the apparent feeling is spurious, as well look for it in birds. His lack of edge recalls the malleable Venice, his blue and red-brown are the Venetian colors, and his half-bird figures allegories of the city. Like Tiepolo's his paint, rapid, washy, has the momentary quality of watercolor. In these marine paintings which never depict the sea directly, nature is reduced to its unstable elements, water and sky, and his canvases become more and more unstable until the latest seem painted with a substance even looser than water.

Piazzetta's descendant starts with a superhuman facility of hand which required almost no development we know of, and which allows him to carry Piazzetta's atmospheric discoveries to an ethereal pitch that leaves Turner earthbound. On the ceiling of the Pietà in Venice he has taken Piazzetta's palette lightened

to light blue, siena, yellow, white, and gray, disposed figures haphazardly as in a far-off galaxy, and produced an effect of great energy so impalpable we feel it may vanish before our eyes. Tiepolo's angels—there are dozens of them here—are more birds than people, more matchsticks on a stream than that. His ceilings are expansive and prodigal like the Roman ones but the painting never fills the space, avoiding a true edge, so that his compartments are holes in something solid, not heavy matter in heavy frames. Many paintings on ceilings present figures flying upward but only in Venice are these visions convincingly insubstantial, for only there does a sense of the illusoriness of all existence turn everything to streaks of cloud in the sky.

One of the great uses of painting is to give hints of a place after we have left it, or to teach us about it while we are in it by showing what it meant, tried, or wanted to look like, giving a purified ideal version the reality only hints at. Paintings tell us what to look for in the streets and vice versa, reflecting on each other till the alternation seems the most productive procedure and we follow a closing avenue of comparison, seizing the coincidence more and more unerringly. Canaletto has always had so much of his value reminding people of Venice that his paintings are compared to postcards, of a different Venice from the unseizable Tiepolo's, a Venice all smooth continuance, regularizing its irregularities till all views of it look the same, a potent conventionalization which works better when it can't be checked against the original.

But there are less obvious cases who because they do not paint views or even contemporary subjects are not seen for the local growths they are. Francesco Solimena can be recognized afterward as repeating certain sensations we have stored up as peculiarly Neapolitan, and interprets that confusing place to us better than it does itself. Like Canaletto's all his pictures are somewhat indistinguishable, as if there were a single flavor he meant to convey over and over again. They seem at first even more emptily atmospheric than Piazzetta, types of subject undifferentiated, religious and classical alike thronged with large people in heavy satiny clothes.

Many of his scenes take place partly in the sky, like Tiepolo's, but instead of putting it over our heads he seems to have let it slip under our feet. His angels still fly, through skies dark like huge bruises, but heavily as if realizing their inefficiency, a flight which instills disbelief in itself. They fly because they are used to it, because it would be unthinkable not to, but in this heaviest airborne painter they suggest culture finally unable to bear its

accumulated weight and anxious to set down the burden. Solimena like Tiepolo represents an End when subjects lose track of their specific meanings, and martyrdoms, orgies, and visions convey the same emotion and swamp reason in the same unfeeling way.

For a number of reasons it is almost impossible to remember afterward what the subject of a Solimena is. It is almost impossible to remember this when one is standing in front of it. They are indecipherable not because they are so crowded—most Northern painting includes more separate details—but because they are deliberately decentralized and unfocused. Perhaps inevitably a higher number of figures reduces the separate emphasis, but crowds in Solimena lack main characters without putting in their place the unifying tangle of crowds in Rubens and most other Baroque painters. His compositions are not thrown obviously askew like Tintoretto's; from a distance their organization looks conventional. But heads turn every which way, seemingly at random, figures ape each other's gestures without reason, and the superficial solemnity of the picture disintegrates. Because of this lack of subordination it is even hard to think of him as a narrative painter, his canvases stretched out horizontally to fit in more jostling figures, unpredictable and uncomfortable places, in which by an elementary arbitrariness bodies are not bodies, cloth is not cloth, functions are forgotten and substances come alive. His forms are all of confident grossness and lax amplitude, and his people resemble cows or gourds in their obliviousness; the miles of satin cloth are as intelligent as they are. Something has gone wrong with the light in Solimena, until the wrong things are illuminated and the wrong ones darkened, and we are distracted from grasping the main event by a dog or a servant. We even come to feel that he fails when he leaves his subject easily recognizable, one of his discoveries being the huge resistance of dumb matter to the impulses of the mind.

But the distinctive feature of this very foreign painter is his color, which begins in a studious and perverse avoidance of any freshness, brilliance, or beauty. In the large *Ascanius Before Dido* in London where the figures swell to the edges of the frame and seem the wrong size for the canvas, every color partakes largely of gray, without making the picture dull or dark. In fact it glows unhealthily because everything is made of metal and slightly phosphorescent. He has found a way of making it all the same color, and obtains the bizarre continuity of another substance depicted, of a metal relief intervening between the painting and the event, keeping us from life.

Dark painters always seem stodgy, overloaded, world weary, choosing deliberately the already defeated of the two extremes. Solimena takes a large step further toward darkness than dark pigments will go by using reddish brown like the color seen inside the eyelid of closed eyes, to represent a shadow more profound than black. But the result of this eccentricity is a spectral illumination—because literal pigments cannot convey this depth, his picture is an imaginary version like a photographic negative and may even hold a messenger from the world of light, like a Tiepolo, lurking in it. No more than Caravaggio's do Solimena's scenes take place in a real night, and no more than his do they give any sense of the outdoors. His people are even more dismally abandoned, worn down by sluggish pomp not squalor. A place dark, airless, and vast seems a strange impression of Naples, but Solimena is not far from what the insides of its houses feel like, and dark painting brought by Ribera had a much longer vogue there than elsewhere in Italy, as if dark painters are freakish except in Naples.

Night is not just another part of reality that demands representation too, but an opacity whose meaning we cannot fix very well. Arriving in a new place at night is inevitably potent, perhaps because the visual uncertainty corresponds to our uninitiated ignorance. Waking up and setting off on our first walk in a city seems exactly right too, another way of acting an allegory of knowledge, like K. starting out in Kafka's *Castle.* Everyone needs something to embody mental night, like Germany or the Dark Ages or the two superimposed in Grimm's tales. For them Germany represents a life inaccessible and hermetic which impressions of it will do little to affect, a darkness no amount of knowledge will dissolve, the mind at its most imperious making a single symbol from the diversity of a million lives.

In his anonymous darkened obscurity at least Solimena is a very un-Baroque painter, and night is an unrevealing experience in Baroque cities which they would banish if they could. It is an older type of settlement whose nature is brought out at night, night places to which daylight comes almost by accident, unreliably, like Erice in western Sicily. Like Venice these shrouded places exemplify one variety or another of physical impossibility. It has its two systems, water paths and land paths, frequently untraversable whichever you happen to be using without a major translation, and they are plastic curiosities which each present their styles of difficulty or inaccessibility.

Erice fills the top of a steep hill two thousand feet above the plain below, so it makes a separate world surrounded by the

rubble of fortifications, towers, and castles, like a city built on a tower, doubly a city where a visitor almost expects different laws and money. The accidental steepness of the geography becoming a major part of the building as in Bruegel's Babylon, the houses fitting themselves in like objects in a drawer, very tidily but according to no grand design. Like other preserved towns, consisting wholly of the past, it has shut itself up and is empty. The winds of Erice sweep it clean, no loose unintegrated bits lie around, it is perfected like a Chirico, and made entirely of stone, evenly resistant, seems the work of one maker. At night, deserted, it becomes the empty city of a fantasy, where the monumental buildings assume impossible forms, awkward and imaginary, or display messages for us on their fronts. One church is decorated with flaming stone hearts, either made of pink stone or faintly colored. When we come upon these symbols after a long walk in the dark, hearing only our footsteps, they are felt as an answer, the reflection we need from outside, a violent meaning heightened by isolation among the teasing vacancy of an empty city.

The old upper town of Agrigento in southern Sicily is another abandoned-feeling large construction. In this impossible place there appear to be no streets, or they run only sideways across it, terracing on the slope, and to get into it you must climb endless flights of stairs, all fouled with the debris of weeks. Stairs that go on and on lose their point, not progressive any more but static, so Agrigento becomes the hardest city to enter or leave. When we reach the top we are met by a cathedral that looks like a warehouse, has its own long flight of steps, and is boarded shut. The nonexistence of the city somehow gives it piquancy, makes its garbage marvelous because it is the only sign of life; where there is fresh decay there has recently been activity. Terrain again plays a crucial part but unlike Erice, Agrigento itself goes up the hill, creating ranges above us like a series of parallel towns we needn't know about. Because they are so disjunct, the obscure vertical and clear horizontal paths make two hermetic geometries, and appropriately it is impossible to find a full map of this warren, which if it existed could only posit delusive coherence. The people down below advise one to stay out of it; they have turned away from this nearest approximation in the actual world to the half-empty settings of Kafka. A Baroque city would still express its intentions when deserted, but empty spots in Agrigento make vacuums not clearer geometry. This abandoned city is more perplexing than an abandoned house because it suggests the whole community is a single organism.

Some places like Siena are organized to make this point.

Siena drags one more actively and persuasively into the past than the Sicilian towns. It is built on hilly ground around a semicircular square sinking sharply toward the town hall, an eerie constructional effect which creates a space like the cradle of a huge hand, and from surrounding streets the finger of the spindly tower framed between buildings beckons imperatively. Outlying streets follow the curve of the square so that we glimpse it again unexpectedly when meaning to head away from it, and are brought back to the same place by a soft persuasion. Siena tolerates other irrationalities of design imposed by the terrain, which occasionally lets parts of the city be seen inaccessible and near across a sharp ravine. Such hindrances would be the final obstacle to a Baroque replanning of Siena if the town hadn't already wrapped itself by a persistent winding pattern into its ground.

Other cities have curved streets but nowhere else do they feel as confidential or as yielding, nor do circular city plans usually overwhelm reason this way and work odd magic. Vienna, which was deliberately remade in the 1860s, uses the symbolism of the circle extrinsically in The Ring, which puts a protective shield of monumental boulevards around the heart of the city, replacing the old walls. In the space gained from the demolition of fortifications were erected museums, a Parliament hall, churches, theaters, as if in an attempt to intellectualize and civilize the old idea of communal circle, a plan civic-minded in a way that could only have occurred to the nineteenth century with its reliance on education. We try to animate the idea every time we see the word *Ring* (most tramlines have part of their route around it, each small segment named after a different imperial personage), but this ring is too large to be seen whole. It is mainly a way of orchestrating traffic, the center preserved inviolate from trams which radiate in all directions. It gives a flexible, adaptable way of approaching the center since there are always at least two routes to any point inside, and holds up always the idea of the gemlike core.

Nineteenth-century reimagining of capitals like Napoleon III's Paris and Franz Josef's Vienna had a progenitor in Baroque Rome. Redesigning an already existing city is an imperial act, like a territorial dream enjoyed at home, an imposition from an aerial region of the mind. It is as if the Baroque planners had come in from another sphere, not understanding all the knots because they had never known them from ground level. They are outsiders who see destructively of habits, and their plans have a common tendency to rationalize and clarify, not to mystify, the awe aimed at arising from evidence of physical power. The oddity in

Rome is that the points connected by the boulevards are the basilican churches, an imperial pattern imposed on the shrines of early Christianity, but unlike Renaissance planners those of the Baroque throve on the clashes and contradictions of forcing their huge figures down on messy existent tangles. In Rome these processional ways came into full glory only when used for some grand progress, the arrival of an ambassador or the Pope's or-dained tour of the shrines, when the streets made his pilgrimage a triumph, gave a military welcome to a religious leader. Rome is naturally fulfilled in the Baroque, as unlike Venice it started with a classical base, waiting for another imperial style to com-plete it. But when it comes, the style of seventeenth-century potency in Rome has always something of playacting about it.

Noto, a small town in southeastern Sicily rebuilt in a new location after an earthquake in the seventeenth century, shows more clearly than Rome what the initial difference was of rational Baroque planning from the incommunicative, unviewable world of the earlier towns. It feels as if space has been discovered with the opening of vistas which present an immediate challenge: they must be filled with gestures worthy of the theater. Unlike medi-eval cities Noto calls for admiration, confidently assumes it can show us things worth looking at. It is a city on display, but only a village aping capitoline gestures. The Baroque makes every city a capital, and when the streets remain asleep as at Noto, it feels more a plan than a city.

At Rome the theater was finished by the end of Sixtus V's reign in 1590, and his system of avenues and obelisks is essen-tially the one that remains today. The greatest Baroque dramatist, who took fullest advantage of the new opportunities, was Gian-lorenzo Bernini, whose work is neither sculpture nor architecture, but something that combines them. His grandest project is also his most indeterminate, crossing the most boundaries. Over a period of fifty years he made various improvements at St. Peter's, which begin quite far from the church, on the bridge crossing the Tiber, where Bernini has spaced six figures of angels carrying instruments of the Passion. Sculptures on a bridge are hard to view discretely because they combine with the air and water, the traveler's motion puts them in motion, and they orchestrate space more architecturally than sculpturally, but with unarchitectural animation. Much farther on, in the huge colonnade reaching out from both sides of St. Peter's, Bernini turns architecture into sculpture by using the four series of great columns that move in a gradual ellipse to break a wall into constantly shifting activity. Though they are all the same, from inside they feel all different,

less uniform than the parade of statues across their tops. The immensity of the interior oval creates an abrupt clash of perfect vacancy with the density at the edge, and to the pedestrian under the colonnade, crossing the huge space by circling it becomes interesting minute by minute because Bernini has broken it into a hundred separate views.

His next effects are off center, the Scala Regia at the end of the right-hand colonnade, and the statue of Constantine, only visible from a door at right angles to the stair on which it sits. By ingenious lighting and framing he has made the stair longer and straighter than it is, an endless steep ascent. The Constantine is almost just sculpture, except that the point of the pose is given by the theatrical light flooding the emperor who starts back on his rearing horse at the moment the sign appears in the sky. A large jagged drapery behind him takes the imprint of this sky, expressing the crisis by its slippage, an artificial background which organizes the scene into a single violent emotion. The rake of these surfaces in concert is finally made plain by calculated natural illumination, so as always, Bernini's visionary experience is rooted in the physical, expressed in disturbance of rich hangings. Thus far, in what is meant as a temporal system, his effects have been intermittent, clouds parting unexpectedly for supernatural glimpses. We feel privileged if the doors on these sights happen to be open, but when we enter the church we are no longer in the world of accident.

Here the eruption of regal color, purple, gold, and gray, and concentration of ecstatic forms at the far end make the theater that has gone before look sober. In the Chair of St. Peter, Bernini overwhelms the viewer with a rush of precious materials and novel conglomerate forms, a vision almost impossible to view analytically because firmness moves into softness, metal into plaster into alabaster, earth into cloud. Four fathers of the church in agitated robes stand on gorgeous marble bases in a loose square, staggered so that the front ones only slightly overlap the two behind. They appear to support a fantastic throne of scrolly curves that yet seems solid and dependable, all its flat surfaces enriched with scenes and garlands, but they are attached to it by streamers and it floats in air. Gilded clouds peek out beneath it, surround it, and turn above it to a throbbing halo of cupids and angels around a dove in a burst of alabaster light. The light is continued above and at the sides in glittering spiky rays of gold, and the heavily populated mass fills the end of St. Peter's from floor to cornice with its disturbingly irregular but symmetrical outline. It is not architecture, or sculpture, or an altar, or a chair,

or a reliquary; you do not ask questions of it but simply succumb. The fact that it contains pieces of the old chair of St. Peter encased in its bronze one seems an irrelevance before its total and orgasmic magnificence. But it is a visionary event thought out too much in riches, more like opening and emptying coffers than an intimation of heaven, a flood of coins from above. St. Peter's is palpable in the wrong way to express spirit, here wealth never loses its intimidating power because displayed so untransformed in gold and jewels, and consequently the excitement it produces is more like greed than aspiration.

The series of Bernini's works at St. Peter's, including the Baldacchino, tombs, and decorative elements not described here, is to be seen as a system, parts that by a centrifugal, swelling motion produce an overpowering field of magnetic force. None of his improvements is really structural; he is not to be confined in buildings. He uses a range of materials and techniques to integrate a whole environment, which makes his art the great example of overwhelming by design, producing deliberately the dynamic effect cities have always produced by accident.

Bernini's great rival Francesco Borromini is as secret as Bernini is public, sharp as he is fluid, pure as he is impure, chaste as he is riotous, contriving with a somewhat similar vocabulary utterly divergent social and psychological results. A visitor to Rome cannot miss Bernini, who in some sense is Rome, but he can easily miss Borromini, whose equivalent of Bernini's colonnade is reclusive and difficult, a strange joke in a private house. In waste space at the Palazzo Spada, a blind alley between other people's property, he has made a perspective passage, narrowing toward the back and lined with columns of diminishing size. The classical statue silhouetted at the other end of this dark tunnel appears to be lifesize and over a hundred feet away, but as we approach along walls insidiously coercing, it shrinks or we grow and find ourselves at the end aroused with no place to turn, everything a quarter the size expected. Borromini's illusions are both more pointed and more baffling than Bernini's.

His grandest massed effect is not the partial renovation of St. John Lateran where he hoped to rival St. Peter's and was curtailed, but the small and secluded university chapel of S. Ivo. Many of Borromini's projects were done for convents or monasteries, private places, and the results are often flamboyant misfits, uneasily settled in city streets, teaching with their high drama the hard lesson of another world. He interprets the cheapest public imagery—family insignia and coats of arms—passionately and mystically until it becomes the propaganda for his private coun-

terworld. When he builds a chapel for the Sapienza he takes the name seriously, and in S. Ivo produces a small but unimaginably complex building, a masterpiece of concealment.

In place of St. Peter's barely focused oval, the court before Borromini's church is a narrow rectangle, walled in, with a small door at the opposite end. The concave narrow side shields the church whose convex dome rises immediately above it, the effect of which is to trap the building in an alien substance; its edges cannot get themselves free. The dome cannot be recognized as a dome from outside but simply as an irregularly bulged wall with a large cornice on top. Above this is an astonishing construction, a lantern which has shot up in a spiral and equaled the dome in height, decorated along its edges with flaming torches and frequent knobs in lighter stone, and on its surfaces with large carved jewels in geometric frames, all exuberant but not luxurious, Borromini preferring to represent riches in cheaper, sturdier materials. On top of the steep spiral is a jagged crown of flames, on top of that a solid ball and large cross. This freak is not visible from the street in front; the only outside view is from behind, where like towers on other of his works it tantalizes because we cannot see how to get to the building it goes with. Naming the parts falsifies our experience, for the warring elements coalesce in a nervous ecstasy; no one would think this was a dome with its lantern, so clearly the only thing of its kind.

Borromini is flamboyant outside but entirely different within, insides and outsides discordantly expressing a division in man and the world. The magic beanstalk or mushroom sprung up in the prosaic court does not prepare us for the smallness and purity of the inside, where every surface is painted a dazzling white. It is a house of thought in which the decoration begins high up, at eye level severely empty, with niches that have little overhanging lips to sharpen the shadows at their edges. Every edge here is as hard as a line in a drawing, like other designs of his, beautiful in floor plan, making satisfying figures. This is a gorgeous six-sided crystal in which semicircular extensions alternate with triangular; a triangle imposed on a circle, a mystic insignia. Because it is based on threes we can never get a sense of correspondence in the church, for if we are standing in a circular alcove, a pointed one will be opposite. The perfect figure makes the visitor uneasy, who keeps trying fresh positions looking for one that matches, calculated frustrations—the sense of being off center and beneath the realm of excited activity in the dome—which act as spiritual rebuffs and trials.

Unlike Bernini, Borromini often gives no sense of using ma-

terials at all, and in S. Ivo his medium is a colorless transparent one from which his slightly abstract imagery shines out. All his buildings are decorated with the same enlarged and simplified stars, crowns, palm branches, and angels, with mountains and oak wreaths added at S. Ivo because they occur in the arms of the Chigi Pope. His versions of these symbols express their extravagant meanings chastely and sparely. They are all spearlike pointed forms, only once, in the spiky crown at S. Andrea delle Fratte, vivid reminders of the tortures of martyrdom, usually a calm spiritual poetry like Henry Vaughan's. Borromini has found a unique level of language, more independent and informative than decoration, more impersonal and pure than sculpture. His radiant images transcend their materials and float free in the mind, closest things in the physical world to figures in poems. The strain in his buildings is felt when the mysterious symbols are plaited through tormented structural motifs, as at Propaganda Fide where wreaths and garlands are fixed in portals that look like bodies turned inside out, the joints painfully reversed, bones about to crack. Or when sizes unexpectedly change—at S. Carlino the inner rim of the dome is a huge silhouetted martyr's crown of alternating spikes held over our heads.

Borromini's most openly expressive images are the winged angels' heads wedged into corners or triangular spaces at the Lateran and S. Ivo, or used as herms supporting a tower at S. Andrea and in his unexecuted design for S. Agnese. Bernini is also enamored of this motif, but uses it more naturalistically. From his domes and altars float down staggered lightning flashes of cherubs' heads swathed in plaster mist, filling the air with delicious presences at a moment of extremity. Bernini's heighten a rapture while Borromini's remain fixed emblems, surprising not for their absolute mobility but for rational profusion. At the Lateran our eyes sweep down two long rows of them, repeated in the right angles of every aisle vault. Like all Borromini's symbols they are too large to be illusionistic, unless they are overbearing powers from dreams, and he wants to provoke thought about them, not provide the right company.

Bernini's way of representing spiritual experience is full of contradictions, felt clearest in the famous St. Teresa which sags with utter nervelessness and yet is borne aloft. Her right foot presses naturally into what is supposed to be cloud; her left foot hangs off the edge as of a bed. Comparing the poses of angel and saint to remembered ones of Cupid and Psyche, we feel the relaxation of these creatures who undergo an unstringing as if about to pass out of definition entirely. Yet there is nothing vague

about the modeling. His forms do not swirl, but give way in a vibration of jagged, flattish patches which mimic lightning, not plant forms, so ends of lines are only temporary, and their current diffuses itself further, less visibly, in air. Borromini's forms are dry ice, Bernini's loose electricity. As a representer of mystical experience he is closer to St. Teresa than Bernini is; his thirsting geometric visions burn themselves more durably onto the soul. Bernini creates overwhelming effects here and now, but Borromini strains beyond the bounds of substance after the ineffable.

As Tiepolo is the natural place to leave Venetian history, Borromini is the place to leave Roman, unless we take it up again when foreigners scavenge it for the material of their neoclassical visions over a century later, when even Piranesi sees it as a foreigner, deliberately distancing himself, dehumanizing and disinhabiting it. Bernini represents a kind of perfection to which Borromini replies with a countergesture, which paradoxically advertises privacy. Because Bernini has used up all the space, he who comes after must squeeze himself in, presenting his ideas in a space too small or the wrong shape for them. Of course he relishes the triumph over these invented obstacles and becomes in his own way another imaginer of grandeur. But this brief examination of the grand style may cause us to reflect on how relatively short-lived communal visions are, depending as they do on combining energy and assent, and to wonder too if grandeur rather than true sublimity isn't the natural mode for them.

Chapter 5
Books of Things: Architectural Fictions

A strong concern with
architecture signifies in fiction as
it does outside a concern with protection,
a desire for established existence and a home
for consciousness. If we take *place* in the narrow
sense of a physical envelope for the self, and consider
the books which try to provide as literal a shelter as possible, we
trace the specially spatial imagination expressing itself in words
as it does in buildings through a desire for the reassurance of clear
definition, pointing always to the finality of the tomb, a form
which appears in many of these books. Unlike more imaginary
art forms, architecture boldly does something and books centered
on buildings feel they have made a more definite assertion than
another "what if?"

Prose architecture is usually built by builders more like Bor-
romini than Bernini, though the temperaments which build
buildings and those which imagine them in prose are perhaps not
the same at all, since those of the second are generally hermetic
and unsociable, and fictions focused on buildings often seem to
use them as a code by which to bury their main meanings.

The order of chapters implies that the imagined buildings
embody a more advanced kind of thought, which can be granted
by remembering that it is always a parody architecture like the
architecture depicted in paintings, like other imagined art which
draws a cooler attention to itself than imagined experience. This
easier kind of building satisfies more quickly, signaling if not
disclosing its secret more immediately than actual buildings, al-
most inevitably romanticizing even if it clarifies the architectural
categories of empty or full surfaces, inhabited or deserted spaces,
by showing architecture in more perfect use than can be met in
actuality, imagining just the right life to go with it.

A writer places a building at the center of a book in order to provide the scaffolding of automatic organization, for adventures in adjacent rooms hang together by themselves, and the overlay of much in the same place achieves intensity unattainable in the picaresque. The idea of keeping all the characters prisoner in one lonely spot, epitomized by the patient world of *The Magic Mountain,* depends perhaps on a decadent indoor sense of form, the book an invalid condemned to repetitions, immobile as a dying fire is.

In the earliest examples architecture seems the device of a writer anxious for something to hold on to. The faith in geometry leads to a magic of spatial arrangements, in which life's difficulties will be solved by positioning things properly and making prescribed movements. The Gothic novel is a spatial riddle where the heroine must guess the proper alignments, where villains work spatial malice on her, where being locked up turns out to have been a useful step in the process, a trial for the solution.

A fifteenth-century Italian prose romance, *Hypnerotomachia Poliphili* by Francesco Colonna, the purest novel of automatism before the twentieth century, puts objects at its center, externalizes itself so thoroughly that the main characters are buildings and the book an itinerary. Here the story forms an excrescence on its attempt to be pure mechanism, and the human character only offers a convenient way of moving from station to station. Colonna's narrative is written in macaronic Italian dotted with Greek and Latinisms unheard of before or since, to which the nearest English parallel is Corvo's *Don Renato,* and feels literally unreadable in a way of its own, in the original or the Elizabethan partial translation by R.D. But to say a book is unreadable always exaggerates its difficulty without describing it. Because their writers concede little to the desires of the reader, the books of our category are markedly self-defeating and most of them appear at some point unreadable, registering extreme after extreme of self-indulgence.

Colonna's dinosaur title could be rendered *Poliphilo's Love Struggle Told in a Dream*—the Elizabethan version is *The Strife of Love in a Dream.* It is a dream related by the dreamer who falls asleep at sunrise after a night of sleeplessness, wakes in a mead, gets lost in a wood, and tired again, sleeps again to wake in a lusher place, when his purely architectural adventures begin. The tour of the monuments follows a logical pattern but is presented with such subjectivity this is obscured. Poliphilo meets a wolf succeeded by a strange construction in the distance, and as he gets nearer makes out a large cubical porch topped by a pyramid of

1,410 steps on which rests another cube supporting an obelisk bearing a winged metal statue of a woman which makes a tinkling music turning with the wind, and though hundreds of feet in the air appears of normal height. Around its base are exquisite toppled fragments grown over by weeds whose species he enumerates, and then suddenly he is on the second level, at the base of the pyramid, unable to make out anything on the ground, afraid of the height but protected by a metal railing. Now he enters a large Medusa's mouth surrounded by artificial hairs mixed with jeweled snakes, and climbs by spiral stairs to the base of the obelisk where he finds the architect's name and learns that the monument is dedicated to the sun. The reader adjusts to the pace with difficulty, continually mistakes his position, often anticipates the end of the journey. Suddenly Poliphilo retreats to the ground and becomes absorbed in reliefs on the lowest level, enters the porch to make an echo with his voice, then moves to the deserted hippodrome in front. In no book are the experience of it and the summary so unlike; we have practically no sense of accumulation or of anything being illuminated but the ground directly beneath us, for darkness immediately descends on the rest.

Now he hears a peculiar moaning and distracted toward it, enters upon his next adventure. The moaning issues from the mouth of a fallen bronze Colossus whose head rests on pieces of marble as on a pillow, a noise made by the wind finding its way into rents and tears in the bronze. Poliphilo pulls himself up by the beard of the figure, stands on its chest, then descends by its throat through the journey food takes, noting frequent inscriptions in three languages labeling the interior parts. The bowels are lit by many "loopholes and wickets," and Poliphilo finds that nothing which goes to make a man has been omitted. He had imagined the giant was lovesick and coming to the heart inscribed with explanations of the disease of love, frightens himself with sympathetic groans that resound through the bronze body; outside again, he notices a female companion figure modestly buried to the neck and unvisitable.

He turns next to an elephant on a pedestal nearby, surmounted by another figured obelisk, made of obsidian speckled with silver and gold, and entered by openings and stairs in the base and body. The cavern is lit by hanging lamps and occupied by two sepulchers with nude figures on the caskets, a man's at the tail and a woman's at the head. They hold shields inscribed trilingually with dark clues to their mystic meaning as respectively flesh and spirit. Outside again, he catalogues the images on

the obelisk the elephant carries, one of many descriptions of carved scenes in which the reader loses track of whether Poliphilo is describing a temple portrayed in a relief or one he is about to enter.

In a temple he decides wishfully is a temple of Venus, he meets a dragon instead of Venus and flees by an underground passage which exits to an outdoor fountain animated by streams of water from the nipples of a nymph discovered by a satyr, a sight soon followed by the approach of nymphs, who are received by Poliphilo without surprise as if he knew it must happen this way. They take him to a luxurious bath decorated with carved dolphins under the water and marble children half submerged, whose pool is being filled by a carved putto pissing. When Poliphilo puts his foot on a certain step the child raises his prick and squirts him in the face. After he bathes with the nymphs they exercise each of his five senses in turn, and enter a garden containing houses and passages made of trees. After a feast and many washings in the palace of their queen, a storehouse of images and precious substances with rooms entirely covered in pictures, they return to a maze whose hedges are separated by waterways instead of paths and undergo emblematic trials culminating in a series of triumphs representing the various loves of Jupiter.

In these later parts of the book Poliphilo begins to have hallucinations of his beloved, decides in the end it has been Polia all along, and makes an ecstatic confession, to be told he must wait. Now he and she are led through a sequence of ceremonies and love rites—after sacrificing in the temple of Venus they visit a ruined temple in which they decipher dozens of epitaphs, are taken in a boat by Cupid to the island of Cytherea to visit a large amphitheater and finally the sepulcher of Adonis. The book ends with a request that Polia tell how she fell in love. In the much shorter second book the lovers exchange the stories of their past lives, Polia crowns Poliphilo, disappears, and he wakes to lament the end of his dream.

Hypnerotomachia is an extended experience of emptiness, a demonstration of how unconsoling art can be. The early parts convey this undiluted, but even when the scene is peopled the book is all outline and no shadow, presented with an extreme of explicitness peculiar to itself and literally superficial to a baffling degree. It illuminates the connection between architecture and other rigid stony realms—ceremony, luxury, code—and between all these and loneliness, for it sees architecture as the art of loneliness, the record of atrophied or undiscovered functions.

It provides the gloss or key to many mysteries, a prime docu-

ment for understanding the Renaissance attitude to artifice, and the Romantic conception of architecture as the most interesting art, which converts it from social to private, pre-personal, mythic. Though the book is a grammar of ornament, constructing machines which combine in one assemblage every possible decorative motif, Poliphilo surrounded by things is looking for some other thing which is not there, like the Homeric moly, which modern writers never mention. Even vegetation is wrong in the modern world, so he asks to have the past back physically. All the tedious precision about objects described, dimensions and details of materials, intends to give the reader the illusion he could reconstruct them himself, and tries to win for the book the authenticity of a recipe. Dreaming the fantastic is not enough; it must be lived. Everything is objectified to be fixed in the memory, and the objects are memory devices, automatic history as characters are not. Intense fear of loss or forgetting makes the fixing itself a central act.

But objects can be felt as unrealized potentialities and hence as suggesting action, so a space can mean a journey, a height a climb, or a fountain a bath. The fictional Poliphilo only begins to realize the possibilities in the physical environments of the book; perhaps prodded by his essays we are intended to separate each of them for further meditation.

It is a book offered in place of a building, a book trying to approximate stone as closely as possible, a carving so inhuman we hardly know if it was done by a living hand, and Colonna is one of the rare writers who might have preferred building a large ruin garden to the writing of a book, who has written a book someone might dream of carrying out entirely in stone and shrubbery. Building a series of buildings like this in prose breaks down our belief in objective and subjective as distinct categories. To see the solidest art become pure whimsy tells us there is no limit to what the mind can impose on the world once it has summoned the courage to do it, held back now only by the fear of seeing its thoughts too clearly.

Colonna's environments are pure expression of personality, ideas hardened like the shells of sea animals, which make their intentions permanently visible, in shapes fantastical but firm. All the expanses are still the trap of the self. *Hypnerotomachia* tries to strip consciousness bare, and concoct a story about nothing but the soul's own feelings about itself. An effort this extreme to reach essential principles ends as a journey without coordinates, without anchor, without end, an impossible story to tell. In the psyche there is no motive and no morality, simply creation and

destruction, life and death. Colonna's objectifications tend to unreality; his furthest, ultimate objects, jewels, which though natural are beacons of artificiality because so condensed and pure, haunted the late Renaissance as we can tell from Bronzino and Elizabethan portraits. Like the philosopher's stone, jewels might be the idea of result itself, the conclusion to a search or process. Preciousness, always small, is simply final.

Writers of this sort make both art and religion into things, cling to suggestions of the palpable in spiritual realms. Colonna, Pater, Corvo, failed priests, give their books the shape of irreligious ritual, the form of religion without the content. The final recourse of lonely subjectivism unwilling to give up its isolation is an architecture careless of materials, the ritual framework of neurosis. It ends by claiming that all life is in mechanism, in litany and ordained sequence.

They depend so heavily on other works of art for their inspiration because they doubt the reality of the world outside themselves, and their works are dreams because that is how life appears to them. For Pater or Colonna these historical and psychological artifices are purest conveniences, entirely suitable. When a work of art is not a thing the reader has already handled, as it is when Pater makes Apuleius' fable or Ronsard's poems into characters in his drama, it is at least an individual with little suggestion of a class, automatically unique and fully determined. The work has in some sense been done by the previous creator, so all the present writer need do is put a border around the object. This timidity needing the work half done characterizes all criticism, but also more independent-seeming work, for after all, writers do not invent their material, nothing can come of nothing. In the illustrations to *Hypnerotomachia* carved scenes are recognizable by an extra border within the outside edge, which is the limit of the substance they are carved on; in other respects they exactly resemble the doings of Poliphilo and the nymphs. Deciding where to draw the borders is a large part of any artist's act; now contemporary painters realize that a border by itself ordains the work and produce minimal constructions which meet the requirement in the most grudging way. Most of the illustrations to *Hypnerotomachia* depict works of art of one kind or another, and blur toward becoming the work when they represent epitaphs or inscriptions filling the whole page, only distinguishable from other pages of type by the mockery of a jagged stone edge which has deprived us of some of the words. But they can be read like the other pages of the book with the difference that we cannot go on to the next one in the usual mechanical way. This device

turns a page of print into a thing, a jewel, a special crystal distin-
guished from the adjacent anonymity, and makes us imagine a
book which would have throughout such authority, which would
always be image as well as word, never relying as books do on
the reader's powers of materialization.

Hypnerotomachia conceives of the work of art as a machine,
an artificially animated thing which goes on doing work. This can
be a metaphor, as with scenes which pose a riddle, inscriptions
in strange languages with pieces missing, or monuments which
need to be climbed, but the idea is increasingly literal as the
works described become more Cellini-like and ingenious, reach-
ing an apotheosis in portable fountains connected with the natu-
ral function of eating. The work which musical weather vanes,
spraying statues, and revolving fountains do is seldom very use-
ful but nonetheless real. They take simple materials like wind or
water and elaborate them beyond recognition until they are fixed
in artifice too, the purest kind of machinery, whose only object
is to civilize the natural world. At the feast the series of three
traveling fountains, essentially wheeled vehicles with water dis-
plays for passengers, makes the meal into a procession, trying to
set in motion a naturally static event.

They are more exquisite and perform more startling transfor-
mations of vegetable forms to gold, crystal, and coral than
outdoor fountains which need concern themselves less with
representing the plants they are in fact surrounded by, as if to say
that indoor gardens are the only ones worth the trouble of con-
ception. The fountain in the courtyard of the palace is more
inventive in its manipulation of water, consisting of six stages
described in ascending order (against the flow of the water) which
should not be read consecutively but treated as separate parts if
they are to stay unconfused. Only the illustration puts the parts
together—without it, as so often in this book, we cannot form the
pieces into a whole. Basins and sets of figures alternate, the fig-
ures in metals and the bowls in stone. In a large bowl stand three
harpies supporting another bowl in which sit six dragons, on
which perch three Graces from whose six breasts come streams
hitting the dragons' heads and making them vomit it forth. Be-
tween them and beneath them are six lions' mouths which partic-
ipate in a second system of water originating at the top in the
goddesses' three horns. Relations here between human, half hu-
man, and animal form an intricate society of which the implica-
tions would not soon be unraveled. Such fountains usually
diagram an idea of man's place among other kinds of life, and of
relations between the monstrous and the normal. They are self-

sufficient worlds more alive and energetic than life, whose energy comes partly from the act of transposition itself, living things turned to the most artificially prepared and polished materials, freshened by killing them. Replacing flesh with metal or paths with water reverses in both cases our expectations, means our relation to reality must be rethought, instead of reawakened by a simulacrum.

The giant metal man abounds in riddles of naturalism: is it more naturalistic to have him talk through his mouth than it would be to have the moan come out his feet? Poliphilo fashions the whole emotional meaning of the figure from the accidents of time—decay has made his legs look like a sick man's with the flesh falling off, he has toppled onto fragments which support his head like an invalid's, and the wind is the sound of someone dying: the weather has made a pitiful story out of an unfeeling statue. Poliphilo pulls himself up by metal hairs, so the feature most impalpable, ephemeral, and difficult of representation now becomes the functioning part. The figure seems more real to him because of the explanations written on him, and though it is a great help to find windows in the intestines, this is a feature of buildings not of bowels. But here base concessions give us pleasure, and practicality seems a flash of wit when we have been maneuvered into this strange corner. The episode brings into the open a mystic meaning latent in many buildings, by seeing the stones as a living human body, but perhaps like some of Freud's theories this emergence spills the beans once and for all and is unrepeatable. Like other elements in the book it is too good to be true, too complete a disclosure.

In *Hypnerotomachia* both statues and men are approximating a kind of living machinery. Poliphilo is made to exercise his five senses in order and finds it arousing. Becoming conscious of the body's capacities is a kind of mechanization which leads to pleasure, which is itself viewed mechanically. At that moment the dangers are vanished instantly by feeding him a certain herb. His progress consists in being handed on from one object to the next, like taking on a series of mechanical identities. Many things lead us to conclude that machines are usually not appliances but identities, more satisfactory selves correcting discontent with the body, by which man means to replace himself, exercises in self-entombment more impressive than their devisers as the various monuments are than their visitor. Poliphilo may find his sensation of emptiness wandering among the shrines delightful because like other tourists he takes it as a sign of really final experience about to begin.

Hypnerotomachia has provoked mechanical esoteric interpretation and been supposed a disguised alchemical treatise. The most rigid buried scheme in it is the pattern made by the first letters of the thirty-eight chapters, which spell out *Poliam frater Franciscus Columna peramavit,* a mockery of usable architecture or true coherence, an illegal sentiment scribbled in such a dispersed and disjointed way that both the risk and the point vanish. Instead of systematic arcane meaning, these hints point to Colonna's peculiar feeling for sequence: he deliberately avoids a comprehensive view and takes one step at a time, making his book unreadable because so entirely occupied with the present moment and unconcerned with consequences. Thinking in distinct moments is translated into images that look like layer cakes, a visual version of the pure *and then and then* structure, a vision which is most peculiar when applied to people. So when Poliphilo meets Polia he begins describing her costume rather than her person, taking it feature by feature and giving it the formality and regularity of jewelry without the full luxury. Clothes are exciting because the flesh quivers under them, but sublimation has become itself delightful and her dress impossibly complicated, composed of endless parts and many materials. Ecstatic culminations are reached in the jewels decorating her breasts and in the intricate knot of her hair. This is the apotheosis of seeing in parts, increasing his wealth by subdividing it finely until he has many Polias, since all these parts belong to her, and her wardrobe multiplies her power. The nymphs have earlier made a joke on his name as perhaps the lover of many instead of the lover of Polia, and this writer is certainly the lover of many who manufactures series, who feeds himself with course after course, creating a meal in which there is not one dessert but five. His book consumes inventions rapidly, supplies more parts than can possibly be required, like the three elaborate fountains brought in at intervals so the guests can wash their hands. Colonna imagines an unending supply—surfeit in which each new toy is quickly replaced by a newer one—and trying to imagine a book that used up characters as this one does objects brings this home to us. Like art covered with writing, such surfeit suggests there is no end to the succession of ascending thoughts we can have, the mind pursuing its dream of coherence on and on in diminishing congruent boxes. Yet all these piled sweets hang together very badly, speak a disintegrated consciousness and a more jaded fiction than any other. Writers like these who concentrate on architecture seek reunifying images to solve their own fragmentation, and art made

of art discloses a more desperate rather than a more etiolated search for order, invokes its rigidities to cover its teetering.

The institution which corresponds to this manner of thought is a parade or procession with its constantly shifting pageantry. The four triumphs with scenes of the loves of Jupiter are examples of an established series with a certain number of slots to be filled each time. Each car is described in the same order: wheels, car, scenes on sides, animals drawing it, trappings, riders, tableau on top. It may be wondered how a book about the unconscious can be capped by the hollow rhetoric of public ceremony, by triumphs not even progressive as they are in Petrarch. But from other sources we can guess this kind of public symbolism might have been felt as psychodrama, a way of sending dreams through the streets. In one of the last appreciations of such festivity, Goethe's in *Dichtung und Wahrheit,* the spectator is able to rationalize his awe at the walking myth, the tale from Grimm reenacted in the present. Dreams can be the most polished and affected literary form and extreme artificiality the mode for unrealized meanings just because they cannot be integrated, because they are alien and extrinsic to the conscious self yet uncomfortably captivating. So they are seen walking by slowly at a distance, as if closed in the trance which the spectator suffers. When Colonna offers something else in place of what we expect, a jeweled vessel in place of a tableau on the fourth car, he does not say so, but assumes we know it already. A writer painstaking and elliptical acts as if we have prior knowledge; things do not need to be explained, only recalled, one of the methods of vision, revealing a maker enraptured by his dream. It never occurs to him the reader lacks the connections in his work without perspective where Poliphilo sits absorbed in a monkish fantasy of reassuring classical parallels with Polia forgotten beside him.

Just as the woodcut illustrations of 1499 have overshadowed the text ever since, the nearest parallel to Colonna's book is not literary but visual. The Tempio Malatestiano at Rimini is like *Hypnerotomachia* a shrine of profanity, made from a Gothic church which becomes the gnomic hiding place of a cult. Its echoing scenes are carved in low relief which emphasizes whimsy at the expense of solidity, forms in the cold gray stone clear but carved from darkness, the fine surface complexity concealing what lies inside. Imagery in *Hypnerotomachia* gets increasingly dense, and the materials more precious until we are overloaded by the same things exemplified again and again, more and more dazzlingly with perfect security that we will not guess the creed which fits the ritual.

All our difficulty in this book littered with things arises from its having just one character, a central consciousness which vanishes for lack of comparisons. Gérard de Nerval felt it to be an archetypally Romantic work, autobiography elemental and intractable, and it bears a surprising resemblance to another type of fiction subjective verging toward solipsism where the whole world is a set of emanations from the heroine, the Gothic novel. *Hypnerotomachia* is the architectural framework for a Gothic novel without the heroine, a sea shell without the creature, a city without inhabitants. A deserted world or ruin is the most egoistic piece of imagining possible, the world left behind for the self alone, and Gothic novels differ from earlier subjective fictions like Sterne's and Rousseau's in wanting to freeze or institute the feeling in some external form like a castle or a landscape. Colonna is purer and more self-absorbed than they because he gives the things without appending explanations. They provide elaborate glosses, instructing the sensibility how to react, and letting interpretive footnotes outgrow the sources. Mrs. Radcliffe has pillowed the ragged edges of *Hypnerotomachia* in the surrounding vegetation of Emily's reflection.

Gothic fiction is now remembered by its mannerisms because most readers know it from imitations or parodies like Peacock's, Jane Austen's, and Shelley's. If *Hypnerotomachia* were to spawn a class of ruin fiction, its clichés would be collections of wordy tombstones without owners, hollow statues big enough to enter, mechanical devices looking like decorous art which played jokes on the perceiver, huge deserted monuments, and incomprehensible inscriptions. The clichés of horror fiction are graveyards, dungeon castles, architectural tricks like secret passages, hidden panels, and peculiar locking arrangements; monks, bandits, secret papers, and Alpine scenery. Most of them take place in Germany or Italy, as their revealing titles tell, so in *Zastrozzi* Shelley economizes, putting Italians in Germany. Any art that tries to be shocking will slip into self-caricature occasionally, but a less outrageous example like Mrs. Radcliffe's *Mysteries of Udolpho* (1794) does not often feel like a sequence of used effects. She handles the mode she is remembered for gingerly, and this book opens with a long languorous section mostly landscape without villainy or dangers and so hardly Gothic at all. The book does not enter Italy until a quarter of the way through, introduces the sensational material carefully, and sets the Gothic crisis against a background of more tranquil life. Though the disjunction in Mrs. Radcliffe between the titillating danger sought and enjoyed in rough scenery and the decorum observed in social relations—

Emily is abandoned in her response to pines and torrents and precisely proper in dealing with men—is healed by later Romantics like Byron, her heroines are still afraid of themselves.

Landscape is first of all a test of taste, so insensitivity shows in cutting down old trees or in the brutish preference for city life to retirement. Emily and Valancourt first feel kinship when he reveals that his hunter's outfit is a disguise making inconspicuous a sentimental rambler chasing effects of weather. If the tree-laden opening of *Udolpho* can be trusted, Gothic is a response to a newly alien Nature without God, where we feel an excited uncertainty of what to inform it with, since we cannot assume its sympathy. It is a huge empty field at the disposal of the self, alien but not hostile. These scenes represent this more easily for Mrs. Radcliffe because she has not seen the places she describes and depends on paintings for suggestions; her Nature is an imagined other.

The first act of St. Aubert, Emily's father, is to create an ideal retreat by amplifying a cottage he knew as a child. He is a botanist who pays attention to the communication of each room with the outside; in the end they open so insistently onto views they feel as if they have trees in them. But having retired from Paris to the country, St. Aubert now retreats from his retreat, and builds a rustic fishing house where he leaves a few books and comes for reveries, a further more insinuating extension of himself into the vegetable world and secretive withdrawal from the world of men, the goal to become more and more lonely till he finally disappears. In this little bubble, enclosed but exposed to breezes, the mysteries begin to occur. Verses now write themselves on the wall, lutes play themselves in the vicinity, Emily finds things slightly shifted since her last visit, and objects she drops disappear. Our conclusion is that something is after her, that she is desired by the wind or an invisible man. Now the landscape has an intention toward her, more tolerable the less we know what it is.

After the mother's death father and daughter begin their travels, taking a longer scenic route which turns out to be dangerous. Although they travel sketching, reading, and provisioned, beautiful scenery contains gypsies and leads them out of touch with their carriage in search of views. They never reach their destination as planned before dark and so spend a short time each day feeling homeless. A considerable part of the drama lies in the landscape, in the shift from one type of terrain to another, or in the intervention of scenery to discharge intensities becoming too great in their relations, as when Valancourt gives away all his money to beggars and he and Emily are dangerously drawn to

admire him. In a terrain faintly treacherous, mild excitement raises our spirits gently, as if the gardens at Stowe went on and on, or we could really live in a landscape painting.

Later when Emily and Valancourt are separated the landscape becomes a safer substitute for being together. She walks through the Alps every day at sunset remembering how much he likes doing the same. His imagined presence is more perfect than his real; a meaning immanent in a landscape is more comfortable than a body standing beside her. Landscape goes out of the book after the peaceful opening, but in the later, frenzied part which has begun to take place mostly at night, we frequently find Emily looking out the window of her room in the castle of Udolpho. In some way this communion is the most satisfying of all; she has the sense of being prevented, but not entirely prevented. She is not allowed to walk in the surrounding woods but she enjoys these secret rambles of the eye. Because no one is there and no one can see her, at night the Apennines are entirely hers; she takes possession simply by opening the shutter, and does it in spite of the wishes of others. Finally the news of her rescue comes to her this way, in the singing of the same song she heard near her father's fishing house, the music keeping its distance, unlike the men in the castle.

The real justification for calling Gothic a nonprogressive fiction of pure setting is that the fears of intrusion on the self are not exorcised but only manipulated. The Gothic battle is the attempt of self-control to withstand the onslaughts of the irrational, their subject is staving off madness, and they give the contention spatial form. When Emily retreats into the inmost privacy of her own self, the room in the castle that is most hers, she finds that she is not her own master because she cannot control the doors: they come unlocked unexpectedly when she has been away briefly. Besides the main entrance there is a secret one, with quickly plunging stairs on the other side and its lock out there too where she can see it but not use it. What she fears finally happens: creatures enter her room in the night, leading to the furthest violation, a sword fight in the sanctuary itself. Afterward the trail of blood to the door makes her think she cannot return to it. Gothic novels bring life-and-death struggles right into the house, and people can be shut out even when they are inside, so Emily and her aunt have been locked in when their servant Annette comes begging entry, as the fighting which now rages through the house comes down the hall after her. But being prisoners, they cannot let her in; later she is locked up by her lover for her own good in a remote part of the castle. Relations between persons are

translated into these constantly opening and closing doors, a shifting distribution of compartments.

Emily's position is represented as mostly defensive, the story something that happens to her without reason or explanation. In the prison of subjectivism our thoughts happen to us, we are the spectators of moods which appear and disappear like characters we do not understand. And Emily exhibits a certain avidity in ferreting out secrets; her sensitivity heightened by sleeplessness, begins a series of nighttime expeditions to inaccessible parts of the castle. Though she defends her own secrecy, her dearest wish is to know what passes in Montoni's head, and her troubles all begin when she spies on her father who thinks he is alone in a mysterious glass-walled alcove in his study. But he leads her on by entrusting her with secret papers which he asks her to burn unread. The world of Gothic is the world of secrets where others know things you are desperate to steal because they are more yours than theirs.

The other side to this is fear of revelations one cannot control, so Emily who has been savoring manageable memories of her father in his books suddenly becomes terrified of his ghost, as if even he threatens her ego when thoughts of him become too vividly intrusive. The constant defense is so wearing it can be a relief to give it up entirely and assign oneself to others, and she is glad to be carried securely back into the castle after the first chaotic attempt at escape when she becomes confused who is from outside and who from inside the castle, who friend and who enemy. So also is she haunted by temptation to make the ritual submission Montoni wants and give him her name on the papers which sign her property over to him. The dead end of the search for privacy is to be a voluntary prisoner in her room, reduced to a mouse who scurries back without food on hearing a noise.

Jane Eyre by contrast is much stronger and much weaker than Emily. Because she is more individual and not just a feminine sensibility, the naturalism strikes us immediately rather than the similarity to Gothic. Yet for all the directness with which this hard little kernel of ego in a hostile world expresses itself, the drama is the same as that of *Udolpho*. Because the actors are children the tortures are as ingenious but more sudden than Montoni's, and the precocious heroine makes the exaggerations from inexperience which Emily practices from more cultivated motives; Gothic has been naturalized by putting the feelings in the mind of a child. In both books the treatment of the hero causes the greatest discomfort; other characters often disgust Emily, but at the beginning only Valancourt, with whom she

imagines herself in love, regularly frightens her. He surprises her by his appearance; she hears a footstep and it is only Valancourt. Even the loved one is a perfect stranger, who must be painfully met over again each time. In some sense Montoni is less troublesome because his motiveless malignity is evenly alien. The qualms about Valancourt are unresolvable, so he is as dangerous in the last meeting as he was in the first when he properly walked along beside their carriage instead of coming into it. The last meeting occurs in an abandoned tower in semidarkness where they cannot detect each other's expressions. Emily remains reserved when conscious and yielding after fainting spells, but cannot give up the idea, suggested by rumors, that Valancourt has become unworthy of her during their separation. Finally she does not renounce him, yet we remember her as perpetually about to renounce.

In more concentrated dosages than Mrs. Radcliffe's the villain and hero are combined and the ambivalences in Emily's feeling about Valancourt brought into the open. In Maturin's *Melmoth the Wanderer* the best delights are mixed with pains, hatred produces ecstasy, and lovers are torturers or inquisitors. The secret of this book's extremism is that it tries to let words perform the work of sex, to wake us from our deep sleep of boredom or withdrawal by telling a secret horrible enough. Now our only desire is that the truth be sufficiently awful to produce the revivifying shock. One end of the line of subjective egoism is de Sade who pushes everything to the edge. In *Eugénie de Franval* the father overseeing the daughter's education gives her the control over existence no one else has and makes her his creature at the same time. After many experiments on themselves and those around, they are led from incest to murder, a goal foreseen from the beginning. The father ends pulling the corpse of his victim (his wife, now his mother) from the coffin, lying on it, plunging the knife in himself, and drenching her in his useless blood. Even in these ruthlessly destructive parodies of the novel of sensibility de Sade failed to wake himself up, but he shows us where the Romantic fascination with danger comes to rest, and his identification of sex and death appears in eighteenth-century artists as mild as Fragonard and Mackenzie. Mackenzie's *Man of Feeling* presents the urge to dissolution in the unlikely form of a depersonalized drama of tears, duets and trios of tears, threat always followed by relief, an endless bathing removing the signs of experience and leaving a reborn infant behind; repeated and repeated into a delightful wasting away, characters like dwindling pieces of soap.

The tears blot out the features of the faces, and in *Udolpho* all the men outside Emily tend to be the same man, all events to approximate an Ur-event of primal threat, and everything to happen at the same time in the same place, at night in the castle. She has all her adventures without leaving home, a series of midnight journeys through her own halls. This part makes a lopsided omission of waking life; one person steals out while everyone else lies dormant, Emily's individuality is expressed by when she chooses to be conscious.

This reductive tendency is first evident in the meeting between her father and Valancourt, where there are too many of them. First the older man shoots the younger and then begins to feel replaced by him. When Montoni and Count Morano fight in Emily's room their identities become confused, and Montoni's victory makes him the Count's replacement, for two people who want the same thing are the same person. Almost as soon as it is clear the threat from Montoni is sexual, its power is weakened, and eventually he is disposed of offhandedly, forgotten because superseded by the good Count de Villefort, another father, who welcomes Emily back to France. This bizarre substitution veils the powerful figure of Montoni in front and behind with the two Frenchmen, her father and the count. The three of them adjoin but do not overlap in time, and all three can make her obey. The book's core is its dark middle; it deepens there and lightens again on the other side, like going through a tunnel, her father and the villain only day- and nighttime versions of the same idea.

In a world where every event is surrogatory, referring to a root drama beneath the visible shadows, art has an important place as the one activity always done in place of something else, always a detoxified substitute. In *Hypnerotomachia* it was the things themselves, in *Udolpho* it is the process of appreciation or composition, not the objects. But for Emily reading and sketching are equivalent because when she looks at a landscape she sees a Salvator Rosa: her creation is copying. Gothic novels feed on books. They set their heroines to reading them and then make things happen; fears and noises coincide with the story and so life is intensified by the filter of literature. But to say something always happens when someone sits down to read is simply to reinforce our own activity as readers, to remind us that all occurs in the imagination.

Reading is a solitary way of being together, and looking at Valancourt's underlinings or finding the open book her father was reading when he died are moments of ultimate intercourse. For the oversensitive Feminine, absence is richer than presence.

So it is satisfying to know someone from the past only in a miniature portrait, and a Gothic heroine often carries in a locket a person mysteriously related to her, like the tiny figures of the soul which issue from the mouths of the dying in medieval paintings. When Emily has answered the riddle of the jewel portrait all the mysteries are solved.

The complaint about Gothic fiction lodged by Jane Austen's and Peacock's parodies is that it is so literary, but their own inspiration is more literary still. *Northanger Abbey* is marked off from Gothic by its wit and sharp intelligence. Jane Austen teases the reader with pert exactitude, Mrs. Radcliffe comforts him with imprecision. *Northanger Abbey* sets itself the impossible task of conforming to the Gothic pattern in no way, so Catherine must be prosaic and ordinary through and through, but we soon tire of negation and want the exceptional after all, and when she gets to Bath Jane Austen discontinues the prank at the grownups' expense in order to make the book a novel of social encounter. Even in the youthful force of the opening her serious criticism of Gothic as propagator of dangerous notions can be felt. The idea of the disappointments in store for the girl trying to live like a heroine in the ordinary world inspires in this writer positive terror.

Peacock's *Nightmare Abbey* conforms more strictly to the type of parody as a concentrate of the original, giving a reader more of the author than he does himself, gratifying the taste for Gothic more luxuriously than the longer works which first aroused it. He makes events happen with remarkable speed, ideas to fly after one another like butterflies in an exciting rush, and causes them to vanish like a magician:

Mr. and Mrs. Hilary brought with them an orphan niece, a daughter of Mrs. Glowry's youngest sister, who had made a runaway lovematch with an Irish officer. The lady's fortune disappeared in the first year: love, by a natural consequence disappeared in the second: the Irishman himself, by a still more natural consequence, disappeared in the third.

He conveys both the poison and the cure, brings over all the motifs of Gothic—hero and heroine even suck blood from each other's arm—so that his sanity follows on infection. To have something more to grab on to than the foibles of fiction, he includes the ideas of theorists of Romanticism as well and shows in the process the continuity of all intellectual realms, treats opinions like things, sprouts ideas in fictional forcing beds, and arrives at fancies better than the originals, as when he has a phrenologist compare the skulls of Christopher Wren and a bea-

ver, a violinist and a skylark. It is almost a more scholarly work of Gothic fiction, one that identifies all its German sources, a meta-Gothic with commentary. The parodies of Gothic may show the mind regaining control over its errant impulses, or more likely simply diagnosing its sickness, for Peacock's ironies remove the possibility of actual fulfillment without weakening the fantasy successfully.

Mysteries of Udolpho is so long partly because its writer is still finding her subject; a later writer like Poe is self-conscious enough about the effects he is after to remove the things and boil the feelings down to a kind of architecture. "The Fall of the House of Usher" (1839) is a concentrated poison, the essence or elixir of a Gothic novel, whose inventor realizes Gothic is read for something in particular, so takes that part out, and does away with all the rest. The result makes an entirely different impression from Mrs. Radcliffe, not couched in the ebb and flow of normal life but like a drug trip or intoxication. As it tends to orgasmic intensity, its natural form is short. His fictions are more specialized and belong more completely to a separate genre than hers, the pact with the reader more detailed, exclusion of unwanted experience more rigorous, the bathing in selected sentiment more indulgent. He escapes the trap of overheated language by inventing the cool scientific teller, detached from and interested in the horrors he has seen, a truth seeker made of metal. The narrator is an expert summoned to the haunted house from outside, who recounts events with the delicious unconcern of someone reading a paper on hysteria before a learned body. At the moments of greatest superstitious strain the language turns pseudoscientific, as when the house begins to decompose in sympathy with the inmates.

False disclaimers are lavished on the reader as well as on Usher by Poe, a practiced dissembler consistently suggesting what he pretends not to be talking about and striving for a story like a building full of trap doors, where we constantly trip springs with our feet. His behavior and tone get more clinical as Usher disintegrates, a way of making sure madness stays a safe distance from the self, a precarious hope in this ectoplasmic landscape where an object and an idea are trying to inhabit the same place, feeding on each other, until finally one swallows the other.

Romantic fiction grants everything outside the hero uncertain existence; other characters do not last long because they have only the status of thoughts. Even Poe's center is only a sensing mechanism, a great Eye, and its perceptions are shockingly unreliable. In fact the more intense the experience of this unbodied

eye, the real hero of the tale, the more it feels like pure hallucination. Thus the narrator seeks relief from the dismal first sight of the House of Usher and finds it already fallen at his feet, turned upside down by reflection in its moat. The reflection is a senseless trick of perception but an accurate forecast as well, and it feels to the observer that he has caused it by seeing it, proof of the great danger in letting the eye or the mind wander.

The peculiarities of Poe's language are traceable to a disbelief that anything reliable lies out there to be talked about. It is excessively adjectival, not because it describes something, but because it attends entirely to what occurs in the reader:

I had so worked upon my imagination as really to believe that about the whole mansion and domain there hung an atmosphere peculiar to themselves and their immediate vicinity—an atmosphere which had no affinity with the air of heaven, but which had reeked up from the decayed trees, and the gray wall, and the silent tarn—a pestilent and mystic vapor, dull, sluggish, faintly discernible, and leaden-hued.

It does not matter what the words exactly are, only that the reader should understand he is to steep himself, close himself up entirely in a unitary feeling, as later when a long list of Usher's theosophical books is included, the impalpability of the tale is unviolated because they only elaborately suggest the kind of thing we might think of, tell us topics for our brooding. So a sensitive translator might give his French equivalent a linguistic distinction this does not have. Poe's own language is convinced and hopeless at the same time; because it finally does not matter what one says, one has said the right thing.

He takes consciousness itself for his subject as deliberately as Henry James does and presents it as a great secret, pretending to talk about Usher's sensibility directly only to claim it is a shrine inaccessible to our clumsy powers. Usher is reserved so he must be keeping secrets, and secrecy resides not in definable things but in a way of regarding them, a secret is simply translated fear of the other, pretending to be exclusive and superior. The grandest evidence of Usher's refinement is that he is afraid not of danger but only of fear, nothing intimidates him but himself. He is consciousness pursued to the end, so pure its self-knowledge destroys it. All we can do is try to be like him and if we succeed we have finished, because self-improvement is suicidal.

In Usher's sister this idea of self is more dramatically and less conceptually realized. Under the burden of it she is physically dissolving, is now a footstep that passes through a remote part

of the chamber and closes a door behind itself. Characters in Poe stories need to be able to recognize each other's footsteps because people so spiritual often reveal themselves in no other way. But after her supposed death she becomes suddenly visible; only then is she gross enough to appear to normal perception, and to occupy her brother in a practical way as he must dispose of the corpse. He will not let it leave the house and puts it in a large metal-lined cellar which the narrator realizes he has already seen in Usher's painting of an imaginary tunnel, empty in the picture and now filled. After this no one in the castle can sleep and so they try reading an old romance which begins to come alive, sounds deep in the house echoing its events as if literature causes life. Usher has expressed a fear of being the last, the last of his house when his sister dies, a way of expressing the universal loneliness of separate identity—we are all the last. She cannot die until he does, and appears bloody and tormented to drag him in an embrace to the floor. The narrator, realizing that everything is collapsing, rushes from the house to watch it fall into the moat, the reflection eating the original. In the poem written by Usher earlier in the story, "The Haunted Palace," the house is raised to an even higher level of idealization than elsewhere, anonymous observers see thoughts moving through the mind as figures glimpsed at its windows, courtly medieval life turns to demons in a cauldron, as if the mind had no control over its thoughts and feelings. At the end, enlarging from individuals to the building, like mocking up a tiny sketch to a full-size cartoon, feels like a rationalization of the theory of consciousness. The coherence of the two levels makes the solipsism probable and true. We have seen the mirrored images of the house dissolve into each other, the split personality reassembled, making not one but none. The mind's self-defeat can be diagramed for study.

Unfortunately the experiment of making sure the first novel a reader ever reads will be late Henry James proves impractical. All his novels come so late in the history of fiction they are meta-novels, not just imaginary lives but imaginary fictions whose subject is narration not experience. There is a version somewhere of *The Spoils of Poynton* in which Mrs. Gereth is a pious old woman, not the book as we have it but an earlier more primitive text. Likewise the simple model for *The Aspern Papers* contains plentiful descriptions of the ordinary tourist's Venice, but we know this only because a novel cannot be set in Venice without reminding us of Venice as we know it, without repeating impressions we have had, and *The Aspern Papers* does not repeat. Everyone who reads it knows Venice too well, is pleased to find

it transmuted to finer substance, not having realized before that there are Platonic ideas of things so accidental as particular Italian cities. But the question of the level of existence which things in his novels enjoy is the most difficult posed by Henry James.

Perhaps the reader so sophisticated he does not try to guess what it is really like underneath the prose, to translate him back from consciousness into reality, does not exist. But it is a furtive process, because James himself will never admit there is an ordinary view of things, and the reader must sneak about behind the scenes trying to figure out how the novel was built. It has often been noticed that as James went on he made the most important parts of the fabric the least accessible, as in his treatment of the sick heroine of *The Wings of the Dove.* The center of *The Spoils of Poynton* is inert for a more prosaic reason—it is a collection of rare furniture, but this word doubtless puts too sharp a point on it.

The reader sits throughout the book waiting for what never comes, description of particular objects in the collection. James is more taken with the idea of a pile than with individuals, with muchness itself, not things. It is unimaginable that the story should take place at Poynton; it opens at the antithetical vulgar country house, Waterbath, and Mrs. Gereth has already lost Poynton to her son's prospective bride. So the things for the most part cannot be seen, only talked about, which suits James exactly. Things assume importance for him by being talked about, by becoming the focus of mental struggle. He stays away from his subject because he wants to make tenor and vehicle change places, to substitute his thought for the world in a literal way, just to replace it. His delight, not his burden, is that the chosen subject is impossible, that it leads him into talking about the things behind their backs with persistence that seems parodic, and to staging meetings in accidental places between characters propelled by the things. Fleda has fled to London to get away from Mrs. Gereth and her machinations, Owen has been notified in a letter that Fleda is in London, and his fiancée's mother has likewise heard it from his mother and finds them unexpectedly together when coming to plead with Fleda. People's changing place in Henry James is always wonderfully arbitrary; they live so thoroughly in their minds it is illogical these haulages should matter but they do, and this intersection particularly makes us reflect on physicality and the mysteries of co-presence. The letters which are the efficient causes of the momentous meeting work like stage directions, messages from James about where to stand; here, as often, it would be easy to translate it into Kafka.

The subject of *The Aspern Papers* is absurd in a similar way,

again a contest over objects, a poet's letters. The unnamed narrator pushes himself into the house of the recipient as a lodger and sets about to trick or steal them from her possession into his. At the climax he is surprised in her room by the dying owner, about to pry open a large desk. This conception seems so nasty because it suggests a parodic version of the inquisitive artist who finds a use for other people's love letters and not just, as elsewhere in James, the rapacity under the world's high pretension. For him possession is always stealing, he will not forget that things are gotten from somewhere, and there is a strange guilt that any experience is stolen from someone else. Fleda finds for her passion the chilling figure of a prisoner she keeps, renunciation becomes a possession, and the refused possibility hers alone:

Their protected error (for she indulged a fancy that it was hers too) was like some dangerous, lovely living thing that she had caught and could keep—keep vivid and helpless in the cage of her own passion and look at and talk to all day long. She had got it well locked up there by the time that, from an upper window, she saw Mrs. Gereth again in the garden. At this she went down to meet her.

It would be taking advantage of Owen to admit she knows he loves her or that she loves him. These tangles of pronouns which James's impasses produce are horrifying losses of separate identity, these close relations are threatening violations. James's heroines are overwhelmed and overloaded by experience, so excited they cannot think. His constant ecstatic tone is an ecstatic blur, and his conceptions become increasingly abstract to prevent the discomfort of the bombardment. So in "The Jolly Corner" he takes up rooms without any things in them, and sends the hero prowling through the empty house looking for the self he might have become, a way of reaching the form of thought without the content. In this story the main event is that a door at the end of a vista of doors seems to have been closed, by his own ghost, he supposes. Closing a door is the most elementary transformation of nothing to something; experience this semaphoric is experience of the bare idea of exclusion, of privacy. Pursuing a rich and complete mental life we find ourselves alone with a ghost in an abandoned house and firmly shut out.

In James these architectural images seem to hold out the hope for consciousness of an expanded field. Some of the most dazzling moments in the later books come when he fixes on a roomy figure to represent the principle of a personality, so the Prince's eyes in his face are Renaissance princes at the windows of their palace in *The Golden Bowl;* or the principle of a relation: Maggie and her

father's is a quiet square made grand by the insertion of a Palladian church, the Prince. These ecstatically strained figures evince a fervent hope that the clear image will somehow dissolve moral ambiguity, but must be counted magnificent failures which exacerbate instead of healing the tension between lucidity and warmth. Instead of winning wide new spaces for the obscure realm of consciousness where its impulses could be exhibited more calmly, the clinical figures empty and sterilize the subject in a discouraging and final way, heroic intelligence defeated as much by the goodness it dreams of as the iniquity it meets.

Though he is alarmingly straightforward and his settings often painfully low, Kafka gives us even less to go on than Henry James. *The Castle* cannot be described so as to sound possible: it is the story of how something gets further and further from happening; we slip back instead of advancing toward the tiresome bureaucratic confirmation which would be fulfillment. But it is not even a negative progress because we cannot tell how far we are at any point from completion. Distances are not crossable in Kafka; they may be leapable. For him there is no sure way of getting from one moment to another; because the rules have changed, each new situation feels like a new beginning and the order of chapters problematic. In this book he makes a spatial allegory of this fact of consciousness in the shape of the castle standing above the village, controlling it, probably feeling some interest in it, but communicating by roads and telephones which never function reliably, give no answer or a higher personage than one can comfortably talk to.

The Castle stands out as his most argumentative, disputatious work, focused so raptly on its limited subject. Because of its density it feels best read like a scripture, in small bits, but long forms do not suit Kafka and his most beautiful conceptions are perhaps his most incomplete, the unfocused and unfocusable beginnings with which he fills his notebooks, in which his ideas swamp him instantly in moments of overwhelming sensuous apprehension. He seems simply to be trying to get out from under the impression, to escape the assault intact, and it often feels as if he strays further from the moment of vision the longer he fiddles, weakens it by becoming accustomed to it. The brooding ratiocination which follows on his flashes is consistently fascinating, and more describable and "characteristic" but less rapturous than his first perceptions.

Whatever is left of romantic medieval associations to the castle in this book is supplied by the reader. Things do not need to explain themselves in Kafka because we are so far from com-

prehending them that literal-mindedness throws up its baffled hands. So the settings feel but do not sound individual, details we could point to are sparse and laconic, yet places like the barroom at the inn or the schoolroom in which K. and Frieda try to sleep are indefinably distinctive. His intense feelings about how space is used are embodied in the constant surprises and frequent silly violence which occur when someone tries to make a public room private, especially when he tries to sleep.

Kafka's settings impose on us by their squalor; they are not fit to be seen but there is severe grandeur even in the way the world takes no account of us. His dark rooms are senselessly barren in some parts and crowded in others, with inhabitants who go on rooting through papers or hanging up washing. Despite the huge disparity between the world of gross servants and that of austere officials, the spaces used by the higher personages are also hard on the senses. K. is told about one of the outer offices in the castle where officials checking huge volumes and dictating in whispers are squeezed behind a counter which leaves most of the space free for the suppliants who must never do anything to attract the attention they crave. And he witnesses himself the queer distribution of files from a cart in the long corridor of office cells at the inn. Both places are temples and offices at the same time, where supreme authority is industrious and self-denying and K.'s fondest dream to catch them at their work. The officials' cages at the inn are temporary quarters in which they sleep or interview clients at night and fight for possession of files in the morning. This grim idea has yet its truth, the most enviable state a mental absorption which forgets its surroundings and therefore needs only a close-fitting shell. K. is told much later that his presence has influenced the truth of what he has witnessed, the distribution of files is not regularly so boisterous, and his being there has agitated these fine mechanisms. We become jealous of the mystery at the center of Kafka's world until we acquiesce in the retraction of our one glimpse and believe its reality would be corrupted by our contemplation if he tried to tell us what the center was like. K.'s goal is the castle which he never assaults physically after his first day in the village when the road which points there begins to lead him away, but even the edges shake him off when he seems about to get a footing.

We despair of conveying Kafka's mystery because it is so unexpressed or because it resides in minute adjustments of the prose. He is finally unfathomable, and not another Poe in spite of the obvious similarities of program, though in time his metaphysical pretensions may also come to seem simply lubrication

keeping the story going. Conceiving the quest as a runaround, he has devised the most open and ramifying drama with endless possibilities for K., in interpreting, to mistake his position. Under the narrative's continuous subtle pressure, K., this weak potentiality without a name, this problematic but not very promising about-to-be character among others with flat but sturdy names, is never right the first time, is perhaps never right at all, but never loses his enthusiasm for seizing a speaker's words and wringing a meaning from them. He exemplifies the mind as agile but untrustworthy pitted against an authority, against a reality, whose unyielding power lies in its being stupider than he is.

Looking in fiction after Kafka for the next member of the series, we find the continuers too frequent not too few and couldn't give any inevitability to our choice of Barth, Pynchon, or Burroughs. Like other ways of marking the stages of Romanticism our sequence forms a clear story of relations between subjective and objective and allows us to locate the critical point between Radcliffe and Poe, where idealization carried too far leaves cynical manipulation of consciousness as the only resort. Parodies and derivatives of Gothic fiction show that its ignorance of the real subject was a saving innocence. In *Udolpho* the heroine has only herself to be afraid of, but she doesn't see that yet, whereas in Poe consciousness is clearly recognized as a trap. Once the dilemma has been noticed there is no escape and it even ceases to seem heroic staving off the madness that will come.

Kafka's mysterious truthfulness has always felt undermining. It undermines reliance on anything outside the self, since nothing secondhand can carry the force of these excuses cooked up in our own mental kitchen, which feel uncontaminated just because they are so ignorant of what really goes on outside, just because they are so wide of the mark and based on such textbook ideas of other people's motives. When fiction explicitly becomes the drama of explaining the world to oneself, all existences are finally spectral whatever their momentary plausibility, Kafka's special pang coming from the intensity of the fade effect as the initial power is lost.

It may seem that we have completed a circle, Kafka's K., like Polia's lover, a homeless Crusoe set down in a lifeless landscape and setting himself at once to making it work, but K. can't wake up at the end, though occasionally, rubbing his eyes, he tries to pretend he can see it all from a different level. Too much depends on the search and it is almost as if the resulting nervousness causes the recurrent hitch in his mental stride which means the

landscape can't unroll. The distance we have come is marked most surely by the fact that K. can't get started and so there is virtually nothing to see.

Chapter 6
Books of Things: Topographical Fictions

*T*hough historical novels
always start with material some-
what inert, a special class could be made
of those in which history is seen primarily
as a spatial construction in an effort to bridge the
gap between individual consciousness and the suprapersonal
idea of whole civilizations. The idea of civilization inevitably
disheartens and passifies because it leaps so far beyond individual
lives, so the characters in these books are always on the point of
being smothered by more or less obscure weight, as if the period
were an old disgrace inhibiting their development. But if histori-
cal reconstructions are generally lacking in humanity, more
scrupulous ones feel even more like furnishing the tomb than free
ones, some like Broch's *The Death of Virgil* reinforcing this mean-
ing by choosing a dying hero and others like *Romola* expending
themselves manfully combating the deadness of learning.

Moving from novels infused by reverence for the past,
vaguely archaeological books which emigrate to cities selected for
their patinas, to more literal historical reconstructions, we move
from a death-haunted present to the land of death itself. At first
there seems all the difference in the world between antiquarian-
ism and the arrogant and childish change of residence involved
in historical reconstruction. The passage from the émigré's day-
dream to this complete make-believe was achieved in the nine-
teenth century, and appears at first a great widening out, the
discovery of many new places to inhabit. But how often we end
crushed by the consistency which is one of the main beauties of
visions of the past, the imagination its own prisoner, and history
only a prevision of death, deriving its seriousness and power from
its resolute opposition to life. A conspectus of past civilizations,
as Spengler attests, is the most discouraging of vistas, suited to

the end of life and closing up shop. Nineteenth-century historicizing forms a counterstatement to the belief in progress by implying that there will be no future or that it won't be worth having.

Of the two kinds of calcified books, fictions about castles and fictions about cities, the first seems fanciful, the second dutifully researched, an only child as against the member of a family. But the second makes archaeology of the city, views it as a skeleton and lays out the bones not as preliminary to extrapolating the organism but as the end itself. The constant tension in historical novels between the given and the guessed, between what the writer finds in the record and what he further imagines, can be resolved in misuses of learning like that in *Romola* where evidence of thorough investigation authenticates the lives of the characters inserted in the empty construction, protective coloring for the fantasy. Others, like *The Marble Faun,* put characters at the service of terrain, tying them so closely to the landmarks that they cannot stray far away, bringing us constantly up short against some familiar Roman stone. These are books written with maps at hand whose subject could become so extensive it abandoned selectivity, like one of the volumes in Pevsner's *Buildings of England,* and tried to cover every inch of the ground in some fashion.

Writing twenty years after its publication, Henry James considers *The Marble Faun* required reading for English-speaking visitors to Rome, a part of the experience of Italy, and it judges so many stops obligatory there is little time for anything else. But if Hawthorne is here impossibly constrained by a subject too scattered for a proper fiction, he is also irreducibly strange, a changeling like his main character, who cannot be kept for long in the world of the living. Even though it is set in the present it tells a physical history more literal than Walter Scott's and suggests we might profitably stretch the class of historical fictions to include such émigré books. A more bizarre but digestible case is Corvo's whose overstudied *Don Renato* in a strait jacket of impossible styles and insistences on details of Renaissance life indulges wishes unmentionable elsewhere, the type of history as private, even secret, life. By interspersing topography and drama, history and gossip, these books can provide the purest wish with a blatantly circumstantial form. In accurate historical costume their daydreams are protected from vulgar prying, and given a false legitimacy by their double remoteness.

Though a ready-made element, imposing an extrinsic integration, the cities provoke imponderable responses. For some reason they seem the oldest things on earth, make us feel that life

was here long before as hills, woods, or the sea cannot. The massed experience is usually more daunting than comforting— we will never master it; and the web of streets a snare—we are no longer free once entangled by them. These writers share a foreboding of the city as collected sin, as if great knowledge and a long history must be built on a series of crimes; even Henry James sets *The Ambassadors* in Paris because it is hideously dangerous though less venerable than Italian cities, the most precocious settlement, a feeling so primitive he is ashamed to admit it.

Perhaps in all cities the past so overbalances the present that they are more dead than alive; certainly the ones which inspire pilgrimages and far-fetched love are the deadest, where one goes for the remains not the activity. To Protestants like Hawthorne Rome has an allure it cannot have for Catholics; though it is his first time, he goes back to get to Rome, making moral and psychological as well as historical regression. The traveler looks for the oldest city of all, the true center, the one primal image from which everything else is generated, so he turns south and east toward Carthage, Alexandria, and finally Babylon. Lytton's *Last Days of Pompeii* is the apotheosis of the city as something so old it is now a cemetery, lots of underground rooms filled with recessive life, an imagined life without grossness. If the ultimate model of the city is a return to the past as final as that, the perfect story is one like his where corpses are found in the postures of life, partakers of a suspended animation, contemporaneity without confusing modernity, every bit of it usable history with no waste, kept in tidy storage till he comes. Forecasts of doom for cities are so persistent from Sodom to San Francisco they must satisfy a strong desire to have it all over and done with, to have the latent made obvious, and perhaps a novel even more after-the-fact than Lytton's could be written which took place on buried ruins and sent shreds of former lives through the minds of squalid nomads.

If physical history in these novels is a kind of reliquarism wanting to know what is in the graves, the wishes are well satisfied by Rome with catacombs beneath it, layer on buried layer. The history of Rome makes one aware that men are always digging because there they are continually finding things while doing it. Hawthorne's feelings about Rome are insoluble: though he knows it and loves it better than any place else, better than his birthplace (it is an earlier birthplace than Salem), he finds the love unbearable, wants to escape, and insists happily he will never see it again, attitudes which are taken over into *The Marble Faun* untransformed, so that the book as it goes on becomes a less and less fictionalized feud with Italy and plastic art, less vivid than the

Journal because the opinions are presented as studied reflections rather than momentary impulses.

Hawthorne's feud with Rome and images of sculpture is a feud with part of himself, a struggle between image-worshiper and image-breaker. This self-professed Puritan's confrontation with the plastic arts has profound consequences because the image is the locus of the Catholic corruption, a fight truly dreadful in a writer who thinks in images and often makes a subliminal pattern of them which goes on under a surface of superficial discourse. At home in *The House of the Seven Gables,* his serene castle fiction, he is an unconscious iconologist, but symbolism in Rome always has doctrinal overtones and no longer seems an innocent mode of thought. His most memorable image of Rome is that of the dead monk's upturned dirty feet, which have been everywhere in the city and present its multiplied crimes gnomically in the unreadable overlay of various dusts. Experience is crime also in the more garish form of the lake of gore the artists hallucinate beneath them when standing on the Tarpeian Rock. Miriam and Donatello bring the old Rome alive by reviving the old style of death; he pushes their persecutor off into that depth of history.

At the end of the book Hawthorne turns away from Rome in his own voice, saying that staying away too long makes going home again impossible, an idea whose illogic conceals the fear that Rome will make him somebody else, will lead him to betray his past in a confession of error. Hawthorne perhaps feels that America has given him nothing and that he must return to hold onto his free and undetermined imagination. His description of verminous Italian cities where every memory finds a cranny and persists, where the whole substance is alive, a condition of which he professes horror, reads like the scenario of *The House of the Seven Gables,* whose past is all present in the rich tomb. Reality has got the jump on him—his fresh discoveries were the musty institutions of Italy—but the superstitions he finds ready-made are not as compelling as the ones he could make up, weaving together the fates of men and old immobile burdens in their surroundings.

We do not need the *Journal* to guess that *The Marble Faun* is imagined backward from the way it says. It opens with the three artists finding a resemblance in the faun of Praxiteles to their Italian friend and asking him to stand beside it for comparisons. But of course Hawthorne started with the statue and tried to imagine its coming alive; the life not the art is the hypothesis. A drama among the statues is an escape from history, as out of these

things without pasts are produced people who have had no lives, Donatello a blank stone untroubled by thought tested in the too-much-experience of Rome. This act of reconstitution starts with a vacancy—given this to perceive, who can you imagine perceiving it?—reversing the order of most fictions. Hawthorne loads the city of art with artists, making three of his four characters painters or sculptors and the hero a natural subject for sculpture instead, a proportional oddity which Henry James writing about artists in Rome in *Roderick Hudson* realizes and reverses, because even in Rome the artist is exceptional.

In artist characters Hawthorne has found those who feel most powerfully that Rome was there before them, and so in *The Marble Faun* it is a sense of history which makes continuity impossible, the existence of old art which precludes the production of new, the past preventing the present, drawing artists and then silencing them, a great muffle of creativity. The characters become each other's fictionalizer, and as they paint and sculpt each other those already the subjects of fiction adopt poses even more ideal and the book rises to a higher level of impossibility. The studio where this occurs is an idea factory where thoughts become palpable, but in the extended inventory of Kenyon's studio even the half-finished works are ideas frozen and sure which the novelist uses for a series of allegoric exercises, presenting the germs for many stories in rapid succession. The stones are antihistory, time without experience, on which Hawthorne's embroideries are pure fancy, discardable in any severe accounting, for he likes to present stories as moonshiny nonsense, not the equipment of serious thought, belittling his own inventions as if to avoid their terrible consequences.

When he launches into a polemic against the enlarging machines and overskillful assistants used by sculptors, it is dramatically ill digested but closely tied to the subject of the novel and his own art. He achieves a hieratic distancing and mechanization of character by locating it in immobile images, marking stages in his characters' progress by comparing them to the figures in famous pictures. A young Italian artist makes a picture of Hilda which Hawthorne says can still be bought along the Corso as an engraving, survival in an emblematic afterimage, an instance of his peculiar association of art with death, which marble sculpture, the sort of art engaging him, is perhaps likely to foster. He shows preternatural interest in the element of decay in paintings, and sculpture enters as alabaster skulls or detached marble hands, but representations and corpses are most strikingly conjoined when the fascinated artists stand around the laid-out monk who seems

a cunning wax image until he begins to bleed like a saint's relic. In the *Journal* Hawthorne laments the inconvenience of corpses and wishes they burst and vanished like bubbles. A newspaper story about a widower's ring set with his wife's body chemically resolved to a jewel prompts him to imagine a drama focused on the ring after the man's remarriage. The crux of his dispute with Italy and Catholicism lies here: in his fear that interest in the body will end in corpse-worship, that all images come in the end to images of death, which he contemplates most happily after they are purified relentlessly to signs.

The connection between Puritanical fastidiousness and an interest in corpses is clarified in another foreigner's fiction about Rome, Corvo's *Don Renato* (c. 1902), which pushes many of Hawthorne's preoccupations over into caricature. Corvo's is a discouraging case: he wrote a number of books that were unpublishable or that he decided not to publish, devising tactics with publishers designed to ward off publication, as if he is trying to call back the part of himself exposed in the book because once released it will not belong to him any more. *Don Renato,* his most peculiar, original, and erudite work, exerts the exasperating fascination of learning so queer it becomes purely personal. It is a detailed historical imitation, the "Diurnal" of a monk attached to a noble house in sixteenth-century Rome, practicer of idolatrous classicism and magical medicine, connoisseur of painting, onlooker at sex and violence. Dom Gheraldo writes in a medley of styles chosen from classical writers he considers appropriate to his subjects—Seneca for a youth poking out a pagan's eye, Juvenal for cleaning up after a cat in the night—with results dense, plastic, and uncommunicative, idiosyncrasy as secrecy. Corvo creates an imitation of imitations, a parody twice removed, and with Dom Gheraldo he assumes an identity which cannot possibly be his, whose literal classicism calls every dead king Divius, uses Roman numerals and names for days, and creates countless awkward Latinisms—an undramatic classicism of words and things. But Corvo habitually assumes impossible identities and has been accused of fraud for manufacturing so many protective cases that it is only convention which allows us to decide what to call him. He changed the name he was given, Frederick Rolfe, to Fr. Rolfe after he had been refused admission to the priesthood, and later assumed or was awarded Baron Corvo, an animal identity like the Crabbe he adopts for *The Desire and Pursuit of the Whole.* They are as much dark hiding places as they are self-advertisement; he had a tenderness even about giving his name,

so that his shells look as much unlike him as possible but hold clues for sympathetic inquirers.

The monkish narrator of *Don Renato* introduces as a subject the physical form of the book we read, by having artisans make it a precious binding. Like looking in a mirror this gives him the illusion of himself outside in the world, a legitimate object of admiration. When after the monk's death this corpse of precious material is rescued by Don Renato and carried through sewers to safety in a remote place, to be discovered much later, Corvo watches one of his inventions protectively caressing another of them and feels secure. In the story, the story survives the writer, as all books do in fact, and Corvo's manuscript fulfilled a similar vagrant history, buried in an attic, unearthed and published sixty years after its composition, his pleasing fiction of the corpse-book brought to pass. Reading it, we are by this magic closer to him; he has hidden and come forth fresher than if he had not been buried.

Dom Gheraldo's medicine is magic and science at once, superstition given a technical form, a triumph of literal-minded-ness over mysteries of instinct. The image of the corpse, inert in Hawthorne, exists to be manipulated in *Don Renato,* where the monk's medicine perverts classically inspired worship of the young body into worship of the young corpse. Bodies come most to resemble pallor of antique statues when he lays them out for embalming or tends them when sick. Medicine is an elaborate, learned, and remote sexuality, which Dom Gheraldo can practice promiscuously but in which he is the only possible partner for all his subjects. Though its formality makes consummation impossi-ble, he is granted intimacy as a matter of course with partners unwitting and as passive as he requires. It is like voyeurism in which he can touch without arousing his object, or like sex with the image in the mirror which has another body without a contra-dictory personality. Corvo's model for an ideal relation to the world is that of a monk who doesn't quite realize he is attracted and so doesn't quite use his many opportunities.

The associated images express an antisymbolic turn of mind, so his physicking takes the form of tying a sleepwalker to the bed or salving wounds he has just made with a whip. The most extreme manifestation of the book's desire to mechanize physical relationships is Dom Gheraldo's scheme for reviving a corpse by opening the veins of a younger man, tying them by silver tubes and silk ligaments to the veins of the dead man and wrapping the two bodies together in a blanket. Observing the youth's repulsion and weakness, feeding him wine and broth, the monk enjoys but

does not partake of the mirror sex, a transfusion of energy which drains life from one person to another without costing anything emotionally. Here reason absolutely commands the flesh and replaces feelings with things; passion is a mechanical hookup available to anyone. The desired object has obeyed Gheraldo's will without implicating him, his lust dictates without revealing itself. The ideal relationship is to have the beloved for a servant who does not suspect his love, so that it belongs entirely to him even as he gratifies it.

In a little parody of making love to a corpse Gheraldo keeps an amethyst which he frequently furtively licks. Jewels embody best the fascination of the inert and make a mockery of efforts to awaken a thing. Amethysts were thought the coldest jewels and protection against intoxication, so Gheraldo's relations with the stone are monstrously efficient and insurance against other entanglements, multiplied representation of self-containment.

Another recurrent image in the book—nude models posing for painting—gives an odd parallel to the physician's relation to flesh, even more hieratic and institutional, the body commanded to stasis like a corpse, and being used for something, this time without physical contact, except insofar as strange garb we make it don represents us by proxy.

To represent a tortured saint Don Renato is strung up by a system of pulleys until his naked body hangs upside down a foot above the floor. His disinterested father the painter, studying scientifically the effects of inversion on the body in order to produce a religious image, has him lowered periodically to restore the circulation. Later when he impersonates Cupid an unwieldy but ingenious set of mechanical wings is manufactured which presents vividly the idea of flight but is so heavy it must be supported by wires. It is the only thing he wears and expresses again the enslavement of beauty by intelligence, making it obey silly commands and taking the sting out of the sensuous. This contraption is a materialist's answer to God, changing myth into clothing—practical, decorative, trivial, and though presented as worship, feels like a subtle kind of degradation, new science antiquated by its service to the imaginary.

Renato and his cousin's pose for the picture of Cupid and Psyche is presented as a frozen tableau, already art before put on the canvas, an opera staged before the painter has really begun so that again creation is twice removed from experience:

This day of Saturn, in the audience-chamber, the Supernity of my Lord studies the Divine Cupid and the Virgin Psyche. On a prasine carpet,

about viii. cubits square, laid in the middle of one-third of the longitude of the said audience-chamber on the place where the robust floor begins, Madonnina Marcia vested in the antick mode stands, with admiring hands which timidly depend on the grand shoulders of Duke Renato. That very formose Celsitude genuflects before her; his arms extolled delicately embrace her; his vivid face is elevated; his astrilucent eyes seek to penetrate the veils of hers. His splendid wings expand themselves by means of ash-colored filaments of silk, almost invisible, which extend from the extremities of certain plumes to the lofty rafters, in such mode that the inrestible dival supplicator appears in the very articule of alighting on this orb of earth. Behind the examples, the rest of the marmoreal floor, where plebeians usually stand, partly is concealed by laurel shrubs very artificially disposed to simulate the Lauret described by Messer Gajus Plinius Secundus, whose obscure opulence of color augments the pure candor of the said examples.

In Hawthorne characters are painted or sculpted as themselves, but here their naked flesh is a costume representing a mythical being. They are metamorphosed to gorgeous images by stripping them of their clothes, as if superior secret selves hide under everyday appearances, valuable statues in tawdry wrappings. Corvo the historian finds the truth in things, in trinkets trivial but private, and gives an intensive notion of the period by telling it entirely in intimate manifestations, the history of the world in prized possessions and unspoken superstitions, in the jewelry of life and thought. This eccentric writer conveys textures better than other Renaissance historians because he shows its intersections of delicacy and crudity, of violence and refinement with the immediacy of linguistic imitations. Prose so uneven presents a hard surface, so unpenetrable leads a physical existence, and makes us wonder if these motions we don't quite understand may be pornographic, the suggestive leer of the passage's obscurity indicating that they are probably up to something they shouldn't be, but alternately reassuring us with technical-sounding expressions. Corvo has found a shortcut to history through passions which don't usually make it into the record, by attributing obscure motives brings it purplishly to life, a method which in spite of the labored writing seems suspiciously easy, linguistic difficulty a too literal token of the opacity of the past.

In the end his narrator has become gorgeous like the book; only the hard, precious parts remain. In the cellar beneath the trap door they find his clean skull cloven by a gold dagger, with his rosary, his amethyst, and other jewels beside the skeleton, and he is parceled out among the survivors. The palace the events took place in is now being demolished so they disassemble the imag-

iner along with the scene. Corvo asks to have the skull, while the less pious Countess wears the rosary as a necklace and uses the dagger to open letters and books. History certainly represents more often than we realize a kind of shortcut to the tomb, an extreme simplification of motive sought as refuge from the present. These grisly and exaggerated books even instill the doubt that some of the other false orders of knowledge spring from something like death-worship, that many of the mind's conclusions are simply failures of energy.

Corvo shares with Hawthorne a certain literalism of imagination which makes Catholicism tempting and corpses a source of obsessive dread. In *The Marble Faun,* not only the performance of evil but knowledge of the crimes of others is corrupting, so when Hilda guesses the murder the horrid secret destroys her innocence. A powerful sense of sin like this arises from a belief in radical purity but is itself a confession of corruption. The antithetical possibilities for this kind of imagination are carnival: life without form,—and corpse: form without life, which Hawthorne's art resembles in its tendency to an inertia of symbols. His repulsion from the boisterous Roman merrymaking and his resistance to his chosen subject are expressions of desire for renunciations even when no one asks them of him.

Veils and masks take the part in Hawthorne that nudity does in Corvo—another excessive response to man's physical meeting with the world, Corvo's more complicated because it represents even less than Hawthorne's a usable answer. The proof that Corvo struggles with a sense of sin lies in the hedges around his sensuality, in his making nudity a stringently controlled event in the laboratory. Because they feel the dilemma of purity so deeply and apprehend temptations so nervously, both these writers seem to us jaded and innocent, fresh and weary, disillusioned and credulous. Extreme self-consciousness can never remain simply innocent, so as with all the squeamish, there is something not quite clean about Hawthorne, a grave flower, a pale but decided ghost to whom everything in some unimplicating way has already happened. He berates Rome for setting a trap and casting a spell, but like these other writers he covertly seeks a genuinely corrupting reality, an other so compelling it will steal him from himself, change his principles, destroy his conscience. For the Protestants Catholicism seems a likely place to abandon the self and the difficulties of individuality.

Jung never went to Rome because it meant more to him than other cities, and Proust abstained for a long time from Venice, the one that tempted him. Both of them planned the journey but

turned back when given bodily warnings against it. Jung decides he would recognize too many ghosts there, that the visit people undertake so lightly is overfull of meaning for him. Perhaps he is guided here by the idea of leaving oneself something important to do, of saving the best for last. See Naples and die contains a threat, as if there is such a thing as a conclusive experience, conversely perhaps one cannot die with that ahead of him.

In two French novels of the nineties—Rodenbach's *Bruges-la-Morte* (1892) and Huysmans' *La Cathédrale* (1898)—decadent heroes come to spend an afterlife in a sleepy provincial town where all the glories are former glories; neither Bruges nor Chartres is the recognized capital of Christendom, but in the writers' private schemes of things they are truer centers of faith than the ones crowds flock to. Like all converts Huysmans supposes he does the faith a favor by becoming interested in it, that it shows originality in one as sophisticated as he to be devout, and that he has created Chartres as a literary subject. Rodenbach did in fact create a vogue for Bruges as a place with indefinable esthetic fascination, possessed of an atmosphere more precious than monuments, as one of the powerful paradoxes of tourism—the undiscovered place, which like all secrets must be published. His book, organized in successive layers like an onion, is even more concentric than Huysmans' focused on a single building. The jaded hero picks Bruges after his wife's death because it matches the delicate gray of his death-haunted mind. It is a corpse whose arteries, silted canals, no longer beat with the sea's pulse, where he furnishes a house sepulchrally dark and quiet with one ghostly pious servant. The holy of holies in this tomb decorated with relics of his wife and past is a glass shrine which preserves a long shock of her hair from the corrosive damps of Bruges. The tomb within the tomb within the tomb overexpresses its meaning like the house that Jack built or the fish that swallowed the fish. All complexity is reduced to a single consistent exfoliating image, the same in small as it is in big, an overbearing congruence that would be monotonous even in a short lyric, a conception of reality liturgical through hypnotic reiterativeness.

He follows the same itinerary through the streets at the same hour every day, at dusk, when he never meets anyone, a monotony to which Robbe-Grillet's *Erasers* presents a queer parallel, running over and over the same tracks of character and circumstance, claiming the least possible for the senseless patterns in the end, when it has seemed to the reader impressive in its witty aimlessness, such close calls to significance as hard to engineer as the thing itself. We see the writer's infatuation from

the other side in Rodenbach who makes everything in the book point to his Hughes. Though in Rome he would not stand out, in the provinces he is notorious, so in spite of his never speaking to anyone, the townspeople know the hero by sight. Mirrors placed at angles in their windows let the Puritans of Bruges spy on Hughes as he walks by: decadents need Puritans to create their scandals. In embracing enthusiasm and devotion the city person enters a masquerade, a more or less thorough self-obliteration, but coming to the country sets himself apart deliberately from the surroundings which match his new beliefs. To be a hero he must cut himself off, and find a means of distinguishing himself from every class of person as well as his former self.

The first person Hughes meets in Bruges, at a religious service, is his dead wife in a contemporary form. When he sets her up on the outskirts of town as his whore, he offends not only the Puritanism of Bruges but his mystical pursuits. A liaison in Bruges is obscenity in a holy place, nowhere but at the altar do blasphemies have such force, and so a fierce war begins between these two needs of his nature. When she paints her face she makes life seem vulgar: the decadent uses religion to sophisticate a fear of sex and turn impotence to a sort of refinement. Their struggle culminates over whether she will be admitted to his real house in the center of town, where lace curtains and hoarfrost like ladies' undergarments keep her from spying in the window, the house a delicate woman she wants to violate, an ideal of Woman she destroys by being different from it. She flaunts her hair at the window while watching the Procession of the Holy Blood, a ritual with primitive suggestions of menstruation or sacrifice, and then she commits horrid sacrilege by wrapping the wife's hair around her neck. When he completes the strangulation past and present are reconciled, he has his wife and the world dead again as he prefers them.

Bruges-la-Morte is like a historical novel in having stuck a character off in an outmoded period, or rather in a place like an earlier time which gives him the leisure to wander over a prescribed ground. The historical novel always appears to be sticking itself off in a backwater because even imperial Rome has now a superseded feeling, and in degrees and kinds of backwater the differences between various historical novels lie, gravitating often to peripheral areas and ages. True historical novels require a real plunge, however, not just dabbling in Bruges, the whole hog instead of selected aspects. They are inevitably more demanding, but there may lurk a fallacy in this appearance, for *Romola,* one

of the most scrupulous, does not feel rigorous much of the way. Certain demands met, they can continue with a fuller license.

One of the peculiar and characteristic turns of nineteenth-century thought is the desire for the illusion of knowing the past intimately, for entering into the habits and costumes of this or that remote period, a desire which shows up in the historical genre painting of academicians like Alma-Tadema and Lord Leighton, in the Pre-Raphaelites, and in the subjects of most grand operas. The intent of these forms is childish and magical transport but the method is scientific, making fiction into an affair of measurable accuracy. It is above all the clothing and furnishing of the past which we enter into, and photographic accuracy regarding this is ahistorical except applied to the nineteenth century itself; in the twentieth it ceases to be fashionable and we see that the truth of photographs is as dated as that of other images. The nineteenth century wanted its own intensely moral and materialistic consciousness to play over late medieval forms, so it preferred Lord Leighton's picture of Cimabue's procession to unfiltered Florence.

All historical novels are translations, even Walter Scott's supply glossaries of dialect and traditions, and there are much more foreign ones like *Romola* and *Salammbô* where the writers have to look up their settings and travel to them. The need to visit the place so one can write about it seems inimical to fiction, plotting things which must come from deeper places than tourists' itineraries. However natural it is for the novelist to be a scholar, he will seem to labor under the preordained dimensions of his matter. We find George Eliot importing her favorite moral types to sixteenth-century Florence, an excursion which cannot seem necessary. Scott's novels set in eighteenth-century Scotland translate the past into the present but the commoner, less mature kind sets the present in the past, intellectual imperialism which stamps everything its own. The one enlivens the forgotten, the other deadens what everyone knows, a radical divergence arising from the different starting points, the second type giving itself away with Roman matrons who look like nineteenth-century magazine models.

Even Dickens uses foreign locales to broaden his field in *Little Dorrit,* but the problem is different when exotic color is the predominant tonality not a momentary distraction. Local color now seems one of the vices of many nineteenth-century styles, a penchant for representing alien realities as concentrations of oddities, emphasizing the points of outlandish difference from what we are used to. But how does one make foreigners appear foreign *and*

comprehensible? They cannot speak Italian, an exoticism we tolerate in opera because of the music, so some writers give them occasional exclamatory phrases in Italian to remind us that by magic we understand those who do not speak our language. Conrad found the expedient of making Marseillais speak literal translations of French—"How is it with you, my old?"—a scholarship too obtrusive to be digestible, but admirable because most writers make the foreign and the remote too easy.

In *The Cloister and the Hearth* the past continually ingratiates itself by jokes, barely disguising a feeling that learning is so musty it is a wonder to find any ordinary humanity nearby. Trading on this philistinism, historical novels can make tawdry romantic sentiment seem a fortuitous discovery, so banal love stories will be excused when set in ancient Rome because they bring the world into the study, animate research, give it needed robustness. Lytton's learning in *The Last Days of Pompeii* is a charade which calls attention to itself in footnotes showing how little he is making up, and how much of it fits actual discoveries, but the coincidences are trivial: pieces of jewelry found by the archaeologists are now given by one of his characters to another. By contrast George Eliot's learning eschews such professions and lends weight to the ingenious accuracy by participating in the intellectual disputes of the Renaissance; in *Romola* a serious writer takes up what had not really been a serious form. In fact at the beginning it seems a romance of learning, glorifying the libraries of the past, its more precious and hard-won scholarship.

The book opens in the streets of Florence, however, not in the scholar's study, with energy which seeks no place to rest, all vivid sensation and changeable, raucous life. Her Florentines are sharp dealers—contentious, superstitious, talkative—by which she combats implicitly a dream-notion of the past with a romantic picture of another kind, a gritty rather than a mellow picturesque, so the dialogue is mostly the affected speechmaking of people anything but ordinary. Though as in *Felix Holt* she seems awake to the attractions of difficulty, the thorns of the subject, her characters are still caricatures. She differs in tonality but not in mode from lesser historical novelists, avoiding the common traps but keeping to the common ground.

Like Victor Hugo's bird's-eye Paris of the fifteenth century, George Eliot's Florence is more full of features than any real view; everything stands out, people organize themselves by groups—students, washerwomen, lawyers—and keep more to distinct quarters of the city than now. We have the strange feeling of knowing it better than our own world because this more orderly

society is a huge family, the whole place friendly and familiar as no actual place can be. We can be nostalgic for something we never knew because it is the ideal of a flourishing vastness as comfortable as the dinner table, an endless experience of familiarity.

This opening in the streets recapitulates to a certain extent the experience of a foreign visitor to Florence, Tito the Greek embodying the stranger who needs explanations, but the novice's discomfort is never felt because we have only to look at a strange sight and instantly knowledge of it pops into our head, the laborious process of finding out wonderfully short-cut.

The most interesting of the predictable high spots are not the monuments of the city but the historical personages she introduces—Piero di Cosimo, Machiavelli, Savonarola—who have become monuments too by the residue left of their thought or work. When the people history remembers are not people with ideas, they often come like Napoleon to represent an idea, so unlike ordinary characters they provide the writer with the inflexible frame of an edifice: thus a Machiavelli already exists who the book will more or less reveal, the incompleteness of view fascinating. When we meet him first at the barber's, our sense that he did more than chatter and have his hair trimmed lends a gnomic air to this glancing portrayal, and makes possible a peculiar tact in the presentation. Like biographies of artists and Ruskin's personal appreciations of monuments, historical novels can profitably leave some things untouched because their subjects have a rich existence outside the book, and they only intensify a preexistent reality with human coloring inappropriate to its high manifestations. Imagining the casual conversation of an artist like Piero di Cosimo who left no literary remains but gives strong suggestions of character in his paintings is a valuable parlor game which pursues more tenaciously the guesswork all criticism consists of, the effort to reimagine the maker. Historical novels glamorize scholarship by making living in books into living in ancient Rome, try to turn the author's reading about a subject into an imagined existence, but George Eliot gives it the added power of having entered the ideas of the dead not just the ruffles of their clothes.

There are two antithetical visions of history: that it is very like the present, that it is very unlike, the first represented by *Romola,* the second preeminently by *Salammbô* which appeared the following year. Flaubert avoids by a great rigor of exclusion the friendly course of humanizing the past, emphasizing the difficulty, even impossibility, of a modern reader's coming to terms

with it. He establishes Carthage memorably as a literal place and then makes it unenterable or at least hugely uncomfortable, which lets him seem more serious than George Eliot, the effort required of him more unpleasant, hence harder to sustain. In fact one of the wonders of *Salammbô* is his managing to go on with it, resisting to the end an unworkable scheme.

His book is so hostile to ideas, opinions, or intellectual content, and so determined to have no moral pretensions that it becomes almost a tract about the vulgarity of introducing these things in fiction, a crushingly serious work masquerading as dilettantism, his perversion no more lighthearted than that of Sade, who constituted his favorite reading at the time he was writing about Carthage. Though the operatic settings in Hannibal's palace and the Temple of Tanith make the strongest impression left by the book, there seems an irony in its great popularity, in the Empress's request for help in planning ball costumes based on it, and in the abortive project for an opera, because Flaubert had wanted to create a world in which no one would feel at home.

Together with Moreau's paintings *Salammbô* (1862) represents the furthest reach of the Romantic taste for the exotic, for conceiving an unthinkably bizarre gorgeousness and locating it in some remote place. When Hannibal returns he tours his house, moving from wasteful luxury to wasteful luxury, from a roomful of money to a buried cone-shaped chamber with a statue standing in the middle, a light kindled in whose head makes jewels stored in the walls flash, to a more secret chamber whose substances are so precious they have no names, to a hive-shaped hall where naked slaves squeeze unguents, grind amber, and fill little cells in the walls with balms and perfumes. Each setting tries to contain everything, and cannot let anything go without an applausive word, so the prose grinds to a halt in stuffing itself full of lists. Hannibal moves through it in a suppressed rage, kicking and dismissing slaves, because he suspects that his daughter has fallen with a barbarian. The human accompaniment to the rich surroundings is regularly violent, cruel, and destructive emotion —a roughness and simplicity played against the subtlety and intricacy of the architecture. Along with endlessly detailed setting goes flat, nearly nonexistent character, but Flaubert wants to represent his people as incomprehensible rather than simple. Father and daughter meeting can express nothing, seem to us to enact only a pompous ritual of greeting; the lovers' consummation is carried on at the level of myth, pure sadomasochism realized as fire and wind. Personality is deliberately banished to keep the events in the alien past, to keep this life from resembling that

of the nineteenth century in any comforting way; their humanity, to be unlike ours, must not appear to us human at all.

To make a complete escape Flaubert has chosen a civilization more remote and recondite than Rome, and to baffle by a further unfamiliarity picks a strictly African episode in Carthaginian history, not the Punic Wars from an unexpected vantage but an internal struggle without European reference. The unused possibility of connection to our history is a sign he feels free to be irrelevant, so unlike all the other writers he makes no authorial reference to the present, gives no sign events are not being related contemporaneously with their occurrence, and at the end leaves Carthage victorious without hint of subsequent history and its annihilation. Playing dumb on such elementary and important questions is a sign of the highest art which makes the book a closed chamber surrounded on all sides by midair and giving the illusion of no communication with anything outside itself. It achieves the goal of nineteenth-century historicism to turn rootlessness into something almost positive, to enter another world so fully that no trace of the starting point remains, to escape our own historical identity entirely.

But of course if this success were not illusory it would be self-defeating; it must be an imitation of irrelevance and incomprehensibility. When discouraged with *Salammbô* Flaubert considered the project of a novel about the meeting of Orient and Occident taking place in Paris and the Near East with two heroes, a barbarian becoming civilized and a Westerner becoming barbarized, which suggests that like Yeats he feels himself to be standing on a great pivot, on the verge of a transversal of values. He might lead us to wonder if late-Romantic primitivism in Gauguin, Picasso, and Lawrence has something to do with literal imperial expansion, and calls up social threats from lower down by the resemblance of his barbarians carousing to Zola's proletarians gorging in *L'Assommoir*.

The emotions in *Salammbô* are cruder and the images in which they are expressed even more garish than the unconscious material of dreams. Of the many deliberately horrific scenes in the book, the most astonishing is that of the huge metal idol Moloch devouring children fed to him by their parents in an ecstatic sacrifice. Whatever we imagine Flaubert's motives to be, our own in taking up the atrocious dream must be more trivial still, finding satisfaction in sensational things to talk about and in doing it so collectedly.

To get the grotesquely large images of the gods into the streets the Carthaginians must break down the temple walls like

movie sets which have been built only to be destroyed or to show how much easier and quicker destruction is than creation. The urge to obliterate, so strong in the book, finds a grand variety of expressions in this sequence: there are many ways of dying. Now the god glides through the streets propelled by his worshipers, a powerful image of passivity and abdication of responsibility like that of Virgil carried on a litter through the endless warren of Brindisi in Broch's *The Death of Virgil,* where every sentence is a dying sentence, the last. The idol is accompanied by crowds of self-torturers whose vivid and ingenious devices diversify an essentially reductive experience. Flaubert's style finds many ways to prolong the short-lived act of self-destruction, makes paradoxical expenditure of impressive art to deny life and proclaim loathsomeness. After the mechanism of the god's arms is tested to remind us that the tortures are coldly calculated, the priests flay, gouge, and cleave themselves to encourage parents to contribute their children, and then the consumption of bound and muffled infants begins to the accompaniment of drowning music and the hypnotic rise and fall of mechanical arms lifting them into the fiery mouth, an imitation of living movement more powerful for its clumsiness. We meditate on such images because writers like Flaubert, Kafka, and Lawrence keep giving them to us, and because the confirmation of Auschwitz makes them seem prophetic not simply neurotic.

In this sacrifice as epitome of wasted ingenuity, Flaubert expresses the suppressed rage of the Romantic at the end of his tether, for whom the operations of the autonomous mind are simply an exercise, a kind of masturbation. The imagination becomes ruthless, but carries itself down with the rest in the holocaust. In *Salammbô* everyone is doomed, so no one's, not even children's, thrashings matter. Here the sense of the intervening time may come in to cancel meanings and make everything unurgent, an effect we certainly notice in Pater's *Marius.* But if sophistication and fineness could feel itself borne down and worn out that long ago, where are *we* left? Flaubert's scene is immediate and it is no time; it is the depravity which presses outside our door or the fume of an absolutely idle brain, from which we repeatedly shake ourselves awake. Hawthorne's, Rodenbach's, and George Eliot's books all suggest books which might have been written if the writers had been bold and consistent enough to carry them off, but *Salammbô* is everything it promises to be, shows history as an alien place without any of the comforts of home. Yet despite its enviable certainty and decision it is only a moving example of waste. Flaubert's refusal to mean anything

leads him to a great vulgarity; the continued explicitness of archi-
tectural setting without informing purpose achieves a perfection
of which readers still ask the point, exclusion for its own sake an
insidious self-defeat and omission of ideas not a natural but a
correctible grossness, a ruinous stubbornness: he loses the world
to save the integrity of his own conception.

Salammbô is set in a savage and Pater's *Marius the Epicurean*
in an overcultivated time, one less and the other more civilized
than ours. *Salammbô* is formidably inaccessible, *Marius* all too
accessible, one all hard edge of overliteral plastic model, the other
all soft center of evoked scene, the one outside time beyond
resonance or echo, the other wholly time-infused. Yet they are
strangely close in spirit, both marooned and cut off by something
past explaining, but finding divergent physical forms for the
experience of the world as vacated or about-to-be-vacated
premises.

Marius the Epicurean, His Sensations and Ideas (1885) describes
a life's relation in time, a kind of space, to other lives, a relation
of nonparticipation and isolation. It is a book of not doing and
not being various things most people do and are, and is set in a
remote time as a way of saying I cannot hear you, or I could not
heed you so finally I can no longer hear you. The book shows
nothing as pronounced as renunciation, but makes a drama of
abstention, the things one has not done are more memorable, life
lies in deliberately unused possibility which is a preserved youth.
Pater resembles in this his descendant C. S. Lewis, another clois-
tered child-scholar, who creates even more emphatically than
Marius a life based on a dreamed recollection of generalized
childhood.

At the beginning we find the young Marius in a provincial
villa falling slowly to ruin in the days of Marcus Aurelius, the
unenergetic moment, immobilized by thought, just before a deca-
dence. Life in a ruin is shorthand for disillusion, but here the
exhaustion occurs prior to the experience which would justify it.
Pater leaps straight to the end of time without the tedium of
acquiring knowledge, then sends Marius through the motions of
which the result is already guessed. When he finally comes to
Rome it is to a perfect place on the eve of decline, a vast intellec-
tual museum at which he arrives too late, too late for acting, in
time for brooding. Pater crowds our sense of time uncomfortably
by pushing his characters onto a ledge and then telling us that
modern Rome is more like classical than we suppose, that we live
in the past without knowing it after all. The book lingers and
lingers over perishable materials, drawing a moral at sunset from

rambling conversations during dinner, all thought out and written afterward, unlike most books trying to be evaporative not immediate. Marius is repeatedly shown passing indoors or outdoors, preternaturally alive to dust motes in sunbeams. Though most lives are passed largely indoors, his sensations are those of a life so deeply indoor it is nearly a prisoner's. Fears of barbarian invasion give him a delicious thrill of possible liberation, and his interest in foreign gods is likewise an abrupt approach to the otherness he shuns in its less extreme manifestations. Pater joins in the late-nineteenth-century vogue for making early Christianity weird and foreign, which reimagines it from the pagan outsider's point of view in order to freshen it, a tactic found even in Newman's *Callista*.

Marius's experience takes place before everything and after everything: there is not time for all that has already happened to happen to him, so all his knowledge will feel like that of a past life or another life. The cause of these estrangements is that his experience is book experience, his raptures only a kind of sleepwalking. The book is the product of a mind full of quotations, its truest flashes are literary excitements, and the hero is about to be a writer. Pater writes a polished book about the more intriguing state of preparing oneself to write something, which comes very near being a work of literary criticism, an interpretation of classic literature as *The Marble Faun* is of sculpture. *Marius* makes intellectual autobiography prescriptive by portraying it as the formation of *someone's* taste, the someone a generalized soul and the portrayer an authoritative teacher, now indulgent toward his younger self. This is evident in extended treatment of writers like Apuleius at different periods in Marius's life, which presents autobiography through the medium of changing enthusiasms, as well as in the selection of certain tones for various parts of classical experience. Especially in his treatment of gladitorial entertainment Pater seems to be distilling his own reading in order to reconstruct a habit of the Roman mind, sharing Lytton's conception of fiction as a seemly veil for ideas, without distributing as mechanically into various corners of the book a complete interpretation of the classical world. In the character of Marcus Aurelius the dramatic situation becomes an engine of indirection, gives a more circumspect way of publishing a belief he finds interesting by putting it in the mouth of the emperor, driven by a need to find another way of saying something without muffling it too much. The emperor is the secondary hero, shielded by the protective filter of Marius, so that Pater seems not quite to have declared himself for a recognizable historical figure. Though out-

spoken in various ways, the book finally fails of commitment, and placed this way the opinions are always dissolved in the end after satisfying Marius temporarily. The model for Pater's art is Penelope's web which comes apart at the end of every day, or a succession of stones dropped in a pool.

His most striking textural effect is a haze produced by mixing religious and esthetic vocabularies, speaking of "exquisite correctness of spirit" or "tasteful devotion." This is a higher criticism of faith carried out by someone who is entirely priest not saint, and the effect is seriously befuddling as two realms which do not go together are conflated. The destructive wit in the technique is never admitted and marks his closest approach to the mixture of precious and coarse he admires in decadent Roman styles, a means of reclaiming some of the immense tracts of experience left out in his view of things. As it always does, as it does in Wallace Stevens, elegant fastidiousness conceals in Pater high tensions. He preaches abandonment to the senses but prefers sensations minimal and severe, favors a semiscientific vocabulary:

There was a voice in the theory he had brought to Rome with him which whispered "nothing is either great nor small;" as there were times when he could have thought that, as the "grammarian's" or the artist's ardour of soul may be satisfied by the perfecting of the theory of a sentence, or the adjustment of two colours, so his own life also might have been fulfilled by an enthusiastic quest after perfection;—say, in the flowering and folding of a toga.

He sets a peculiar indulgence in a landscape of dearth.

The problem of his seriousness or triviality was one that divided Pater's mind before it occurred to the readers of the Conclusion to *The Renaissance.* Along with trivializing important things—for him art hallows religion, not the other way around —goes solemnizing trivial things. He turns into dandyism a serious derangement of what he is able to pay attention to. To an intelligence so thoroughly puritanical any satisfaction is unserious hence wicked and so dangerous it must be mediated by a form like the Mass. Pater's ritualism is not a mistaking of the vestments for the body but a necessary avoidance of looking the sun directly in the face. Reverence plays in fact too controlling a role in his notion of religious life, he wants to cede all independence at once, and his paganism comes down to a petrifying name for all he cannot have.

The vividest and wittiest writing in *Marius,* which might be set beside Flaubert's Moloch, appears in the account of bloody play in the arena. Here he can give up the struggle to get the mind

to accept the body and give in to painful jokes at its expense, the pressure of the experience making the prose almost crackle and turning Pater to a learned casuist like Kafka:

People watched their destruction, batch after batch, in a not particularly inventive fashion; though it was expected that the animals themselves, as living creatures are apt to do when hard put to it, would become inventive, and make up, by the fantastic accidents of their agony, for the deficiencies of an age fallen behind in this matter of manly amusement. . . .

The time had been, and was to come again, when the pleasures of the amphitheatre centered in a similar practical joking upon human beings. What more ingenious diversion had stage manager ever contrived than that incident, itself a practical epigram never to be forgotten, when a criminal, who like slaves and animals, had no rights, was compelled to present the part of Icarus; and the wings failing him in due course, had fallen into a pack of hungry bears? For the long shows of the amphitheatre were, so to speak, the novel-reading of that age—a current help provided for the sluggish imaginations, in regard, for instance, to grisly accidents, such as might happen to one's self; but with every facility for comfortable inspection.

Recherché tenses lull us so that we are unprepared for his jabs at contemporary novel-readers, demolishing the moral superiority of the present, a constant of historical fiction. Pater has it in for someone, but who can tell exactly who it is? except that it is someone outside the small circle he draws around his own faint voice. Schoolboyish jokes about such horrors point to gaps in his experience, different from his pupils in having lived with his inexperience, gaining long experience of it.

His theory of symbolism is in fact a sophisticated denial of mundane existence. Every person immediately represents to him a quality, ordinary objects like bread and wine usually sacramental, the untransubstantiated state exceptional. But a life of ritual is a contradictory idea; when the heightened state no longer stands out, elevation becomes tedium, a combination of qualities we find in *Marius.*

In Pater history is getting increasingly vague, as if the vaguest would be the most sophisticated, contours dissolved, discussions reduced to moods, until an afterglow was the most vivid physical existence one could imagine, filling space in the most palpable way. We disbelieve in the occasional claims that it is like other novels, that Marius undergoes important change or that anything could happen to surprise us (Marius does not quite think of marrying Cecilia, who is not quite free to marry—that is the book's idea of resolution), because all his art is really

directed to denying the reality of the world, and his prose an elaborate experience of cancellation, as a sentence from the early essay on Winckelmann neatly shows:

But it proves the authority of such a gift as Voltaire's that it allures and wins even those born to supplant it.

He creates a lure in order to blot it out, and we resent the seduction because it ends in oblivion: the real spell of his prose is that of the charmer death. Suggestions of the sweetness of ends crowd each other in *Marius,* especially in the long brooding on his martyrdom before it happens. Pater's rapture is always the rapture of the mind winking out, as snow falls or dusk descends.

Having seen how often historical novels are founded on disguised nostalgia, we find in the twentieth century when the great age of historicized fiction has passed and the form assumed a lesser, more specialized place, a peculiar equivalent in the exile trying to reconstitute a lost and remembered culture. Joyce in Trieste, Auerbach in Istanbul, Nabokov in the West, are characteristic modern figures re-forming the isolated pieces which remain into an Ireland, a Europe, or a Russia that no longer exists. Many of Nabokov's books are memorials for a dead place, a distant Northern land of which even the name has changed. *Pale Fire* makes the difficulties of justifying nostalgia primary, as if the novelist were introduced as the main character of *Romola* or *Salammbô* forging for himself a satisfactory Florence or Carthage. But in *Pale Fire* there is more than one of him, the Zemblan prince has a prosaic American double who cannot be made to remember anything interesting.

The book reads itself in a peculiar way because it masquerades as a piece of tedious scholarship, the edition of a poem dwarfed by apparatus of introduction, notes, and index, so the narrative struggles out of the prankish form, staggers along in choppy notes. The annotator is the interesting writer, and the poem which provides the base of the edifice only an obstacle the reader—or "rereader," as he is called—must find a way around. *Pale Fire* is a game which gets more complicated the longer it is played and turns everyone into a leafer and translator. The experience Nabokov makes most vivid to us is that of exile from the mother tongue, reduced to a seeker after equivalents which are almost inevitably bizarre, who writes an English ingenious as no native English has ever been. At first we wonder that foreigners like Nabokov and Conrad should produce such rich, complex, plastic prose but it would be stranger if they wrote a lucid transparent English like Swift's. Clumsiness is hardly detectable in

these polished and outré manners, because it has become idiosyncrasy. The foreign language seems a concrete medium, more substantial and resistant than one's own, a palpable antagonist. Translation has provided the architecture for experience, letting us feel behind it the shadowy support of the alternative, more real but unusable.

Nabokov holds a mystic, salvationary view of reality which corresponds to the translator's relation to language; he lives in a mirror world where experiences have far-off doubles or alter egos, a set of correspondences sometimes accidentally revealed by being trapped in a word, a mirror word like Ada or a negative one which calls up its positive, like Shade or Gradus (the shadow characters of *Pale Fire* corresponding to the Zemblan and American identities of the hero). The artificiality of the index provides us with the sharpest sense of the distance between the superficial covering of words and the secret patterns underneath. Life breaks through there in proliferating characters and continuing lives which the book can put no stop to. Even in this device which is designed simply to reflect, things go on happening and the reader is only a spy finding occasional peepholes.

In other mirror worlds where the imaginer is king of his own territory like Lewis Carroll's or the Grimm tales' we meet infantilism similarly cultivated. Nabokov gets us to accept fairy tale as the only suitable model for his past by insisting on its irrecoverability. The wonder and treachery of memory is that when it cannot be verified it becomes pure literature; he saves childish experience for mature intelligence by carefully showing how one comes to feel himself the prisoner of Zenda, finding his future laid out long before in fiction.

In *Ada* the nineteenth century is equipped with tape recorders, telephones, and motorcars, like Shakespeare dressing his Romans as Elizabethans, a past revived and relived, not updated, because the changes are involuntary. The past differs from the present not in its costumes but in its privacy, the creature of its rememberer at the mercy of his imagination. This writer provides his readers with news from nowhere they have been or can go, into the top layer he has in common with them brings hearsay of the impossible place and its impossible tongue.

History is one of the great conquests of modern man, and these novels represent some of the most compelling thinking about history. Their literalism wants to expand the record and fill in the empty places until the past takes up exactly the same amount of space as the present. This wish that past time not be condensed any more comes from a new fear of having lost some-

thing, something we never had. Becoming aware of history is becoming aware of all that is gone, and history itself is a hopeless battle to get free of books or step out of the mind.

The novels show the final inadequacy of any record, in writing or in stone and brick. The record is eternally remote from the life it records and we may even doubt that it brings us closer, closer perhaps to Pater but not to Rome, to George Eliot but not Florence. Historical fiction looks like an escape from self, which leads us around in a circle, the least historical story of all and most untrammeled, where the limits of sensibility show up more clearly than in social novels because it distills sensibility so exclusively. But the special pleasure of historical fiction may lie in this befuddlement of mistaking our object for a time, of taking George Eliot for Florence or Pater for Rome. Even when the error has been retracted its strange conversion endures; Pater has temporarily succeeded in making himself appear a complete world.

Chapter 7
The Mind's Miniatures: Maps

*F*rom cities of brick to
cities in books to cities on maps
is a path of increasing conceptualiza-
tion. A map seems the type of the conceptual
object, yet the interesting thing is the grotesquely
token foot it keeps in the world of the physical, having
the unreality without the far-fetched appropriateness of the edi-
bles in Communion, being a picture to the degree that that sacra-
ment is a meal. For a feeling of thorough transcendence such
unobvious relations between the model and the representation
seem essential, and the flimsy connection between acres of soil
and their image on the map makes reading one an erudite act.

Yet we find this pure conceptuality an illusion if we turn one
upside down, so to see a familiar map with north at the bottom
shows us how much it has become a picture. This view of it is
as authentic as the usual one, yet its meanings have shifted and
the whole as an integer easily graspable has disappeared. Now
features have explanations, so the portentous interruptions in the
coast of Britain are caused by rivers, self-justifying and uncaused
no longer.

To look at a familiar coast from the other side shows us that
we do not imagine the land out from ourselves flexibly in all
directions, but are always standing in the same place when we
think of it and facing the same way like a statue. Maps sedulously
reinforce and protect our sense of where we are, a sense which
can be very elaborate without being deliberately worked out, and
which we can derange artificially by obliterating the reference
point east or west to which we habitually look.

They are our main means of aligning ourselves with some-
thing bigger than us, and so may be thought of as semireligious
in nature. The appearance of whimsy, of points labeled at ran-

124

dom, is a cover for a rigidly determined order, and we place a faith in these distances that we hardly ever do in those of paintings, partly because we could follow the lines on the ground if we chose, unlike the models for paintings, which have since re-shuffled themselves. Though maps give an essential grounding, for most of us they do this early in life and then are put away as childish along with our charts of animal and plant creation, as if, having once learned what the world looks like, to remind oneself of it were a tedious penance like sleeping in one's coffin.

Other orders which are filing systems to most users give esthetic joy to their devotees, even timetables and indexes, but to see them like this one must regard them mystically, not as ways of planning journeys or looking things up, so nothing seems crasser to a lover of maps than being interested in them only when you are traveling, like saving poetry for bus rides. The other time for maps is on vacation, and most seaside cottages display maps of where they are, because vacations are passed in stepping back from one's position, though lives are not.

Unlike the other dense orders named, maps are all present at once, physical as bibliographies which could be spoken are not, but like the others, contain more information than we need or can absorb, a plenitude which lends conviction, because there is no way of exhausting these little worlds. To have them steady there before us is like recall of things forgotten, and even arouses the hope we can relive the times remembered, an infallible grasp like the collector's or fixer's. Thus studying a map can be like reading a journal of the experience.

Nearby places on maps from faraway places in our experience give the special pleasure of different orders coexisting, of the mind conflating memories previously not in touch. Perhaps the way to assure plentiful memories is to go down many streets, for travel helps the mind in its effort at separation, and memories of it are so dense because they are kept distinct by their anchorage in one time and place. The more rooms one can think of the more memories one has, places which need not be beautiful only different.

Names, the words on maps, carry most of the romance and ones without them are more irksome and baffling than faces without features. The wordless photographs of the earth taken from the Gemini space capsules are in some ways all a map-maker's dreams come true, which solve the problem of how to fit in all the detail. But these perfect representations bear the same relation to maps that early photographs did to painting and show that maps are more than representations. The photographs will

not drive them through Impressionism to Cubism and beyond, but by confirming coastlines which we thought were in their waywardness partly our invention, they deprive them of some of their cleverness. Their range of colors, mostly colors of the desert, siena, pale yellow, purple, melancholy serious colors, reminds us how arbitrary the greens and browns of maps are, their careful gradations signifying something other than we take. Colors on maps have their value in suggesting the outdoors in a general way like the colors in Marvell's poems, not in telling us where to find new shades of green. But then they are perhaps as much about nature as Marvell's poems are. Because they are really about man, only a certain density of habitation gives them point, and though empty expanses without words are of no interest, they will find something to say even about Antarctic ice.

On the kind of map most people use one feature is exaggerated at the expense of everything else, the system of roads. This exaggeration says we will be on a road and moving to another when we use a map, and it causes even someone sitting at home to think of movement. Roads are after all the way maps become possible, travel being the precondition of a comprehensive view. A map reader's exhilaration comes from the sensation of not being tied to Place, of having broken the bonds of the local, and when this point of view enters painting in the sixteenth century, preeminently with Bruegel, what a sense of freedom it gives. He sees beyond one field and one village until it feels he sees everything at once. This is why he can paint local subjects without feeling local himself, because he joins up creatures in a single composition who are in actuality insulated from each other, their enviable comfort arising mainly from something only the painter sees, the ability to immerse themselves without asking what lies over the wall of the farmyard. His paintings give the mapmaker's and road builder's view of people who still haven't thought their way beyond their own village, a disparity which explains how anything so prosaic comes to us so weighted with the pastoral romance. Maps give a kind of false intimacy to adjacent towns like the pleasure we have from seeing nearby but noncommunicating nests in Bruegel, and we imagine their proximity into a relationship, as if the eyes of these towns could meet, or they call to each other over a fence.

In their ideal, map manifestation, roads are wishes or proposals for journeys, and demand to be traveled over. Road signs have in fact migrated from maps, minister to the ignorance of the sophisticated, who are seeing the country as a diagram while they learn it. Looking at maps could suggest to someone the goal of

traversing every road in England, but roads are so obviously unideal when you are on them, their sense of obstacle stronger than their sense of purpose, that it remains a miracle that people find their way on them just because they are named, or rather numbered. The numbering was an important conceptual jump which must have been made around the time American city streets were laid out in the 1820s. Fifth Avenue and Thirty-second Street are no more true names than designations for pieces of music like Opus 94 or Concerto 21, and tell only of relations not of natures.

The learner settles for a knowledge of all the roads of one county; then he will know it all. But roads progress toward the conceptual, and faster roads smooth out the scenery; borders of interstate highways are regularized, perhaps an epitome of what all roads strive for—to be nowhere only to be going. Transport is usually at odds with the idealizing, even the integrating efforts of the mind however. In the largest cities the transport becomes the place, its discontinuities practically cancel the sense of the city as a self-contained whole, so that when London or New York is no longer traversable on foot, calling it by one name produces initially only a sense of frustration. These places unlike Florence or Rome must be pieced together at home, an effort which forces on the learner the truth that everyone's home is his own mind and looking at a map a way of pulling in the boundaries and gathering things up into himself. The perusal can be consuming indoor work that leaves him feeling like one of Beethoven's prisoners, startled by the daylight outside. Maps, like packing for a journey, give the joy of paring down to the bare minimum, so the traveler has a clear idea why he takes what he takes, the few idle things —books, maps, charms—known for the toys they are. Maps simplify the world somewhat in the way a heavy snowfall does, give the sense of starting over, clarify for those overstimulated by the ordinary confusion. Each path in the snow shows, the ground keeps a record but also makes one feel there is a manageable amount going on.

Like maps itineraries impose an illusion of uniformity on loose extent and duration, by attempting to live out a map, bringing the map to life and putting a life to bed in the map. The most natural and satisfying kind of trip is a circuit, which has point automatically in the bare figure it traces on the ground. The huge triangular path along the coast of Sicily insists on meaning something by itself. But a journey is not like the rotation of a flywheel, every segment covered with the same ease at the same speed. Maps say that each trip between the same two points is the same

and suggest that if you have been to a place that is the end of it, something is achieved, so going back has no map meaning. And there is a certain stage of knowledge which occurs after a few days of intensive looking, that of map knowledge, in which you think of the place mainly as a surface. It is this notion of a country that makes a traveler treasure up the names of all the towns he has passed through, because simply having been there seems a final meaning. But it is an early stage of learning because of the limit to how many items a list can contain and still be pleasing. When he has collected a certain number of cities a traveler begins to organize his knowledge differently.

Itineraries are imaginary constructions, often even historical reconstructions in which we follow routes that are no longer there, visiting the thriving centers of the fifteenth century, moving on lines of force that exist now only in the imagination, outworn forms remembered. The idea of visiting all the American state capitol buildings, which seems a clear example of the itinerary with purely arbitrary focus, is not different in kind from any other itinerate conception. State capitals are often invented places in the geographical center of invented divisions, and we go just to say we have been. They exist for those who can think of no place to go on their own, but every traveler lets maps give him desires and goals, and the necessity he is under will not bear inspection.

There is an element of duty in any itinerary, of command obeyed and injunction satisfied. Even the most practical people feel compulsion in traveling. The nineteenth-century guide *The Practical General Continental Guide* offers to help the traveler "see all that ought to be seen in the shortest period and at the least expense." The concerns seem exaggerated here, but every pilgrim must watch his pocket, and translating a spiritual progress to a feasible journey, everyone ends up in hotels.

Because they are so heavily imaginary, trips are more satisfying in memory when separated from their necessarily large amounts of dross. By a similar oddity maps of cities as they formerly were have validity and beauty that ones of the actual place do not, easily understood when as usually happens the older city gives a smaller hence purer version, the kernel of the modern city, less easily when a former grandiosity dwindling leaves a similar sense of loss. The two beliefs are eminently compatible—that our vision has become so muddied by proliferation we can't see clearly, that the best things have disappeared—and fortunately we feel no need of confirmation because none could ever present itself.

Historical maps are breeding grounds for illusions of this sort. The Ordnance Survey sheets of Monastic Britain, for example, which purport to give a record of church establishments in medieval Britain, supply a buried structure in which places hardly existing now, like Thetford, Elmham, and Selsey, are elevated to first importance, seats of old bishoprics. Even bishoprics still existing have a different sense in a map solely ecclesiastical. A secret system of power is laid out beneath prosaic political and economic ones; the fact that its centers, great abbeys and convents, have disappeared only guarantees its ineffability. Somehow this map calls up nineteenth-century Russian revolutionary cells, but monkishness is always liable to suggest a voluntary conspiracy of terrible obedience.

Thetford in Norfolk was an important town from the eleventh to the fourteenth century, the seat of a bishop and a large abbey. Since it had declined even before the Dissolution it is doubly ruined and the visitor to the abbey finds almost nothing to piece together. Like many antiquities maintained by the Ministry of Works it exists somewhere between a ruin and a diagram, imitating a map even more than the usual decayed building, always becoming the idea of itself, signaling functions without performing them. When low fragments of flint wall are cleared of all debris and outlined by gravel borders in a perfect green floor of grass, their jagged silhouettes become arbitrary and fictitious. The substance preserved at Thetford is the floor plan, which seems straggly because presented lifesize. The accident preserved is the upper edge, a crooked line running a few feet above the ground. We would like to have more of the accident or less, overgrowth and jumble or invented Gothic. At Thetford deciphering is the whole act, there is no subsequent musing, it leaves one gaping not enfolded. There is not enough to justify a visit but we are not satisfied till we have been. It is a city which looks important on the map, a name which must be probed so something will be attached to the word. If the place is a disappointment, the name afterward is not, and gives pleasure because of its varied suggestion—the drab ruin and the large plantations of pines north and east of the town. Medieval Thetford was known for its forests so that when they were replaced thirty years ago they constituted a reconstructed antiquity, more successful than the abbey. Cambridge on the map can never look distinctive enough, but a place like Thetford can be just adequate to its meaning.

Setting off to see a building that we find has been demolished produces a different shock from a ruin's. A demolished building

cannot be reconstructed by imaginative effort, so when the trip is over we have seen the surroundings but not the object, a diagram of the building, and now know the edges from experience, the center from photographs. The Columbia Market in the East End of London leads this elusive existence, and is still in guidebooks but not on the ground. It was a Victorian extravagance of Angela Burdett-Coutts, an embarrassingly expensive gift to the slum neighborhood it was put up in. The gem has been removed, leaving a weed-grown lot, still surrounded by the ugliness the market hall was built to relieve. Tenements set off by the demolition are a foil become the focus and we imagine something special in the yellow and red of the overbearing monoliths with open stairs. These model dwellings' massiveness says public more than it says home and feels like the closest look at the Victorian social conscience, an unprepared glimpse of something more important than anything one building can represent, but an afternoon spent in this search partly fruitless gives a faint sense that the world has been refined of its main meanings, leaving present-day London, waste from the process.

The Grand Beguinage at Ghent has disappeared from guidebooks and from public memory, so that it survives in street patterns and names but is not marked properly on maps. The hopeful visitor is not sure until he reaches the desolate edge of town that anything will be there, and knows that the buildings if found will be inconspicuous. He goes to satisfy a curiosity, as a detective. A Beguinage is an almost abbey, a compromise between total enclosure and ordinary social life, and consists of distinct private dwellings collected in a place apart. The buildings at Ghent are a stage set that no one is using; the pink molder of the dusty brick and the unself-conscious green of all the doors feel like an old tale or an old play. No one has chosen it because all the doors are the same, and yet it is lived with, not displayed like the whitewash of the smaller advertised Beguinage on the other side of town. The visitor imagines he is the first to see these things with foreign eyes, that he has made a sight of what had not been seen and found something that belongs in a novel not a guidebook. Sights forgotten this way seem more authentic than remembered ones, as old things in the attic still inhabit the time they lived in first. Dereliction, the third kind of map building or incomplete actualization, is quite different from ruin: the London docks are still usable but they are not being used; most of the houses in the Beguinage at Ghent are lived in but not kept up, and now conform to our idea of the past as quiet, dim, and dirty, spaces mainly different from ours by depopulation.

The docks establish a bigger, less expressive scale than almost anything in London. Roads threading them go on between long blank walls which occasionally take a subtle bend in a slightly new direction, nothing its original color, everything enriched by the soil of commerce, an endlessly variegated brocade of dirt. Glimpses of anything more intricate than the blank panels are infrequent, and surprise makes even warehouses tantalizing. Names that suggest the ordinary and comfortable—Gravel Street, Cinnamon Street, Milk Yard—are increased by the surroundings to Egyptian size, everything is made of a few simple stuffs, and milk is here a type of stone. There is seldom any sense of the water nearby, no sea smells or breezes, but a constructed environment meant entirely for the larger-than-human ships, without thought of comfort or charm.

We visit the docks in London but not in Rotterdam, because commerce is romantic only when it has vanished. Whether this occurs simply because contemplation is possible in the silence of the London ones or because absence spiritualizes all materialisms is not clear. Maps of medieval economic patterns are perhaps fascinating for feeling closer to the day-to-day pace of life than military or religious ones. Because commerce is an unforced, repeated act it feels realer than elevated, one-time-only sorts. Its relation to *things* makes it seem even more literal than war, the transport of actual weights over actual distances over and over again, leaving ruts behind, a solid core around which to group the emotions we imagine for the past.

But for Marco Polo commerce was an adventure in a literal way a map reader can appreciate, and he brings novelty and habit together satisfyingly, prosaic motives in dangerous situations, so that as in Bruegel we can feel the unheroic spiced with something beyond it. Following the routes of medieval economic activity undiscovers some of the world for us, makes a mystery of a clarity. Even the London docks suggest things we do not know about the most obvious of human activities, things that cannot be again but only imagined.

Seeing maps as places where secrets are buried changes the use of them. Traversing every street is not generally a feasible goal but getting lost by calculation with a map can serve some of the same purposes. If in our notion of urban space its most interesting bits are not easy to get to or fully displayed, if we see a city as a puzzle or set of riddles, we will believe ourselves closer to its heart when lost or going nowhere in particular. We want to feel that the city is not planned or known, that it is nature not art so that there can be no question of interpreting perfectly there.

People plume themselves on knowing their way in a city however, and confessing oneself a stranger is harder than in the country.

Sherlock Holmes is an insider, and one of the great interpreters of London partly just in realizing its value and trying to cash in on it. He is more a believer than an interpreter, one who has faith in the city, is truly impressed by it. His appreciations feel like self-applause, like being told our own creations are staggering. Doyle makes the condition of not being a foreigner something positive and simply knowing the street names a triumph. He likes ideas better when they are a little off center, without bite, encrusted with habit, pieties rather than thoughts. His version depends on the myth of the Ordinary Londoner's notion of London, which he voices, the most authentic because the most widespread view of the city. But Doyle's ordinariness is fictitious, he gives ordinary prejudices sophisticated expression, and like other smart men with dumb ideas beguiles because he is a pastoral figure, of a peculiarly English sort.

Though cities are entirely human products, they express most clearly the mystery of human divergences which no single observer can comprehend entirely. So Holmes powerfully reassures us when he finds the mystery of the city a calculable quantity. A more drastic method of coping with the enigma of cities substitutes stylized diagrams in place of maps—the "Practical Plans" in the *Practical General Guide* avoid curved lines entirely, use ordinary typefaces, and tie the main sights roughly together in grids that level diverse cities to a set of wiring diagrams. Their purpose is smooth passage; they allow you to see thirty main sights in Paris between 9 a.m. and dinner at 6½ o'clock. The times spent at and between each stop are exactly calculated, a practicality easier to appreciate in the plan than in the whirlwind itself. As a model it is captivating and cinematic, but trying to live up to it is not imaginable. The schedules of guidebooks, suggestions for the amount of time to spend in various places, are fantastic pretenses at quantifying the most unmeasurable kinds of interest, are again supplying compulsions for the idler by proselytizing the idea of obligatory pilgrimages.

With all its air of literalness, no sort of book is more impossibly remote than a guidebook, a startling instance of the gap between literature and experience. The first facts about a place evade its grasp. Towns experienced suddenly make overwhelming impressions but in guidebooks they are flattened to quantities everyone will perceive in the same way, individual differences displaced by a mass view. The demands of the imagination that

separate items be dissolved in the whole and that it dwell and skip as it pleases are incompatible with a guidebook's uses; it must be disassemblable and uniform, and therefore works better when it ceases to be prose at all.

Abbreviated plans only raise more abruptly the problem central to maps, that of detail. All maps are abbreviated places expressing the strong impatience of the mind. In some the process has gone too far for the results to be interesting in themselves, globes are not maps any more but simply epitomes of compactness. The better we know a place the less we want it reduced, because to stay interesting a map must contain many things we do not know with some we do, and will bore us simply as a reminder. Although we use maps to gauge our knowledge, they make it easy to forget on how few places our acquaintance with an area is based, and let us aggrandize it to a knowledge of Tuscany or Norfolk. It is very satisfactory to see the little slice we know pillowed in the surrounding unknown. Though it might be diverting to have a map that materialized as we learned the places, we would miss the pleasure of keeping track of what we do not know. Maps of places becoming familiar are records of learning and proving grounds for it.

There are scales which seem proper to different kinds of motion. One inch to one mile has too much detail to be taken in in a moving car; in fact it seems the mind wants to move faster than this map will let it, or that the earth is not densely enough figured for this sort of expansion to be rewarding. But a walker finds 1:200,000, the largest scale tolerable for car journeys, too devoid of incident, because he covers less than an inch of its surface in an hour.

Like maps metaphors often seem propelled by a change of scale (a building is a tomb or a coffin is a room), and change of scale seems to qualify as a kind of thought by performing a transformation in which everything is altered but remains the same. As the first thing to know about maps is what degree of miniaturization they practice, so size is the key notion for early Netherlandish painting, which devotes itself more to condensation than other schools. From van Eyck to Bruegel they are all creating little worlds, even worlds within worlds, further ranges of diminishment. They think in separate bits and try to put as many of them as they can in every picture. Most of them work very little by suggestion, so that to be effective a thing must be clearly present. In the best ones the details swallow the whole to present an image of plenitude like that of all creation, where you can lose yourself completely in a corner selected at random. They

are elaborate like a page to be pored over, or a homily with many subheads, a text which can be read in various orders. Theme is developed in these painters in discrete parts, like sentences, by multiplied illustration more proselike than pictorial. Maps are both word and image too, both more synthetic *and* more abstract, higher and emptier than most literature or painting, neither of which word applies in the obvious way to maps or the Netherlandish painters, ceaselessly writing things into their pictures, van Eyck even itching to plait actual slogans through the fabric.

He is engaged in mapping the world with a thoroughness no one else has matched. He seems to leave out nothing, but he reduces everything dramatically. In most of his paintings there is no distance, because it all fits into one corner of a room and can be shown to a single scale. This is consistently a kind of doll size, so that standing the natural distance away we feel the figures to be a foot and a half high. At this comfortable, compassable size, ordinary articles are no longer prosaic, concentrated to jewels. His is an extremely conceptual materialism, in which reality does not feel like itself any more, but a clear medium for certain meanings. We are surprised to find objects in van Eyck showing signs of age and use—the fraying edge of a carpet, the spotty yellowing of figured floor tiles—but such signs are further inclusions, which never obscure the conceived aspect of a thing. Likewise shadows do not dim or obscure the colors, which shine out even and pure, recognized the same in every part, created from a bright hard unfluid medium. His is a jewel worker's conception of paint and of reality.

Van Eyck returns repeatedly to a peculiar sense of pattern, not of the whole painting as an abstract design but of real things individually patterned, smaller patterns within the pattern. He paints most lovingly figured Oriental carpets, copes brocaded with scenes, ivory and blue tiles with intricate designs, sculptural decoration in a church interior. These stored-up treasures are artifacts which store dramatic incidents in monochrome reduced to microfilm. It feels less self-reflective and withdrawn because the scenes within the scene are represented as being in other mediums than paint, and because he delights in hiding parts of Old Testament scenes under the Virgin's stool and robe in an Annunciation, letting the carpet peek around the wife in the *Arnolfini Marriage.* Reality is piled high with meanings but accidents always prevent us from reading them all. We are now the ones thirsty for prosaic completeness and he points out that part is more beguiling than the whole, so the edges of his pictures are sometimes frustrating because we want to see more of the scene

than he allows. We struggle to get closer to distant parts of the picture, to fly into the tiny city.

Reading a van Eyck is like reading a map at home. The overall impression counts so little they hardly seem compositions at all. We immediately plunge into examining them bit by bit, a process never completed in a single occasion. Two of them carry the baffling self-reflectiveness fantastically far and include in the map the point we are standing on. As with ordinary maps which contain the place where we are, these parts of the pictures do not call out but lie unnoticed. The mirror on the rear wall under Jan's signature in the *Arnolfini Marriage* gives back to us two figures in red and blue ordinary dress, one of whom has been identified with the painter himself. The concave shield of St. George in the *Madonna with Canon Van der Paele* reflects a distorted image of a figure in the same clothes of the same colors, jarring more this time with the grandeur of the scene. Van Eyck's art throws out a compressed version of what we put in front of it, claiming perfect receptiveness, but this is a powerful assertion or refusal, a not-choosing which treats every surface equally.

His only compositionally unorthodox work is the mono-chrome brush drawing of St. Barbara seated reading before her tower. In all other representations the tower is a little emblem of her imprisonment carried in the saint's hand, but here it has broken that bondage and usurped the interest from its owner. While she sits statically dreaming, it becomes a living hive, active because only half built and covered with masons and sculptors, so that she is now the emblem and it the incomplete being. But the interesting figures are miniature even in the painting's terms, the architectural Barbara ten times their size, and a background is necessarily a place where people cannot be individuals. The picture feels liberating because it is unsacred, because van Eyck sees nothing but a comprehensible plan, an ordinary act of build-ing, in the bird's-eye view of the statistician.

These painters might be included in straightforward histories of maps because their materialistic mentality is a precondition for good ones. Bruegel is more maplike than maps, and cleverer than the intermediate stage between paintings and maps, that of maps with little buildings where cities are, little carriages dotted on the roads. Both these painters get at the subject beyond maps which maps imperfectly embody, contraction.

Bruegel's landscapes portray huge expanses in contracted spaces, and unlike van Eyck's do not make us feel his powers of concentration but reality's diversity. The most interesting excep-tions to this are his two renditions of the Tower of Babel, where

the conception is more domineering than usual in Bruegel. Map-maker's paradises that put infinitude in limited quarters, these are the only Bruegels that appear centrally organized, but regularity here as in Kafka is the vehicle of further mystery. The huge and radically incomplete tower dominates the picture, though this time no saint sits in front of it; the painting boldly leaves that out. There are figures in the extreme foreground of the Vienna version but the distant building is many times their height and fills most of the space. Very little is finished, but already whole villages cling to spots on its sides. The tower is bigger than a city and has outgrown the mountain underneath, which has been turned inside out by quarrying to construct it. From a harbor built at its base a fleet of ships struggles pitifully to supply it with materials, this building which can never be finished because it increasingly depopulates and consumes the earth, a parasite too big for its host. In the meantime it makes an endless resolved complexity, an image of the earth in which parts can be so far from each other they have no idea what each other or the whole body looks like.

It is not conceivable that this enterprise should fail all at once as it does in Genesis, but the various departments could easily work on for years in ignorance of each other as in Kafka until no one remembers what the original plan was. Bruegel has put a border around all that is known, as we do when we ask if we are to a higher reality what ants are to us, an image of the earth as an anthill which is achieved by a simple spatial trick. Because considerable distance is supposed between us and all the minuteness, we take it as grandly proportioned. It is a map whose reality would be beyond the grasp of our eye, which can be represented only in miniature. Though he often takes for his territory the same space that maps do, he does not generally depend on a single act of reduction as here. In its feeling of confinement the Babel picture is oddly like van Eyck's closed chambers where everything is locked in place by a hierarchy of sizes, great variety never concealing the ultimate rigidity.

In van Eyck nature occurs only as contrast. Plants may sometimes provide a backdrop for floral cloth, but brocades precede flowers. Here Bruegel too makes the artificial represent the natural, enjoys the greater control where determinate human things carry all his meaning. But his best pictures are not like this one mainly about representation. In them he achieves the comprehensive informativeness of maps and earlier Netherlandish painting with a new freedom of reference.

Most of his religious pictures are varieties of crowd scene in which he has stepped back from the ostensible subject to include

a whole surrounding population. The large *Procession to Calvary* marks the mathematical center with the small cross under which Christ has fallen, and around it swirl hundreds of other figures, each in a moment of characteristic activity. There are at least four main scales—John and the three Marys set off in the foreground are the largest, whose tragical poses and elaborate costumes make them the most "painted" section of the canvas. In the tumult proper there is a front layer of individualized figures before those of Christ and of the two thieves in a cart crossing the stream. The main incident in this layer is a tug of war between a woman and soldiers that almost makes a picture in itself, but incidents bleed at the edges, spectators are beginning to look away to something else, or someone running up has not yet crossed the boundary of the scene. The range immediately behind Christ begins to be anonymous, the figures simply gapers or players, whose attitudes are shared by whoever is in the vicinity. The farthest range of figures are specks in the distance, interestingly arbitrary and energetic in their dispersal, and collecting into an ominous blot around the spot where the hole for the cross is being dug a mile away on the edge of the picture's high horizon. At first it seems that Bruegel has simply taken the edge off the scene; in a field so vast even Christ's passion has no shape. But the apparent disorder is that of a more inclusive notion of existence as a harrowing journey. The black garland at the end of this progress has its own speechless grandeur, and portrays death as an empty figure, a hole.

In other Bruegels it is even harder to pick out the subject. *The Conversion of St. Paul* takes place in a fierce mountain landscape threaded by a heroic and ragged file of soldiers which wanders from lower left down toward the corner and then up and across to the right foreground and then off again into the distance in the upper right, in an irregular unpredictable path with a firm pattern underneath it. The fallen Paul has attracted the attention of those nearby but the procession continues on either side of him as before. More clearly than the *Calvary* this picture seems to be saying that its title is not its subject, that the world is wider than any name one can assign. In this one there are no diverting incidents, no characters, almost no faces, the figures all symbols on a map. Here Bruegel tries to bring alive the idea of a mountain road, the subject a continuing encounter between man and rocky geography. Like a map the picture can be read backward or forward, and like many of Bruegel's best pictures shows people in passage, on unmomentous journeys.

His urban pictures are even more drastically uncentered than

this. The *Numbering at Bethlehem* depicts crowds pouring into a town, but feels unsociable. The buildings and figures collect near the edges, in the center is empty white snow. As we have learned to expect, Mary and Joseph's importance is not recognized by anyone in the picture. There are various subcenters—a crowd around a fire in upper center, the people registering in lower left, a group absorbed in slaughtering pigs nearby, a trudging couple at the right, and the unexpressively vague forms of Mary and Joseph off center low down. This is a system of loosely connected foci without any suggestion of hierarchy. The weather is caught in an unrepresentative moment—this painter's skies are rarely a neutral blue. As in van Eyck we find no lapses of attention, his far distances never left foggy or suggestively vague. But in a world as random and undivine as he sees, this concentration feels more necessary. If no plan can be assumed to underlie appearances, they exist only insofar as they have been mapped. Now things are related to each other solely by distances, and expansive paintings ordain the space we live in. When a spatial order replaces the moral, maps become more powerful.

In *Hunters in the Snow* the procession so common in Bruegel's later pictures is begun by the hunters, mainly carried out by the eye, which is pulled from low left to high right to rest on the slightly foolish element, snowy crags. Because this journey leads nowhere it then starts over again, running along the smooth diagonal of trees, more regular than any human movement, a line mimicked clownishly by dwarf houses peering over a bank. The line is then handed over to the sharp edges of two square ponds, part of a concealed checkerboard. Bruegel's reality is not continuous but made of pieces fitted together, so that as in jigsaw puzzles the act of integration itself remains visible, the stubborn ambition to make shredded things one. In this picture the old problems of center and edge are thrown into relief as if for analysis by the cerebral snow. The hunters take up so little of the space we are baffled by the title, and every other part refuses to be any more important. The literally marvelous episodes, straw fire in front of the inn and ice on the mill wheel, are placed defiantly at opposite edges. As he often does, Bruegel gives the position in front center to a clump of frailly elegant plants, so evanescent we forget them in recollecting the picture.

It can almost disappear before our eyes. He will not admit he has chosen a subject, and there is no learning displayed or doctrine exposed in it. As in his drawings he refuses to ask reality to turn around to him, and paints everyone from behind. But the casualness of these poses is as riveting as the composure of any

saint, because Bruegel finds over and over a purely necessary slouch. The reserved force in his self-possessed subhuman figures, smoothed into nuts or potatoes, is the secret of a painter whose only beautification is a kind of generalization.

Everything in a Bruegel does something, every speck moves with a purpose, and yet by varying expected symmetries he manages to suggest a great deal of free space in which other things could happen; in the later pictures his world feels populated but not crowded. Our maps are all old-fashioned and preserve the proportions between man and nature we find in these paintings, with their easy continuities between near and far, seeing to the end of every prospect, a concept at ease with its field. The maps in daily use represent a pre-nineteenth century, a medieval, agrarian world, and only choose to distinguish between country and town. In Europe today not much of either remains, while most of America is too wild to be country, its development straight from wilderness to wasteland. Any improvements to maps we can think of, like using colors to show which cities are expanding rapidly or to show the ages of their different parts, would disturb the map's peculiar calm. They cannot admit that lines they draw are now more or less obsolete as soon as drawn, and go on believing in an eternal order of fields and villages. The idea of improving maps will be to some people a strange one, like Lewis Carroll's boast that he had made improvements in thirty-two popular games. It is the people who live by rules that are always hoping to get them changed, those whose rebirths must come by tidying. They hope to make the order they believe in capable of including more and finally of representing everything.

Chapter 8
Contracted World: Museums and Catalogues

*M*aps seem effective preser-
vatives, but it is museums, Houses
of the Past, which turn all they pick up
to history. The act of museumifying takes an
object out of use and immobilizes it in a secluded
atticlike environment among nothing but more objects,
another space made up of pieces. If a museum is first of all a place
of things, its two extremes are a graveyard and a department
store, things entombed or up for sale, and its life naturally ghost
life, meant for those who are more comfortable with ghosts,
frightened by waking life but not by the past.

The most captivating discoveries of Ruskin, who makes cities
into museums and gets his history through objects, are expres-
sions of the museum mentality. *St. Mark's Rest* contains his quirk-
iest, but shortest and most digested treatment of Venice, in which
the writing is willful—abrupt, homely, bitter—and the procedure
full of surprises. He starts by picking out the two figured pillars
in the Piazzetta, rows out to San Giorgio Maggiore to find the
quiet to tell the reader about them, where the setting calls up
reminiscences of Venetian history that happen to be opportune.
Then he rows back and inspects the pillars again, keeping up the
idea of a literal journey, tells the reader to buy a piece of hard
cheese like Gruyère, and gives him directions for cutting it in the
shape of the capital of one of the columns. Then he is inspired
by the lumpy dragon the figure of St. Theodore stands on, which
he calls

the Egyptian "Dragon," the crocodile, signifying in myth, which has
been three thousand years continuous in human mind, the total power
of the crocodile god of Egypt, couchant on his slime, born of it, mistaka-
ble for it,—his gray length of unintelligible scales, fissured and wrinkled

like dry clay, itself but, as it were, a shelf or shoal of coagulated, malignant earth.

After this he puts off the description of the columns' bases and sends the reader off to look at Carpaccio and enjoy himself. The next day—Ruskin's chapters are the reader's days—he takes him down the Merceria and across the Rialto bridge, tells him to look back and says he is looking at the end of the noble Venetian history. He repeats the same walk the next day looking at different things and chooses a series of five architectural sculptures, making a historical set that begins at St. Mark's and ends by Palazzo Labia near the railroad station. These five little examples tell the whole history of Venice's rise and fall, her glory and degradation, and the movement away from the center of the city coincides with the terrible moral progress. Ruskin is a thoroughly spatial and kinetic thinker who expresses here a mythical idea of the space of a city.

His experience feels more literal than that of other critics, the chance encounter of a real man with a real thing, which leads to unforeseen consequences for both of them. His immediacy and his urgency converge in the hope of solutions springing up in walks through the streets. Though like all guides and guidebooks he is a parent, his imaginary tours constitute genuine initiations into reality. His objects are works of art and his collection of them in a book a kind of museum, but he brings together a museum and a map, because he locates his objects in real space. Most museums now try to take their objects out of space and produce a neutral filing, laboratory slides, so the best embodiment of that mentality would be a slide show that called things before our thought without requiring activity. By giving the sense of a few things with lots of space around them Ruskin conceals the fact that he assembles a museum, but his powers of selection are making an order discriminate like a museum not indiscriminate like a map, and what feels like a further freedom, leaving things where they live, is the occasion for a further order.

He surprises us by his choices of objects, surprises even himself. Beginning a treatment of Venice with those two beacons in the Piazzetta is a bold attempt to find the substance in the emblem, and Ruskin's shifts back and forth across the space in front of those ciphers feels like indecisiveness straining against its itinerary, until he launches into the evocation of slime set off by the routine carving of the dragon's scales, which convinces us he can turn anything to anything. He makes arbitrary choices inevitable by concentration, immerses himself in faces glimpsed at

141

random which may be over a doorway or under a bridge, so that following him is like a game of hide and seek in which you never know where to expect the quarry. The feeling of accident is his most artful effect, and it is museums' efforts to make the chances of their acquisition look inevitable by even spacing, lighting, and rigid historical sequences that produce dully mental spaces. No writer suggests thoroughness or evenness less than Ruskin, who though he devotes himself entirely to out-of-the-way objects and falls under a cataloguer's obsession with capitals or door-frames, leaves the lasting impression of great irresponsibility about which things you do and do not have to look at. He is an objectifier who quantifies Venetian history into four strict periods, but the rationale is that of the Book of Revelation not of science, symbolic and affirmative, not provisional or instrumental. Ruskin ordains moods with his directions for reaching the places he describes, and finally creates a visionary environment more like St. John's New Jerusalem than most people's Venice.

Museums, by arranging history spatially, give us a chance to experiment with various sequences of remembering. The normal order is to progress from older to newer things, but if one day by whim or accident we do it the other way we find it more natural. The mind works backward; a person will more comfortably move from a taste for early-nineteenth-century neoclassical to Renaissance to Greek and Roman, than he will start liking Renaissance because it reminds him of antiquity. Antiquity reminds us of the Renaissance; we can never change the primacy of the point we start from, and all efforts to reconstruct historical moments are noble futilities. As historians we work by filling the centuries that intervene between us and the one we are studying, more intervening knowledge necessary the further back we go. By this method a sense of the period just this side of our object is the best security, so if he knows the early nineteenth century the historian feels safe about the eighteenth, a helplessly timebound view. We tug insistently on the thread which ties us to the chosen period, having pieced together a private path meant to feel continuous which will allow us to travel to a new destination in the past. In fact, much of our study in apparently unrelated periods may be repair work on weak parts of this road, and have as its goal better access to a time several centuries earlier.

The idea of a century is a convenience which permits a memorable scheme for the intervening tract between here and the Renaissance, a space that forms itself into five receding divisions which assume greater authority as they get further from us. This increasing authority is partly just ordained by our rule that each

division must be further out of reach than the last one, so though we may sympathize more fully with the sixteenth century, we can never have the condescending familiarity with it that we do with the silly, motherly nineteenth. A century is comfortable like a large house and all the fragments which come to us from it have an automatic congruence from their nearness in space which their evident disparity cannot alter. In the past we know what goes with what and the scrappiness itself is a sign of order, pieces being pieces of something and the historian a builder erecting the miscellaneous rubble left by the past into a gazebo or summer-house with the illusion of usability. In museums, the most literal form of the vision, centuries are rooms and nothing but rooms.

Though history has an authority the present doesn't have, the mysterious authenticity, as do parents, of preexisting, an imposition we cannot overcome or avoid drawing strength from, the visitor always freely chooses his place in it. Because he responds to all the qualitites of the life of the past, it is less noticeable he has no proper place, but as in other pastoral visions our fitness and reconcilement in history still keep the edge of an ache.

Not everyone searches the past, but it is the main business of some lives. Commonly they cast it as dilettante enjoyment, but Berenson's interrogations of objects for example are hard to see this way. His visits to new places are always a tour of museums and he says on the first one he only finds out what he wants to see next time, a next time which is often hypothetical. In one place he calls himself American, in another European, both true and not true for someone who never mentions his Jewish roots and lives a life that is above all constructed, in an odd relation to his own past as well as to Europe's. He is the historian using the past to approach but finally to skirt something, the skater on a surface.

Ruskin's studies are always compelled from him, the acts of a man who does not feel free but does not know why, campaigns against psychic darkness one of which may sometime yield an answer. In his case a wide range of interests signifies uncertainty of what he is looking for, a feeling that the truth may be found in an odd quarter, or that it needs to be surprised. In a letter of 1881 he depicts himself as more and more separate from other people "as they go on in the ways of the modern world, and I go back to live with my Father and my Mother and my Nurse, and one more,—all waiting for me in the Land of Leal," a statement which shocks us by what it can face, and seems to remove him from our ken. But he often expresses common truths in troublesome, overintense forms, and hints that all interest in art has

an element of reverence for the dead and of inability to give up old ways. Ruskin's dichotomies between Renaissance and Gothic, between modern and venerable, are versions of this same conflict between clarity and mystery, ease and difficulty, energy and peace. He is one of those who take things hard quarreling with all those who take them easy, a person who needs many secret-feeling things because he is unknown to himself or because for safety's sake he must remain so, not a simple self-deception but a defensive campaign which though finally lost is not without fruit. In our excursions into the past we may not want to find out anything after all, which does not deprive our avoidances of a certain truth.

The floor plan of the Victoria and Albert Museum caters remarkably to the divided mind, and the sense of crowding there is produced by the building not by full floors and walls. The four floors are not 1, 2, 3, 4 but 1, A, 2, B—as it were two systems present in the same place. Floors adjacent do not communicate, giving a feeling of not being able to get hold of what is nearby. The most experienced visitors get lost, or at least confused about what they are looking for. Two-things-in-the-same-place of the scheme is echoed by a bifurcation of the displays into galleries which show all kinds of object of a certain period and galleries containing a certain class of object in all periods. In the Renaissance Italian is separated from the others while after the Renaissance English is separated and Italian goes back. Continental art ends in the eighteenth century and English continues to the early twentieth, irregularities which keep the boundaries unclear and create uncertainty of what is included and excluded at any point. The angles of the building increase the confused effect, and cause unplanned meetings. For some reason turning corners in the Victoria and Albert is more pointedly an arbitrary act than in other museums, as if the straight line of history were suddenly bent, so that sometimes the model for it seems the sewers of Paris as they appear in *Les Misérables.*

Because the things collected here are so much more various than in a museum of paintings, questions of where to put them are more insistent, display becomes problematic and calls attention to itself. There is an unfrequented part of the English sequence where a series of huge canopied beds haunt big plastic boxes. Beds that cannot be slept in, dishes that cannot be eaten from, clothes that cannot be worn—the place is full of fictionalized, symbolized appliances, and yet they could still be used, whereas there is nothing you are prevented from doing with paintings. Looking at a bed is not a transcendent act; it provokes

low and irrelevant reflections: Would it be comfortable? Who used it? There is no way of banishing wrinkles or plumpness from these objects half in one mode, half in another, a lot of half-open drawers.

Sculpture, transported architectural elements, clothes, furniture, ironwork, silver, china, textiles, miniatures, tapestries, armor, glass, watercolors, jewelry, architectural casts, musical instruments, books, bindings, prints, the Raphael cartoons, and indescribable objects from other advanced cultures—it is easier to feel this as a disorder than an order. The basis for inclusion is not that the objects are art but that they are interesting, a private basis really. Some people are incapable of treating chairs or dishes as objects of esthetic contemplation because for them such contemplation trivializes human needs, and more dishes or chairs than you can use suggests waste unbearably. Their seriousness proscribes this violation of the plain purpose of the artifact; clothes are not to be looked at unless they are being worn, locks unless they are on doors. Furniture is only interesting if it represents something, and thus approaches painting or sculpture, or if it can be sat on or at. The two attitudes are perhaps not so far apart, both responses to fears of scarcity. The collector of china stores up for life's winter, but the person too serious has tried collecting and felt deceived by it, because it has not cured his greater need for surfeit, and he feels driven beyond it.

But if the furniture in the Victoria and Albert is treated as a background for the sculpture it becomes the richest museum of sculpture, where many lighter suggestions surround each work, try to explain or translate it, and can be left for the edges of the attention to take in. Like the dictionary a museum cannot be enjoyed passively. The spectator must decide what is background and what foreground. Nothing tells him he is not supposed to look at everything; he must learn it is not feasible. Instructions for using a dictionary or museum have not been written because they would be instructions for using the mind, these skills much harder than they look. But the order in a museum is not the arbitrary one of the alphabet; selecting here the spectator feels he is violating history, that it would be more serious to look at things in the order they are displayed. The order is more like an alphabet than a story though, and deliberate juxtapositions are usually less effective than the ones a spectator finds for himself. Because foreground and background are not fixed in a museum, any object or any section can assume any prominence or any recession. No matter how thoroughly they are ignored the other objects always count, and nothing is ever seen alone, though we can come to one

thing from different other things. The sense of all those other things at the Victoria and Albert makes the most powerful of backgrounds, whose numbers and extent more than the light itself cause us to think of it as a large crowded darkness. A visitor is not surprised to hear that there are packing cases in its vaults of which no one knows the contents, for an assemblage this big will have dim spots. As a model of the past, it is messy, many-layered, impossible to see whole, where the mind is suffocated by history, enjoys its suffocation, covering itself in dead leaves and abjuring discrimination. The Victoria and Albert loosens our standards and blurs our sense of a period by enriching it unconscionably, by complicating it with peripheral appliances, and finally the variety takes attention away from technique and the artist to place it on sensation and the observer. It is the greatest self-indulgence, a museum of textures, where as in the house of Huysmans' hero all the artifacts are ministers contributing to a dreamy excitment. Like one big Oriental carpet, the Victoria and Albert creates a tone and lends a hue more than it imposes a design.

In England Italian objects give a more distinctive cast to the existence of the observer than they would in Italy. The fact that they are discontinuous with the world outside makes them Siren powers among which everyone more or less lives the dream of Ruskin's madness. At Dijon, Claus Sluter sculptures are displayed in a madhouse, and in some sense a place of muffled cries is an apt setting for all art, a place outside the bounds of ordinary life with undercurrents of danger and irrelevance. Immersion in paintings, like some forms of madness, is the assumption of an unrecognized fictional identity; we do not know who we have become, only that we are someone else, testifying to the unending mercuriality of the psyche. We can tell our interests are surrogates when we see Bohemian meaning just the same as German for us, a savage dark outside the ring of civilization which is certainly inappropriate to the eighteenth century in either place. Because the distances between these Baroque churches have been traveled less often by the imagination they seem perilous journeys and we even wonder if something will arise to prevent our thinking our way on to the next one. Behind particular objects loom unmentionable entities like Empire and Barbarism, and the force of our interests comes from a few sources we are happier for not knowing very well, not so much because they are degrading as that they would make our thought look oversimple. Museums recklessly disobey the laws of the physical world, allow us to violate history as well as conceive it by giving it easily recog-

nizable shapes and assuring us there is a way to live in it. But this is perhaps what history is, a fictional life more satisfactory because unearned.

The result museums seek is an end to change, a perfect stasis or stillness; they are the final buildings on the earth. We point up the denial embodied in museums by our difficulty imagining the inclusion in them of objects now outside. In order to enter, an object must die, and a non-museum object chosen for a museum is enviable like a maiden elected for sacrifice. Like van Eyck's picture of Barbara they substitute things for persons, stuff for life, a materialism of which a museum of costumes is the ultimate ghoulish expression, though every museum bears this grudge against the world in some form. Their antinaturalism finds safety in deprivations, of air and light first of all, which assure that even devotees will feel relief they have got out of the museum in the end. The spectator, who is always engaged in storing away, in locking up impressions, perhaps has a shadowy doubt that he will be shut in with everything else, but a degree of immurement is the hope of most museum visits, and the fear, that they will be over too soon.

The immersion in the object that stops time is achieved by treating it as an existence to be lived in rather than something to be stopped in front of or looked at, and one can almost tell from people's movements whether they have entered a painting or are only staring at it. The first kind move carefully and slowly as if in fear of breaking a spell, let their eyes glide over and over the surface, stopping and continuing, they can never have enough. Now the ladders, cities, and childish colors of Fra Angelico fill their mind entirely and they live in the holy circus he presents. The longer they spend the more it opens out, the more endless the small canvas seems, and they are brought back not by a languor of the mind but by more prosaic reminders from the body, never entirely certain whether the trance is life-enhancing or draining. Museums need to have many objects because people cannot tell in advance when this alchemic internalizing will occur. Every esthete and every artist has his preoccupations which make him incapable of responding to certain subjects—to naked old people or mountains of food or animals or flowers—or to certain sizes or degrees of crowding. No one's idea of what is beautiful, what is ugly, what is neutral, corresponds exactly to anyone else's, and these ideas are the stuff that museums operate on.

The room at the British Museum in which the Elgin marbles are displayed is an archetype of the way museums rifle the world

for the amusement of the mind, turn it inside out, and present it in a convenient form for absorption. The fragments of the frieze which ran under the eaves of the Parthenon are taken out of the shadow and shown facing each other at eye level in an even, chilly light down the long sides of a large room. The larger pediment sculptures from the two ends of the temple regard one another from opposite ends. A visitor enters halfway down the side and so immediately stands in the center of this building, a building made solely of the sculptural decoration of the Parthenon, like a roomful of icing. Formerly when it all faced outward there were myriad vantage points, but now there is one and we are standing on it, violators who have entered the soul of the Parthenon, a ghost that now beseeches us with hundreds of eyes brought down to our level. Stripped of their fittings—only holes remain where spears, scepters, and horse gear of bronze were attached—and lacking the continuations in paint of features that now disappear into the marble background, the overrich, overdense company who float there just to be grasped by the eye are more mental and less substantial than when smaller and more distant. Here we make a Greece outside Greece, a concentrated disembodied tapestry, imagery thoroughly internalized.

The British Museum, all stone and metal, constitutes a more demanding and serious world than we live in, the imperishable kernels sifted out and waiting for the mind to fasten on them, and the activities in the Parthenon frieze, riding, sitting, seem painfully real, brought into this transcendent realm. That they have bodies is not surprising, but that they employ them as we do is. The rows of men on horses or of walking figures almost look like a regular pattern, a more elaborate flower or acanthus border; considered as ornament the frieze was an ingenious variation on a repetitious system, but when it is independent sculpture this continuity becomes a perplexing stutter.

There are whole museums which convey this impression of a chemical concentrate that overexcites, museums small enough to be present all at once. The Spada Gallery in Rome fits into four small rooms paintings which were mostly collected by the family that formerly had the palace. Unlike the National Gallery everything here matches and makes the experience continuous, the collection a single work with the consistency of a novel rather than an anthology, telling in a connected pictorial narrative the story of the house. Mediocre paintings by obscure artists are packed in three or four tiers on the walls, most of them seventeenth-century Italians, the small selection of Northern painters so carefully picked and thoroughly mixed in that they almost

match, the taste not personal but generic of that time and place and the effect not like Moreau's or Soane's solemnly expressive but ornamental. The dark painters favored—Cerquozzi, Testa, Solimena—make the museum feel like a theater, a costume party in which the identities of various painters are lightly assumed.

As in the Wallace Collection in London, the painters are taken over by the collection, more easily done with modest ones than with masters. There even Watteau and Fragonard are submerged in and contribute to a certain notion of existence. When you imagine Meissonier the inheritor of Watteau, as Hertford the collector of the Wallace did, and surround your Watteaus with exquisite nineteenth-century historicizing pictures, you create your own Watteau. Hertford is susceptible to the femininity of French painting, its abandonment to physical comfort, and so his collection includes none of the renunciation, prison, or mourning of David and that sort. A historical series from the seventeenth century to the late nineteenth is shown here which leaves out most of the familiar figures. Hertford's history includes Steen, Ter Borch, Watteau, Fragonard, Greuze, Bonington, Decamps, Meissonier, a collocation we could never have thought of ourselves, which still does not seem an enlivening counterinterpretation because it consists of too many things like each other. In this taste luxurious but not aristocratic, a bourgeois smugness influences even Fragonard who in rooms full of Greuze trades his mythical intensity for domestic charm. Both these small collections enforce the idea of art as pleasant and unproblematic, a comfort to have around the house.

There was a kind of Victorian museum that imitated luxurious domestic furnishing, filled itself with velvet sofas and heavily carved wooden cases, dark fabrics on the walls setting off statues on pedestals that faced each other as if about to start into life, even sketched each other. Rooms like these suggested that the family had left them only the moment before, present-day museums barer first of all so we will not make the mistake of thinking anyone lives there. Now crowding seems mainly humorous or grotesque and can only squeeze into museums under the pretext of historical reconstruction. But when whole rooms or buildings are transported and set up in other places, like the Gothic halls or cloisters in the Cloisters in New York, acquisition itself becomes the subject. Like a scene in a department store window it makes the world a museum and the museum the world.

American museums engage in such extravagant artifice because they have more important functions to perform than European. They exist out of the world, cloistered and shut off to a

degree not found elsewhere. Even the bushes and paths around the Cloisters are flavored, incorporated into an immensely seductive Disneyland of culture, where the most willing visitor is troubled by disbelief as he sees medieval gardens "re-created" on a continent where there was no Middle Ages, where just the impossibility of there being that pattern on the subsoil makes culture feel imaginary.

This need to embody all the possibilities of refinement, to bring in one massive Ark all the history we haven't had, explains some of the paradisal features of American museums, the splashing fountains and hothouse plants. In the inner court at the Frick it is the sinful realization of a whole esthetic existence, of nature as changed by paintings, an intimation of how we might expect the outside to look afterward. The wild also penetrates the artful until a stupefying perfume fills the rooms (propelled by music in the Gardner museum in Boston, an even more complete orchestration of senses), as in Lotos-land. But Wallace Stevens and not Tennyson explicates the strains, excesses, and unforeseen toughness inherent in American estheticism. Something of the gorgeous and irresponsible water bloom with roots dangling free combines with destructive capacities for cool analysis, dissolving the whole vision.

At the Cloisters the initial shock of finding these things out of place is never overcome; reverence for the past cannot disguise the present's power over it, or the fictionality and impermanence of the present construction. It is fun to see men making building blocks of buildings, but it leads us on to wonder if any buildings are too important for this manipulation, a fear provoked by the creative force in the counteridea to collection, dispersal. Every collection is someone's dispersal, as the latest owner always tries to forget.

At the Cloisters historical reconstruction is done at random, but purposes in earlier ages were usually more specific and intruded more on life. Our museums are distinguished by not being pointed, and gain their unyielding authority by appearing in a way indiscriminate. The Romans tended to make a museum of experience and their city a physical history book, swamped by self-conscious memory of the past until one imagines that statues and arches got in the way of commerce in Rome, a city gradually petrifying under heavy gifts, costly buildings dedicated to someone or other. One of the most efficient products of these great memorializers is Trajan's column, a *reductio* of condensation and the oddest-shaped museum in the world, which tries to get everything into one place, into a point that goes up and up in the

air. Its being almost impossible to look at—the spectator must follow the spiral of the scene—enhances the feat, and the collection partly has its point in permitting no admirers. Everyone will first imagine that the long circumstantial narrative was carved in place, after which the artists climbed down leaving their work impregnable. Certainly to be intelligible the story would have to be unrolled because now not enough of it shows on a side of the column, and each narrow band is interfered with by those above and below it, great wealth which waited to be retrieved finally by photographs.

A later outdoor museum effect shows how differently the quarantine and isolation, deliberately making something inconsistent with its environment, can work. Bramante's Tempietto is more perfect than anything real could be, a model temple materialized from a painting. Its setting in the middle of a small courtyard brings out its smallness by crowding. It has its own container; placed in a box it seems pure invention and tolerates no nature at all. The artifact is simply on display and makes us consider each of its proportions carefully. Being made exactly conscious of the distance between its columns and between the columns and the wall, we realize the building fully, all its elements simply mark something and then have done. This building did not need to be taken up in architectural treatises to become a textbook example, it was one, and all the dirt on its surfaces is like smudges on a plan. Bramante's artifact is transcendent by oversimplified uselessness, Trajan's by perseverance less practical the higher it goes. Both are self-important about their knowledge and intimidate the spectator slightly by trying to teach him while withholding sympathy.

Revivals often produce museum effects. Pugin, for example, tries to fit everything he knows into one of his reconstructions. Their Gothic irregularity lets them be anthologies of elements included somewhat in the spirit that there is not time to display all he has found out about details of medieval practice. The later Gothic revival coincides with the great enthusiasm for museums, which made a public religion of the private mania of eighteenth-century collectors. A museum's relation to the other, literal religion is always uneasy, like Walter Pater's. Its flexibility dismembers ritual and gives the disjointed equipment without the form, strips away the scales by turning religions into styles to be collected into anthologies. Museums simplify piety until it comes down to what you do with old things, save or discard them, and achieve a reverence more inflexible than the antiquarianism natural to all religion. They soothe the tender-minded who

cannot make the decision to throw away a corpse, guardians of memories, of full rather than empty consciousness, avoiders of fundamental truths.

Yet many preserved specimens seem to sharpen the division between the past and the present, the saved thing pointing up and clarifying the newness of all the rest. Victorian Gothic churches enclosed by new housing estates, like St. James Thorndyke Street or St. Silas Prince of Wales Road, are set off again as they were to begin with, conscious recherché exercises, which like other remnants of the past have a museum air, intriguingly out of place and hard to imagine the proper use for. They seem to gain from being unaccommodated, given a little space, set apart but not mimicked. Alternatively, quaint useless buildings are turned into museums, in surrender to their intractibility, usually a way of humoring them, but when in Paris they put a museum of technology in a Gothic church, it makes a historical allegory so brave it is not brutal, so seldom have the Virgin and outmoded dynamos had to face each other.

Nineteenth-century museums were usually largely collections of casts, and fitly the Victoria and Albert still maintains a cast court, in which plaster reproductions of the most diverse works collide and shove each other to transcend taste entirely. Choice limbs of various buildings are put together, portals of several cathedrals, dozens of elaborate Gothic tombs, buttresses, doorways, free-standing sculptures and groups. Here images have become so cheap they cannot be separated from each other, Michelangelo has to be fit in among flamboyant tracery. In the form of casts, forms are simply a language and their existence has the same value as particular occurrences of a word. By this practice museums approached too nearly the anonymity of various copies of a book, and backed away from it, but only when photographs began to perform the function less literally.

Another of the styles which people have by their acquisition imposed on art, the print room, also dilutes the meaning of objects by massing them. With their hundreds of ungainly closed albums these places are not correspondent complications of experience to libraries of books. Nor are they comparable to museums of paintings, because drawings are an intimate form, and there seems a contradiction in a huge collection of them. Like species whose dominance disturbs a natural balance, collections which are too successful sometimes end by killing themselves, swamped in mere number. By mistake print rooms have converted prints to print, have set them as if they were a kind of type, a final stage in the tendency of museums to approximate the physical uni-

formity of books, to systematize objects until they become units that can be handled with lightning speed. In them museums are reduced to means of indexing things efficiently, to triumphs of compaction.

A museum is preeminently an overindexed place, whose stock enjoys a perpetual day of inventory, a process for which a threateningly suitable form has arisen. Catalogues are usually thought of as dependent, specialized tools, sophistications of sophistications, which supply indexes to museums that already index the physical world. They only impede and thwart users who misconceive them, because like bibliographies of bibliographies they can offer no way of getting in immediate touch with reality. Indeed for the cataloguer, objects exist to be transcended or at least bypassed, but it may be wondered which came first, the exhibition or the catalogue. Did that kind of experience produce that kind of record, or that record need an experience to match it? For the catalogue is the intellectual superior of the exhibition, exaggerating its interest and glamorizing it. Unlike most books they correspond to a fixed set of events that can be examined for the time being, and thus seem to make a subject *the* subject temporarily, to suggest everyone is thinking the same thing and produce an illusion of community. They can seem just propaganda, but always survive the exhibition, rather test cases of the relation between art and experience, which fix the short-lived assemblage forever. The objects and the words are two systems that nearly coincide, the catalogue the meaning of which the things are only symbols.

Still, a catalogue does not look transcendent; it seems a tedious and small-minded form, a glorified shopping list. A Sears catalogue is a shopping list, but not a way of representing the department store, since it is the store—there are no other stores. To get from department to department outside it, you would have to walk along the railroad tracks, the whole country having become in some way the store. So you wait at home for your wishes to come to you, turned by the catalogue into a thinker. All catalogues intellectualize their content and their users this way, even large department stores and shopping centers—which are partially catalogue-derived and expressions of the American enthusiasm for overdistribution also found in Bellamy's *Looking Backward*—having some of this effect. A wanderer in one is lost between the categories, occupied in negotiating meaningless distances.

The poetry of lists is not the property of effete Japanese courtiers throwing together "things that arouse a fond memory

of the past" or "things that cannot be compared" or "things that make one's heart beat faster." Sei Shonagon strains after disparate ideas, works by association to produce an elegant and oblique non-syntax, but more prosaic lists realize better the form's triumph over time. Each item of a list is repetition and novelty at once, conflates the past and the future, makes things co-present. Listers and cataloguers often seem to have left their material in too rough a form; it is only the raw matter of learning and needs transforming by digestion. But burying their conclusions as well as concealing their maker, catalogues aim to be incontestable, by being a selfless to become a virtuous form. Making one satisfies someone else, produces something necessary that others will use, and so the temptation is to be too long, showing there is no end to what you know, but modestly because once in the catalogue it is no longer yours. German scholars are always falling into this; their learning becomes refuse left for others to dispose of.

But catalogues are naturally rubbishy, cover a little loveliness with a mountain of unwanted stuff. They never feel they have done enough and cataloguers always complain about what there was not room for. The most exciting catalogues are endless, like Mayhew's of the poor in London, and the more esoteric, impossible, and even horrible the subject the better. Finally readers know what to do with malnutrition, drunkenness, ignorance —to know them. Ignorance gives Mayhew great hope because it is the cause of evil and he will dispel it. Although his subjects are alive, they are inarticulate and need to be discovered, looking more helpless than the inanimate occupants of other catalogues when he first arrives on the spot. Still, he believes he is picking the places for things, and it comforts him that various occupations are located in particular areas of London, but his best facts come in unexpected places and give his record the darting inconsequence of high art as when, apropos of nothing, one of his wretched subjects starts talking uncontrollably about roasts. Finally sheer variety of awful facts makes a pleasing texture and we recognize a transcendent truth in Things conveyed by the Spitalfields weaver's piece of maroon velvet that stays unnaturally clean in the midst of squalor, the world surviving its inhabitants. The poor may go down but the smoke of London lasts forever.

Even a writer like Agee produces this complacency because he makes the reader feel he has worked at comprehending and turned the suffering of others into knowledge by the act. Agee's book about Alabama sharecroppers is an archetype of the humility of catalogues' limiting themselves to unknown subjects

and of the close-up as not attempting to know the world all at once. He is inspired by the images of photography, which are more like facts than prose can be, to a daring concentration on everyday affairs. But devoting himself to the ordinary he becomes an esthete of the ordinary who unlike his subjects knows the difficulty of negotiating from big to small, from continents to overalls. His goal is to disappear into one object, to be swallowed up by a kerosene, but Romantic, lamp that represents all. The cataloguer casts himself aside and inhabits the mote or wishes he could write a book of things—all cloth, earth, odors, and food. Agee's book falls most together when it is most in pieces, in an eighty-page inventory of a sharecropper's house. A spy prowling through a house still warm with the departed inhabitants, he empties and enumerates every drawer, box, and closet. The act creates a Sears catalogue of heavily used instead of new things, of experience instead of inexperience, lived objects anonymous though animate. Now he can sit down at the meal his book leads to, cooked for him alone after time is done and everyone asleep. The book joins its writer up to life again in the kitchen, room of the physical, by letting him partake of its substance.

Readers have unfailing appetite for information about things that repel them in reality when it grants them intimacy all at once. Catalogues make their users authorities on subjects they have not heard of till that moment, abolish the beginning and end of learning and hence apprenticeships. They take a mélange and make it into a consistent porridge, so that wherever we are in them we are in the same place. Entering may be a complicated act: one must often traverse a series of clear subordinations; groups of entries on painters' works are found within the series of their biographies. But this is a safety within a safety, like being able to go indoors and then indoors again. The space now occupied is the most comfortable imaginable; you have gone far up inside and found a hidden den, of which the book is a succession, private room after private room, a realm of studies all prepared. Parts of a catalogue do not communicate and so it is full of solitary places, grants perfect seclusion because it is broken into nearly indistinguishable increments, among which a path is untraceable and pursuers get lost at once.

At first its increments seem a catalogue's compromises with time, which it breaks into minutes. The cataloguer worries about finishing, makes us wonder if he will ever write the work he wants to. A catalogue is the only book that is always written instead of something grander, a preparation for something else

that never comes. The cataloguer plays safe by committing himself a tiny bit at a time, and the whole has slipped by when the moments have passed. The form lets revision almost replace invention; it can be added to at any point, pure tinkering that needs no pretext underneath. We even wonder if a catalogue is a book at all, being made of leftovers that will not make a book, but books of things that do not make a book form a large class which includes *Tristram Shandy* and *Finnegans Wake*. Though it occasionally seems a place for things that belong nowhere, for a lot of homeless information, a catalogue is also an attempt to begin over again with the atoms of knowledge, its discontinuities not those of the mind as a destructive, carping mechanism which interrupts transitions and despises certainty, but of its de-creative boldness which ends habits—it is an unhabitual form. Though its practitioners often conceive their job narrowly, a catalogue always loses the mind in a fertile chaos of jostling categories. The grains may be badly worn, the assemblage is a grand fluidity. It combines impossibly duty and disobedience, convention and vagrancy, triteness and originality. Categories are always old—a catalogue's originality, like *Finnegans Wake*'s, is never that of its topics but of its detail, which acts as yeast to help the mind to rise, or as an inundation not all of which need ever be felt. The triteness of a catalogue is all from outside, no one who has entered can see it that way.

Catalogues are fashioned by their users; any integration they contribute to is made actual by someone, is never just lying there. The user ransacks the world for new matter; perhaps like the museum vistor he is only a collector who does not have room for the objects or want to be burdened by things, only ideas. Catalogues make museums ours, increase our stake, grant possession. They dwell on the collection, are perhaps greater satisfactions to collecting minds than collection itself. They fulfill the desire to do something with a collection besides stand inactively in front of it. If collections are a way of keeping the world present to us on and on, then catalogues are a way of keeping collections, and make things the mind's prisoners.

The mood for this act of possession is always serious. One of Ruskin's first assertions in his autobiography is that he has the most dutiful, diligent, persistent mind in Europe. But Carroll, Ruskin, and Joyce, writers with strong cataloguing impulses, all try to sneak the enemy into the catalogue, cannot create any order without disrupting it. For them the inventory is a skeleton to decorate or disassemble. In *Alice in Wonderland* every question is raised as if it will be settled once and for all, but they all come

down to words in the end. Every persistence takes the seeker someplace he did not want to go, ends in logical and linguistic absurdity. So the book is full of changing the subject, breaking off, ending discussion by walking away. The most creative impulse in Carroll's mind is the impatience which creates these hiatuses. Like a catalogue his mind is full of interruptions, continually checking itself to make a correction. The passion for correctness determines many features of a catalogue but it is distressing to see it gone haywire as in *Alice*. Like cataloguers Carroll is constantly thinking of exceptions to rules, is inventive at imagining mistakes, so although he stays in the narrow field of Victorian middle-class family existence he makes havoc in it. He greets the world of games, riddles, odd pets, and tea parties with a fatal combination of irreverence and primness; he is too strict and too anarchic for anyone's peace.

Joyce is known to have written one episode of *Ulysses* with a stopwatch, which allowed him to calculate exactly the intersections of nineteen separate paths through Dublin over the space of as many minutes. In some parts of *Finnegans Wake* his bafflingly literal mind makes the letters of the alphabet themselves the subject, assimilated to the lunar cycle of matching divisions. But Joyce often had second thoughts about the literalness of his orders, putting Homeric chapter titles in *Ulysses* only to take them out. Readers trust that his books are so densely patterned there are some orders recoverable only by him, and he makes a practice of taunting with insoluble riddles, like the one of McIntosh in the macintosh of *Ulysses,* of whom there is no way to determine the identity. Joyce's deliberate unintelligibility like Carroll's superficiality springs from disbelief in the powers of the conscious mind. After the breakdown of reason, all learning is subsumed in simple repetitive play; *Finnegans Wake* returns to infancy. If the catalogue's passion for pattern is pushed far enough every part looks the same, equally senseless, equally satisfying.

A catalogue's largest function is to create subjects, to give names, or to put topics in touch with a supply of particulars, to bring data to a generalization. They can dignify any noun by starting it with a capital letter, which makes it worth pursuing, an unfinished discussion. Joyce's adventure in *Finnegans Wake* is picking such primitive topics as Builder, Brother, Egg, and Cycle and immersing them in a soup so rich readers will never believe that is what it is about. Catalogues always make users wonder whether the topics justify the elaboration, or it certifies them. Large ones can usually be taken either way but not both ways at

once, part and whole never quite fuse. *Finnegans Wake* is not one unless each part is all, yet if this effect ever happens it is because the pieces have such presence and the connections are so obscure. The path from place to place is too complicated to trace, but we are always in the same peculiar company.

Once given its starting point, a catalogue is fertile and full of surprises, but it must be pushed off, the impetus comes from outside. Like scrapbooks they are collections of beginnings. If scrapbooks are unalphabetized catalogues, all art is in some sense disguised scrapbook: unheard-of new-feeling wholes are made of many odd bits taken from here and there. In a child's scrapbook the sources are evident and edges abrupt; styles and sizes of pictures taken from magazine stories, advertisements, greeting cards cannot be made to match. As in grownups' collages, we never forget these things were not meant to be put together. A writer's notebook is still full of edges, but he has given everything a certain consistency. The writer is eventually able to forget where things came from and thus combine them freshly without strain.

Catalogues never forget where things come from, and so though their starting point is similar, their plan lacks the conclusiveness of a writer like Sterne, who wants to work through patches to seamlessness, a full representation of consciousness. Watching how he goes about it can instruct us in the puzzling business of integrating the loose bits proffered by a catalogue. Sterne often rushes the reader into a place he had not thought of going before he is well aware, so that only in thinking back does the point dawn on him. Such effects are important in catalogues also, but can only happen by the reader's connivance. He invents a mind like Sterne's and imposes it on the catalogue, seizing the associations waiting there in the inert matter, and arguing backward, by assuming a point in the order discovering it. Reading back and forth, he finally recognizes connections with salutary shock as in *Tristram Shandy*.

He often wonders whether to give catalogues credit for their most exhilarating effects. Do they see the world as primeval chaos and plethora because they are not bold enough to grasp its outlines or because their vision is undefended by systematizing habits? Neither, though like *Finnegans Wake* they are works in progress and temporary Last Words on their subject at the same time. That which calls them forth—the hugeness of the world's mystery—is met by a mind which denies the stimulus and pretends control. But the spectacle, control over little and not over great, makes the point as well as *Finnegans Wake*. When a cata-

loguer isolates an obscurity in a painting's subject or its attribution and exhausts himself bringing it to an inconclusion, we feel with rapturous clarity the largeness of the world and smallness of the mind. Even when most fragile and tentative, the cataloguer's speculations show a mind moving, and like all its best products are just things said on the way to somewhere else.

Every catalogue makes a reader feel he did not know there were that many things in the world, that there is more to existence than he remembered. It suggests that presenting all of part is a better intimation of the whole of reality than part of all, a sketch, the antithesis of a catalogue. A sketch selects and magisterially directs; a catalogue abdicates responsibility, presents everything as of equal value, is not a moral form. So although sketches dissemble their labor and advertise their skill, and catalogues speak of nothing but toil and are always refraining from being as bold as they might, it is the second which set the reader loose, free from direction.

Catalogues find more things and more to say about them than we expect. They invent long, elaborate descriptions of simple objects we thought boring or not worth talking about. The old Sears catalogues have become Victoria and Albert Museums of the house, more philosophical and disinterested now that it is impossible to order from them. They will never admit anything is boring, summon enthusiasm for the finish of spoons, construction of shoes, proportions of stoves. They multiply ways of seeing things we had just one view of, are full of new ideas of how to live expressed in a blatant poetry of substance and making, which turns the manufacturer into a creator rivaling not artists but the world's. His inspired productions correct all its ills, most convincingly when not attacking them directly in medicines and photographic kits for making fortunes. Spoons that last forever, which have been subjected to every experiment the mind can think of, and clocks with an endless series of features which are $1.15 cheaper than they were last year, hold out the catalogue's hope most brightly.

This large, handsome bronze, marbleized metal clock is made in two colors, black and green, in imitation of black and Mexican onyx, and it so closely resembles the genuine Mexican onyx that it cannot be detected except by an expert. Better than the genuine onyx, it can be cleaned with a damp cloth without injury and is guaranteed never to warp or crack. This is an eight-day clock—runs eight days with one winding—and strikes the hours and half hours upon a perfect cathedral gong.

This clock stands on large handsome bronze feet. It is ornamented with lion head bronze side ornaments, heavy bronze panel ornaments, and bronze center ornaments. It is furnished with a handsome Mosaic dial in heavy gilt, 5 1/2 inches in diameter. This clock is one of the highest grade made by the Waterbury Company. It has blue steel hands, the movement is highly polished wrought brass. All steel parts are oil tempered. Has the latest improved regulator and pinions, safety barrel and escapement. Weight, boxed ready for shipment, 25 pounds.

No. 5R760J, Acme Queen Cathedral Gong Clock, Price . . . $5.75

That is more than $5.75 worth of words. All catalogues similarly betray their objects by overdescription, and most paintings cannot live up to the expectations catalogues arouse. The page grandly welcomes them, makes them at home in the world, but they look much like others of their sort, do not stand out in fact as they do in inventory. It is better not to think of the relation between words and things as too close, the words are what the thing has become, make a transcendent identity for that which someone is tired of. A catalogue revives exhausted interest, a boon after its paintings have done what they can, filling the space after disillusion has set in.

The Sears catalogue equips and defends us, arms us for life which becomes pure technique, so every object emerges sounding like a weapon or a fort, something useful in a struggle. That catalogue, more obviously imaginary than most, has invented a life it imputes to all its readers, and puts them into the story it tells. The lives evoked by catalogues—musty, secretive, and cluttered—depend on intense vision confined to a small corner like a child's. Though the spell exercised by attic life on an adult is perhaps weaker, his choice of it, unlike the child's, is deliberate and he takes a different relation to dust for knowing it is dead skin, the sloughage of past life. Cooped up in Paris, Stendhal wrote a *Roman Journal* which gives circumstantial accounts of the day-by-day itinerary of a party of tourists in Rome, containing excited first impressions of great art and views, second thoughts, responses to Italian manners and street life, infused throughout with the balmy air of leisured society and pleasant feminine company. The reader only becomes aware it is an imaginary journal when Stendhal's interest flags halfway through, after which he can no longer invent itineraries that interest him and begins to fill the pages with lurid anecdotes of Italian passion all of which end in murder and are excused less and less as illustrative of Italian character. But the miscellaneous, journal form suits this inventor whose novels are also loose but circumstantial, whose *Chartreuse de Parme* is often fabricated in absurd detail, as

if the more like a lie his fiction feels, the better Stendhal likes it. Catalogues too are all fabrications, because past a certain point knowledge becomes fictional, and no one can know as much about anything that is not himself as the National Gallery catalogues do about the physical condition of paintings.

Often the object disappears in the assessment of damage. It has been completely repainted, the old parts are worn, there are holes, or creases where it was rolled, it has been cut down on three sides, it does not quite match descriptions in old sources, its painter was not where he needed to be to paint it, there is complete division on its authorship. As it recedes from us, its interest for the cataloguer grows. These canvases are traps, which are taken as deliberate acts by the innocent, but perceived by knowledge as decaying, ignorant scraps of which nothing positive can be asserted or safely ruled out. Here description defines the object by narrowing the empty space at the center, and telling the lives of painters makes them opaque ghosts. Dense detail is summoned to show they did not make a trip to Venice, or that they could have and probably did not. They cannot be separated conclusively from another painter with a similar name, there are no signed works by either of them, so their identities and work are only as distinct as we feel driven to make them.

The further a catalogue pursues its objects the more impalpable they become. Like Trajan's column, catalogues make their users obsessive porers over experience, but always end in talking to themselves in a language so intimate they are nearly impossible to follow. In the Sears catalogue we overhear America whispering about what it wants to wear, what it wants near it, and in *Finnegans Wake* we seem to catch the world talking to itself, a babble hard to break into. The National Gallery catalogue is less obviously ensconced somewhere in Italy, charming itself with Names, writing a chronicle in which all the data fall apart, but only when they have chimed in the head. The cataloguer is not keeping a secret from us, but with us; while an attribution is uncertain the reader wanders among the possibilities, need not come out of the woods, where uncertainties are richer than the truth, and imaginary Venetian journeys more engaging than actual.

Perhaps it is a retreat to substitute imaginary Venetian journeys for actual, but it is also the only way of holding on to the real ones. First the experience imposes itself and then gradually we impose more and more on it, the ordering of learning which falsifies and leaves us feeling how much is left out. Surely Venice is more than art and idling, and how does one learn the superiority to petty annoyance that all critics express? Achieved learn-

ing, insensitive to pain and distress, opposes a hard shell to most of experience and forgets even its own causes. Though the reader may have felt that stretching the idea of place in these chapters was part of a private search for spaces in which to be comfortable, they have necessarily concealed whatever sterility, confusion, or failure it was that made the writer seek this rest, and have put on a triumphant display of flat surfaces and inert assemblages opening to habitable rooms.

Catalogues are finally inconclusive and the state of mind they foster—precise impressions vanishing as soon as registered, sharp but evanescent consciousness, which seems to lead somewhere but perhaps leads nowhere—is more natural and less forced than the purposeful ones of academic discourse. Connected language after all will only present a more or less presentable identity, and as I come to the edge I feel my foot slipping off into all I haven't known how to express. The more difficult things, anger and passion and feeling alone, had to be given up, but learning always accepts its confinement and comfortably settles for less.

Notes

For the historical and construction data in these notes I have depended mainly on guidebooks, Nikolaus Pevsner's *Buildings of England,* various volumes of the Reclam *Kunstführer Italien,* and *Companion Guides* to Rome and Venice by Georgina Masson and Hugh Honour. The books mentioned, except when actually referred to in the text, were not used in writing this book, but are offered here simply as possible further reading.

PAGE 3

Mannerist Landscape in the Low Countries. All the descriptions available for this group of painters are clumsy. It includes Coninxloo, Hondecoeter, Schoebroek, the Valkenborghs, Paul Bril, and Jan Brueghel, all of whom look more archaic than Peter Bruegel the Elder but follow and partly derive from him. Most of the literature is in German, the standard work being H. G. Franz, *Niederländische Landschaftsmalerei im Zeitalter des Manierismus,* 2 vols., Graz, 1969.

PAGE 4

For the Villa Adriana, Tivoli, see Boethius and Ward-Perkins, *Etruscan and Roman Architecture,* Harmondsworth, 1970, which gives a good brief treatment of this complex work.

PAGE 6

Jan Kott, *Shakespeare Our Contemporary,* 2nd ed., London, 1967.

PAGE 6

Boboli Gardens, extending behind the Pitti Palace, Florence. The peculiar name is corrupted from that of the old owners of the land. The gardens were amplified in the course of a century from Tribolo's layout in the first half of the sixteenth century, Buontalenti's plan for a grotto as a display place for Michelangelo's *Prisoners,* Ammanati's amphitheater with the palace as the stage backdrop, and only in 1637 Parigi's location of Bologna's *Neptune* in the middle of the Isolotto and construction of a then-novel labyrinth in foliage. Botanical gardens and zoos were added later, the obelisks in the amphitheater in the eighteenth century. French plans to anglicize (i.e., irregularize) the garden came to nothing.

PAGE 9

Eve Borsook, *Companion Guide to Florence,* London, 1966.

PAGE 9

Bomarzo. The Parco degli Mostri (as it is called on signs) is located near Orvieto a few miles from the Attigliano-Bomarzo railroad station. It is privately owned and under heavy restoration. Virginio Orsini has been the subject of a novel, *Bomarzo* (trans. 1970), by a South American writer, M. Mujica-Lainez, and ingenious theories. Italian writers have found evidence of a Poliphilesque taste bringing to life the allegorizing mind behind *Hypnerotomachia,* a romance of 1499 (for which see pp. 74–83). A French writer has connected it (unconvincingly) with some intriguing grotesque drawings left by Pyrrho Ligorio and interpreted it as a sacred wood which preaches regeneration through two related

163

myths and offers a progressive journey culminating at the temple. (E. Battisti, *Antirinascimento,* Milan, 1962; M. Calvesi, "Il Sacro Bosco di Bomarzo," in *Scritti di Storia dell'Arte in onore di L. Venturi,* ed. De Luca, Rome, 1956; E. Quaranta, *Incantesimo a Bomarzo,* Florence, 1960; J. Theurillat, *Les Mystères de Bomarzo et des jardins symboliques de la Renaissance,* Geneva, 1973). The attribution of the temple to Vignola is now generally discounted.

PAGE 11

Villa d'Este, Tivoli. The gardens were begun by Pyrrho Ligorio in 1560, slightly earlier than the probable date of Bomarzo.

PAGE 11

Four Rivers, in the Piazza Navona, which still keeps the shape and a few foundation stones of Domitian's Circus, and was the scene of jousts, games, festivals, and annual flooding for naumachie almost continuously from Roman times. The third fountain was added in 1878 for the sake of symmetry. For Roman temporary architecture see the plates recording year by year the festival of the Chinea in G. Ferrari, *Bellezze architettoniche per le feste della Chinea in Roma nei secoli XVII e XVIII, compozioni di palazzi, padiglione, chioschi, ponti, ecc. per macchine pirotechniche,* Turin, n.d. For the remains in engravings and oil sketches of Rubens's main project of this kind Part XVI in Corpus Rubenianum, J. R. Martin, *The Decorations for the Pompa Introitus Ferdinandi,* New York, 1972.

PAGE 12

Dubuffet's many other architectural projects are illustrated with photographs and his commentary on them in vols. 24 and 25 of M. Loreau, *Catalogue des travaux de Jean Dubuffet,* Paris, 1975–76, where he imagines an alternative version of the Otterloo garden as a floating island of polystyrene instead of cement, and in the exhibition catalogue *Edifices and Monuments by Jean Dubuffet,* Art Institute of Chicago, 1970.

PAGE 14

Ruins. Albert Speer tells in his memoirs how he developed a special kind of construction which was intended to result in impressive ruins when the buildings decayed. He and Hitler were vivid imaginers of ruin and their buildings from then on were built to these specifications, but almost nothing survives.

PAGE 14

In the courtyard of the Palazzo Medici are combined marble tondi with motifs enlarged from antique gems in Lorenzo the Magnificent's collection, inscriptions from Marchese Riccardi's collection set into the walls with eighteenth-century frames, and Bandinelli's *Orpheus,* a reminiscence of the *Apollo Belvedere,* on the axis between the entrance and the garden.

PAGE 15

The Farnese Gardens were one of many but the grandest of the gardens created on the hill by important Roman families. Begun by Vignola and continued by Rainaldi, they contained one of the first botanical gardens in Europe and the meeting place of the Arcadia, a famous literary academy.

PAGE 15

Piranesi's Church of S. Maria Priorato can only be seen on application to the Embassy (in via Condotti) of the Knights of Malta, to whom it belongs.

PAGE 15

G. Watachin Cantino, *La Domus Augustana,* Turin, 1966; P. Grimal, *Les Jardins romains, à la fin de la république et aux deux premiers siècles de l'empire,* Paris, 1943, 1969, which quotes an interesting passage on a hippodrome by Pliny.

Notes

PAGE 16

The gardens at Stowe, Buckinghamshire, now the grounds of a private school, can be visited at certain times during the school holidays. N. Pevsner gives a full treatment in the space of six pages in *The Buildings of England, Buckinghamshire,* Harmondsworth, 1960, considering views as well as buildings. *Stowe: A Guide to the Gardens,* sold at Stowe, contains some of the best writing available on picturesque gardens.

PAGE 17

Domus Aurea. See A. Boethius, *The Golden House of Nero,* Ann Arbor, Mich., 1960.

PAGE 18

Stourhead was first laid out by its owner Henry Hoare around 1741, but the present buildings were completed over quite a long period, the largest being finished by about 1767, and the rustic cot added as late as 1779. A large plan is sold at the gardens.

PAGE 20

Oscar Wilde, *The Importance of Being Earnest,* Act I.

PAGE 20

The most complete surviving example of William Morris's decoration is the Green Dining Room he did for the Victoria and Albert Museum, which now opens out of a room in the Italian Renaissance section.

PAGE 22

Francesco's *studiolo* is the subject of a volume in the *Forma e colore* series published by Sansone (Florence, 1965), which contains full illustration.

PAGE 23

The Gothic village (Borgo Medioevale) in the Parco del Valentino beside the Po at Turin was built for the Exposition of 1884 incorporating a number of typically Piedmontese Gothic motifs. For other Italian Gothicizing, see C. Meeks, *Italian Architecture 1750–1914,* New Haven, 1972.

PAGE 24

For Ruskin's childhood sensations, see *Praeterita* I, 1.

PAGE 24

Burges's castle is well illustrated in an article by Charles Handley-Read, *Country Life,* CXXXIX (1966), 600–604. The bulk of his drawings can be seen at the Victoria and Albert and the Royal Institute of British Architects, London.

PAGE 24

For Ruskin's own record of his madness, see *Brantwood Diaries,* ed. H. Viljoen, New Haven, 1971.

PAGE 24

Bollingen. References to this building are scarce: some account in M. Serrano, *C. G. Jung and Hermann Hesse,* London, 1966, and in "Aus C. G. Jungs letzten Jahren," *Aus Leben und Werkstatt,* by A. Jaffé, 1968; a photograph in C. Jung, *Memories, Dreams, Reflections,* London, 1963.

PAGE 31

J. Summerson's *New Description of Sir John Soane's Museum,* 1969, cannot be improved on as an account of how it came into being, what it contains, and what it means.

PAGE 33

Chatsworth village called Edensor was removed to the present site around 1839 to get it out of sight of Chatsworth. The Duke's gardener Paxton, who later

designed the Crystal Palace, had a hand in planning the new village, which is treated along with the other model villages mentioned in a recent book, G. Darley, *Villages of Vision,* London, 1976.

PAGE 34

One of the better biographies of Conan Doyle is Pierre Nordon's *Conan Doyle,* Paris, 1964, trans. 1966. There is also Doyle's own *Memories and Adventures,* London, 1924, 2nd ed. 1930.

PAGE 34

A biography of Edward Lear is V. Noakes, *Edward Lear: The Life of a Wanderer,* London, 1968. Several collections of his letters are available.

PAGE 35

Roberts, known for picturesque architectural subjects in oil or watercolor, did a series of Egyptian views which were issued as lithographs. Lewis's Arab subjects can also be seen at the Tate Gallery.

PAGE 35

Leighton House. For Leighton see W. Gaunt, *Victorian Olympus,* London, 1952, and R. & L. Ormond, *Lord Leighton,* London, 1975.

PAGE 36

For the life of Moreau see J. Kaplan, *Gustave Moreau,* Los Angeles County Museum of Art, 1974, which reprints some of his own commentaries and refers the reader to Huysmans's and Proust's appreciations of Moreau.

PAGE 36

Des Esseintes's turtle. The hero of Huysmans's *A Rebours,* 1884, fixes jewels in the shell of a pet turtle.

PAGE 37

Brantwood is owned by Bembridge School, Isle of Wight, and open to the public, but the arrangement of the bedroom can only be gathered from old photographs.

PAGE 37

Again see Ruskin's *Brantwood Diaries.*

PAGE 38

Industrial architecture. See C. J. Singer and others, *History of Technology,* 5 vols., Oxford, 1958; vol. 4, *The Industrial Revolution,* chapter 15, "Building and Civil Engineering Construction" (S. B. Hamilton); vol. 5, *The Late Nineteenth Century,* chapter 20, "Building Materials and Techniques" (S. B. Hamilton).

PAGE 39

W. Frith, *The Railway Station,* 1862, Royal Holloway College, Egham, Surrey (whose collection of Victorian paintings is visitable on application).

PAGE 39

C. Monet, *Gare St Lazare,* 1877, Louvre. He painted a series of eight on this subject between the end of 1876 and April 1877. Good examples in Chicago, Cambridge, Mass., and Musée Marmottan, Paris. See also his treatments of railroad bridges.

PAGE 40

U. Boccioni, *States of Mind,* in three sections, 1912: *The Farewells,* private collection, New York; *Those Who Go, Those Who Stay,* Galleria d'Arte Moderna, Milan.

PAGE 40

St. Pancras Station. A succinct account of its construction, the functions it was designed for, features of site used, and the engineering feat it represents, in *Survey of London,* vol. 24, London County Council, 1952.

Notes

PAGE 40

Crystal Palace. For the full photographic record of the building see G. Chadwick, *The Works of Sir Joseph Paxton,* London, 1961.

PAGE 41

Bridges. See C. J. Singer, *History of Technology,* 1958, vol. 5, chapter 21, "Bridges and Tunnels" (H. Shirley Smith).

PAGE 42

On machines as objects of the imagination from the Renaissance to the present, with emphasis on the early twentieth century, see the exhibition catalogue *Machines, as Seen at the End of the First Machine Age,* Museum of Modern Art, New York, 1968.

PAGE 42

On the ideology of mechanization in a few key industries see S. Giedion, *Mechanization Takes Command,* New York, 1948.

PAGE 42

Uccello's three large pictures of the Battle of San Romano originally forming a frieze (along with two of his pictures now lost) in Lorenzo di Medici's bedroom are now in Paris, London, and Florence.

PAGE 44

On Roman use–architecture. E. Nash, *Pictorial Dictionary of Ancient Rome,* 2 vols., London, 1968, is a photographic inventory of all remains in Rome by classes (all aqueducts, arches, theaters found together) with illustrations of coins, reliefs from other buildings, marble maps, and engravings to show original and earlier states. Extensive bibliography on each entry follows a brief historical account.

PAGE 45

T. Ashby, *The Aqueducts of Ancient Rome,* Oxford, 1935, contains a good section on the engineering of the aqueducts, large plans and sections of all the Roman ones, and maps of routes.

PAGE 45

C. D'Onofrio, *Gli Obelischi di Roma,* Rome, 1967, concentrates on the Renaissance re-erections, of which it has many good illustrations.

PAGE 46

The Ordnance Survey *Map of Roman Britain,* 3rd ed. 1956, gives the whole network of Roman roads as currently known.

PAGE 46

On Palladio the best single volume is J. S. Ackerman, *Palladio,* 1966. When the *Corpus Palladianum* is complete (in more than twenty volumes) he will be one of the most thoroughly catalogued of all architects. The volume on the *Basilica* by F. Barbieri, 1968, includes elaborate photographs and a complete survey in scale drawings.

PAGE 47

A. Palladio, *I Quattro Libri dell'Architettura,* Venice, 1570. *L'Antichità di Roma,* Rome, 1554.

Palladio also contributed illustrations and detailed information about antique structures to D. Barbari's translation of Vitruvius, 1556. The largest collection of his drawings is in the Royal Institute of British Architects, London (see G. Zorzi, *I disegni delle antichità di Andrea Palladio,* Venice, 1959).

PAGE 47

See the excellent Arts Council catalogue by H. Burns, *Andrea Palladio,*

1508–1585, London, 1975, on the villas, and C. Semenzato, *The Rotunda* (Corpus), University Park, 1968.

PAGE 48

This line of architects freshly treated in R. Venturi, *Complexity and Contradiction in Architecture,* New York, 1966.

PAGE 49

For Borromini see chapter 4. Most of Guarini's surviving works are found in Turin.

PAGE 49

Boullée (1728–99) and Ledoux (1736–1806). E. Kaufmann, *Three Revolutionary Architects,* Philadelphia, 1952 (in Transactions of the American Philosophical Society, N.S. 42, pt. 3), is an important piece of interpretation fully illustrated. Boullée's own treatise *Architecture: Essai sur l'art* is mostly taken up with stirring descriptions of his unexecuted projects (first published by Helen Rosenau as *Boullée's Treatise on Architecture,* London, 1953, French text with English notes and introduction). Ledoux's *L'Architecture considerée sous le rapport de l'art, les moeurs et de la legislation,* 2 vols., Paris, 1804, 1806, is mostly large plates but contains prescriptions for the functioning of the community at Chaux. Photographs of his surviving buildings are assembled by M. Raval and G. Cattaui, *Ledoux,* 1961 (in the series Astra Arengarium, Milan). For the Désert de Retz see O. Sirén, *China and Gardens of Europe of the Eighteenth Century,* New York, 1950.

PAGE 51

Futurists. The anthology of Marinetti's writings, *Marinetti: Selected Writings,* ed. R. W. Flint, New York, 1971, includes his Futurist novel. See also *Futurist Manifestos,* ed. U. Apollonio, New York, 1971, and M. Martin, *Futurist Art and Theory 1909–15,* Oxford, 1968.

PAGE 52

R. Venturi, *Learning from Las Vegas,* Cambridge, Mass., 1972, is a revolutionary piece of architectural criticism.

PAGE 53

Pop art has bifurcated more than once since its origin in the late fifties and includes such a variety of highly cerebral products that it no longer seems a single response to mass-culture. The attitude in the text fits the earliest works but not for example the heroic massiveness of Oldenburg.

PAGE 54

This shopping mall tycoon appeared in the *New York Times Magazine,* summer 1973, but anyone who lives near a city will have plenty of relevant experience.

PAGE 56

San Marco. Otto Demus, *The Church of San Marco in Venice,* Washington, D.C., 1960, gives the building's complicated history and illustrates many details of its decoration.

PAGE 57

In *Italian Hours,* London, 1909, writing about Venice, Henry James sees himself revisiting spots Ruskin and Gautier have treated definitively. His praise of Ruskin is a complex encounter with Victorianness.

PAGE 58

Scuola San Rocco. Ruskin's discovery of these rooms, described in a letter to his parents (*Ruskin in Italy, Letters to His Parents, 1845,* ed. H. Shapiro, Oxford, 1972), is one of the great moments in the history of perception. He

reviews the earlier experience when he is there again with William Holman Hunt in 1869 (W. H. Hunt, *Pre-Raphaelitism and the Pre-Raphaelite Brotherhood,* London, 2nd ed. 1913) and re-creates it in *Praeterita* II, 7.

PAGE 61

Piazzetta cannot be seen at his best outside Venice. The churches of the Gesuati, S. Maria della Fava, and S. Vidale contain important paintings by him, and he has painted the ceiling of a chapel in Zanipolo.

PAGE 62

Francesco Solimena by F. Bologna, Naples, 1958, illustrates the paintings fully.

PAGE 64

Dark painters. See R. Wittkower, *Art and Architecture in Italy 1600–1750,* Harmondsworth, 2nd ed. 1969.

PAGE 65

Agrigento was a large city in Greco-Roman times, abandoned for a higher site defensible against barbarian raids. This medieval core was the base of everything until the end of the nineteenth century. After 1920 urbanization in the direction of the ancient site began, until finally this expansion had to be limited by law.

PAGE 67

Noto, a native settlement before Greek colonization, was moved eight kilometers to the southeast after the earthquake of 1693 and entirely reconstructed by three architects according to a grid plan with long level east-west streets, sloping north-south ones, and a central rectangular piazza.

PAGE 67

R. Wittkower's *Gianlorenzo Bernini,* London, 1955, 2nd ed. 1966, is a model monograph.

PAGE 69

The photographs in P. Portoghesi, *Borromini, Architettura come linguaggio,* Milan, 1967, trans. 1968, are themselves intelligent exposures of a Borromini no one else had seen.

PAGE 71

Bernini's statue of St. Teresa is incorporated in the larger conception of the Cornaro chapel in S. Maria della Vittoria, in the neighborhood of the Baths of Diocletian.

PAGE 74

Hypnerotomachia. There are numerous facsimiles of the edition of 1499; Andrew Lang reissued the 1592 translation of Part I in 1890; French edition of 1546, *Le songe de Poliphile,* with its own illustrations, reissued in facsimile, 1963. Long bibliography not complete for English sources and omitting literary treatments in M. Casella and G. Pozzi, *Francesco Colonna Biografia e opere,* Padua, 1959.

PAGE 78

Apuleius' work is discussed and retold in chapter 5 of *Marius the Epicurean,* and he appears as a character in chapter 20. Ronsard already has an important part in the incomplete *Gaston de Latour,* 1896.

PAGE 82

On processions and triumphs see the note to p. 11, Petrarch's *Trionfi,* c. 1352–74, and many renditions of them in art, Mantegna's cartoons of the *Triumph of Caesar* at Hampton Court, Dürer's woodcuts for the *Triumph of Maximilian,* and J. Chartrou, *Les Entrées solennelles et triomphales de la Renaissance,* Paris, 1928 (French royal entries 1484–1551).

PAGE 82

The fullest appreciation of these Riminese carvings will be found in A. Stokes, *Stones of Rimini,* London, 1934 (an excerpt on the reliefs in *The Image in Form, Selected Writings of Adrian Stokes,* ed. R. Wollheim, Harmondsworth, 1972).

PAGE 83

Criticism of Gothic novels has been scarce. Montague Summers, *A Gothic Bibliography,* London, 1940, gives interesting intimations of the territory.

PAGE 95

Notebooks. Kafka's *Diaries 1910–1923,* Prague, 1937, trans. 1948–49, are among his most important works.

PAGE 97

The best appeared just before this was written: T. Pynchon, *Gravity's Rainbow,* or Wandering in the Ruins, a demonstration of technology as a ramifying central pattern on the point of being grasped, and character as inflexible yet continually dissolving and regrouping, like Morse code, perhaps absorbed as small components in the mysterious machine or device we pursue through the book.

PAGE 99

One serious treatment of historical fiction as a type is the Hungarian Marxist George Lukacs's *The Historical Novel,* Moscow, 1937, trans. 1962.

PAGE 100

N. Pevsner, *The Buildings of England,* 46 vols., Harmondsworth, 1951–75. Complete county-by-county architectural guide to England. He gives clues about this enterprise in introductions and forewords to various volumes but never sets out the rationale of the series. It is even more ambitious than the German Kunstführers it is based on, whose uncompromising concentration on visitable work of esthetic merit is something unknown in English before Pevsner.

PAGE 100

Henry James, *Hawthorne,* London, 1879.

PAGE 104

A. J. A. Symons's absorbing *Quest for Corvo,* London, 1934, has been better known than any of Corvo's own works.

PAGE 108

C. G. Jung, *Memories, Dreams, Reflections,* Zurich, 1962, trans. 1963. M. Proust, *Albertine disparue,* Paris, 1925, trans. 1930, chapter 3: Venise.

PAGE 112

J. Conrad, *The Rover,* 1923.

PAGE 112

Gordon Haight's life of *George Eliot,* Oxford, 1968, gives full details about her researches for *Romola,* and puts her famous remark that she began it a young woman and finished it an old one in context.

PAGE 113

The Goncourt *Journals* contain much interesting information about Flaubert's state of mind and conversation at the time he was writing *Salammbô.* R. Baldick's *Pages from the Goncourt Journals,* Oxford, 1962, is a convenient source.

PAGE 121

Auerbach. In an epilogue on the genesis of *Mimesis* he tells of doing without recent scholarship and even reliable editions of some of his texts because he wrote in wartime in Istanbul, but he also wonders if the grandeur of

his subject "The Representation of Reality in Western Literature" wasn't thrust on him by these circumstances (published Berne, 1946, trans. Willard Trask, 1953).

PAGE 124

Upsidedownness has been an important issue in Western art since Monet, whose play with reflection is often play with the idea of being upside down. Kandinsky claimed that the accidental upsidedown sight of one of his paintings gave him the final push toward abstraction (*Über das Geistlige in der Kunst,* Munich, 1912; English ed., New York, 1947). The user of catalogues of Monet and Kandinsky collections finds out that "How do I tell which end is up?" is more than an amateur's blunder, because they often contain at least one reproduction printed upsidedown.

PAGE 125

Two volumes of color photographs taken from Gemini V–VIII are published by NASA.

PAGE 126

Marvell's green. T. S. Eliot listed the appearances of "green" in his essay on Marvell of 1921.

PAGE 127

On the rationale of grid plans see J. W. Reps, *The Making of Urban America: A History of City Planning in the United States,* Princeton, N.J., 1965.

PAGE 128

The Practical General Continental Guide . . . Red Book for the Continent . . . By an Englishman Abroad [A. T. Gregory], 1866. For France, Belgium, and Holland, appeared yearly until 1874. Condensed versions were also issued. A history of guidebooks remains to be written.

PAGE 129

Ordnance Survey *Map of Monastic Britain,* 2 sheets, 2nd ed. 1954.

PAGE 130

Columbia Market was still illustrated in the 1969 reprint of Pevsner's *London Volume Two (The Buildings of England).*

PAGE 131

London Docks. A full account of their construction and use up to that time in L. Vernon-Harcourt, *Harbours and Docks,* 2 vols., Oxford, 1885.

PAGE 131

M. Polo, *Travels,* New York, 1954; dictated in French, 1298; English trans., 1579.

PAGE 132

Michelin *Green Guides* are really annotated lists which have developed an ingenious system of labeling and indenting that allows many separate items (buildings, frescoes, sculptures) to stand out plainly. They are probably the best starting place for someone unfamiliar with the country he is visiting and provide later a quick means of checking whether anything important has slipped his mind. But these triumphs of condensation can be exhausted and then the traveler may be glad of the German Kunstführers and their derivatives like Pevsner, which try to list *everything* of importance so that the user must know what he wants to look up before he opens the guide.

PAGE 133

Early Netherlandish painting has received more complete treatment than almost any other school. See W. Friedländer, *Early Netherlandish Painting,* 14 vols., Leyden, 1967- (originally published in German, Berlin then Leyden, 1924–

37), and E. Panofsky, *Early Netherlandish Painting,* 2 vols., Cambridge, Mass., 1953.

PAGE 134

Jan van Eyck locations: *Annunciation,* National Gallery of Art, Washington, D.C.; *Arnolfini Marriage,* National Gallery, London; *Madonna with Canon Van der Paele,* Musée Groeninge, Bruges; *St. Barbara,* Konglijke Museum voor Schone Kunsten, Antwerp.

PAGE 135

Bruegel's paintings are fully illustrated in F. Grossman, *Bruegel: The Paintings,* London, 1973. The largest group of them is in the Kunsthistorischesmuseum, Vienna. One of the Babel paintings is there, the other in Rotterdam. H. Minkowski, *Aus dem Nebel der Vergangenheit steigt der Turm zu Babel,* Berlin, 1960, copiously illustrates the treatments of this favorite Northern theme. All the other paintings discussed are in Vienna except *The Numbering at Bethlehem* in Brussels.

PAGE 140

On the history of museums. J. M. Crook, *The British Museum,* London, 1972, contains a good chapter which traces the idea from classical times. G. Bazin, *The Museum Age,* London, 1967, has much interesting material oddly arranged, and V. Plagemann, *Das deutsche Kunstmuseum 1790–1870,* Munich, 1969, is thorough and fully illustrated.

PAGE 143

B. Berenson, *The Passionate Sightseer,* London, 1960 (excerpts from his diaries, 1947–56).

PAGE 144

The variegated history of the collections and buildings at the Victoria and Albert is well digested in *Survey of London,* vol. 38, *The South Kensington Museums Area,* 1975.

PAGE 147

This is a reference to Fra Angelico's large *Deposition* in Museo San Marco, Florence.

PAGE 147

The British Museum sells a pamphlet recounting the history of the Elgin marbles before and after they fell into Elgin's hands.

PAGE 148

The history of the Spada collection is briefly summarized in the guide published by the Libreria dello Stato.

PAGE 149

A history of the Wallace Collection serves as an introduction to the *Catalogue of Pictures and Drawings,* London, 1968.

PAGE 149

The Museo Civico, Padua, contains some of the best preserved nineteenth-century museum decor.

PAGE 149

Cloisters. The intentions of the constructors of the various medieval settings there are well recorded in the *Handbook to The Cloisters,* published by the museum.

PAGE 150

Trajan's column was erected in A.D. 113 to commemorate his victories over the Dacians, and stood beside a basilica flanked by two libraries, one for Roman, the other for Greek books. In its base were kept the emperor's ashes in a gold

urn. The relief is a spiral frieze over 200 m. in length narrating two campaigns, A.D. 101–2 and 105–6.

Trajan's statue which crowned it was lost in the Middle Ages and replaced in 1588 by St. Peter. On figured columns see G. Beccatti, *La Colonna coclide istoriata,* Rome, 1960, much of which is devoted to reconstructing two examples at Constantinople but which also provides theoretical background. For the frieze illustrated see F. Florescu, *Die Trajanssäule,* Bucharest and Bonn, 1969.

PAGE 151

Bramante's Tempietto stands on the supposed spot of St. Peter's crucifixion, beside the small church of St. Peter in Montorio (on the Janiculum, Rome). See L. Heydenreich and W. Lotz, *Architecture in Italy 1400 to 1600,* Harmondsworth, 1974, for brief but comprehensive treatment.

PAGE 152

The Parisian church is St. Martin-des-Champs and it houses the Musée des Techniques of the Conservatoire National des A· .s et Métiers.

PAGE 153

Sears catalogue. See the reprint of the 1902 issue.

PAGE 154

The Pillow Book of Sei Shonagon, trans. Ivan Morris, 2 vols., New York, 1967, like some of his other translations contains fascinating annotation on Japanese civilization.

PAGE 154

Henry Mayhew's *Life and Labour of the People of London,* 4 vols., London, 1851–64, began in newspaper articles and grew to an inquiry uniquely persistent for its time. As a sociological investigator Mayhew has in some respects never been surpassed.

PAGE 154

James Agee and Walker Evans, *Let Us Now Praise Famous Men,* Boston, 1941. This began as an assignment for *Fortune* magazine but none of it ever appeared there.

PAGE 157

Episode 10 of *Ulysses,* "Wandering Rocks," which begins with Father Conmee looking at his watch and ends in the Viceregal procession. See R. Ellmann, *James Joyce,* New York, 1959, for the anecdote about its composition. For the recurrence of subjects in *Finnegans Wake* see A. Glasheen, *A Second Census of Finnegans Wake,* Evanston, Ill., 1963.

PAGE 157

Macintosh. See Robert Adams, *James Joyce: Common Sense and Beyond,* New York, 1966.

PAGE 161

The catalogues compiled by Martin Davies are models of skepticism. In *The Earlier Italian Schools,* National Gallery, London, 1961, and *The Early Netherlandish School,* 1968, he is sometimes reluctant to admit that marks in a row (which others call an inscription) may be letters, and evaporates a number of painters by supplying quotation marks around their names.

Index

Index

A NOTE ABOUT THE AUTHOR

Robert Harbison was born in Baltimore on September 6, 1940. He is a graduate of Amherst College and Cornell University, where he received his doctorate in 1966. He is now living and teaching in London.

A NOTE ON THE TYPE

The text of this book was set in a film version of Palatino, a type face designed by the noted German typographer Hermann Zapf. Named after Giovanbattista Palatino, a writing master of Renaissance Italy, Palatino was the first of Zapf's type faces to be introduced to America. The first designs for the face were made in 1948, and the fonts for the complete face were issued between 1950 and 1952. Like all Zapf-designed type faces, Palatino is beautifully balanced and exceedingly readable.

COMPOSED BY DATAGRAPHICS INC., PHOENIX, ARIZONA

PRINTED AND BOUND BY THE HADDON CRAFTSMEN, INC., SCRANTON, PENNSYLVANIA

DESIGNED BY GWEN TOWNSEND